CONTEMPORARY STONE SCULPTURE

Other Art Books by Dona Z. Meilach

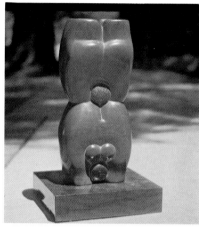

ACROBATS. Ruth Ingeborg Andris.
1969. African wonderstone. 18″
high, 6″ wide, 6″ deep.
Collection, Mr. and Mrs.
Warren Merz, Chicago
Photo, author

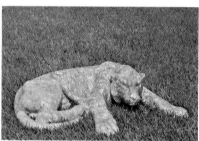

RESTING LIONESS. 1968. Gray
alabaster.
Collection, Mr. Ben Lavitt,
Highland Park, Illinois
Photo, author

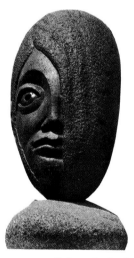

SEVENTEEN. Cabot Lyford. 1969.
Basalt beach stone mounted on
stone. *Courtesy, artist*

HIGH SEAS. Philip Pavia. 1965.
Marble. 50″ high.
Collection, Leonard Boedel,
Williamstown, Massachusetts
Courtesy, Martha Jackson Gallery,
New York

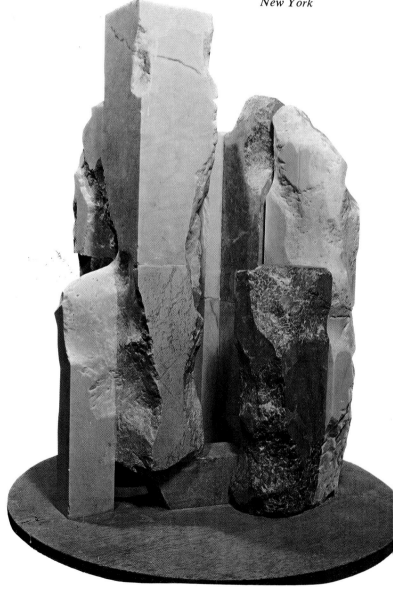

CONTEMPORARY STONE SCULPTURE

aesthetics · methods · appreciation

by Dona Z. Meilach

London
George Allen & Unwin Ltd

FOR: Susan and Allen

Acknowledgments

Compiling this book has been a delightful, enriching experience, thanks to the friendliness, generosity, and cooperation of literally hundreds of people.

Artists, galleries, museums, and collectors throughout the world enthusiastically answered my request for photographs, recommendations, and stone sources. Research took me into the studios of scores of sculptors who shared with me their experiences, knowledge, and philosophy about stone sculpture, past and present.

Special thanks to Mr. Dennis Kowal, Jr., sculptor and Professor of Sculpture, University of Illinois, Champaign-Urbana, Illinois, for his invaluable help with photography and preparation of material, Eldon Danhausen, Associate Professor of Sculpture of the School of the Art Institute of Chicago, and Lawrence Fane, Assistant Professor, Art Department, Queens College, New York, who worked tirelessly with me in the preparation and reading of the manuscript.

I am indebted to Ruth Ingeborg Andris, who so efficiently developed the thorough demonstration of carving in chapter 4 so I could photograph it at various stages. Egon Weiner, the School of the Art Institute of Chicago, Abby Wadsworth, and Ralph Hartmann also worked as my camera recorded their techniques.

My gratitude to the directors of the various symposia who made photographs available to me of works produced during meetings in several countries. Thanks, too, to the manufacturers, quarries, stone companies, and sculpture-material suppliers for discussing various aspects of stone sculpture materials and tools with me.

Sincere appreciation to Mr. Ben Lavitt, Astra Photo Service, Inc., Chicago, Illinois, to Mrs. Marilyn Regula, my typist, and to my husband, Dr. Melvin Meilach, and my children for their patience and encouragement.

Brandt Aymar and his staff have my deepest admiration for their editing and production expertise.

DONA Z. MEILACH

Lincolnwood, Illinois

Note: All photographs by the author unless otherwise credited.

Contents

List of Color Plates

Foreword

When I first began gathering material for this book, my sculptor friends were skeptical about the quantity and quality of stone sculpture being produced today. The consensus was that serious sculptors are working in newer media: direct metal, wood, plastics, light, scientific materials, and so on. A survey of recent magazine articles substantiated this. Yet, in researching earlier books, I sensed there was more stone sculpture going on in a contemporary idiom than the press was reporting.

Coupled with my observation was the slow, but sure, impact of the "sculpture symposia" taking place in various countries where invited artists could work and exchange ideas. This was practically ignored by magazine and news media. I discovered that extremely knowledgeable sculptors were unaware of the opportunity such symposia were presenting to the serious artist. Once aware, they were anxious to learn how they might participate.

Hence, this book is, I believe, the only recent investigation of an increasing interest in direct stone carving. It chronicles many changes that have influenced the use of stone in contemporary art.

In addition to the numerous examples of finished sculpture for historical, aesthetic, and appreciation purposes, the book presents methods and thought processes of artists who are working stone today. The chapters dealing with methods present tools and techniques to help you approach direct stone carving. They deal in depth with the use of power equipment in conjunction with traditional hand chisels and hammers. The methods apply to all varieties of stone. Therefore, in developing the unending styles, forms, and subjects illustrated, the methods chapters should be referred to frequently. The properties of various types of stone are discussed along with their appeal.

The emphasis in this book is on *direct carving*. The demonstrations are intended as guides to efficient uses of tools and procedures in working raw stone to finished sculpture. Photographs and drawings are meant to excite and stimulate you to think about the mental and physical procedures for sculpture. They are aids to help you approach stone, being aware that a form exists within that can be expressed through your efforts.

Even if you never put a chisel to a stone, this book will give you an appreciation of how a stone sculpture evolves. You will see the trends of modern stone sculpture in the multitude of illustrations gathered from sculptors, museums, and galleries around the world.

SANDWICH SEXUEL. Ipousteguy. 1968. Marble. 26″ long, 23″ wide, 28″ high.
Courtesy, Galerie Claude Bernard, Paris.
Photo, Vandor

HANDICRAFT DEPARTMENT,
KING ALFRED'S COLLEGE,
WINCHESTER.

Contemporary Stone Sculpture

INTRODUCTION

Today's stone sculptors are evolving new forms, new ideas, new expressiveness. When one recounts the traditions in which stone is steeped, it is stimulating and exciting to realize that a new age has arrived for the use of this ancient material. During the late 1960's and moving into the 1970's, there has been an unmistakable tremor that has shaken the art world so that future generations may well refer to this period as a revival in the use of stone by the serious artist.

Accustomed to human, animal, and plant forms of Egyptian, Grecian, Roman, Indian, and Oriental origins, sculptors of the twentieth century continued to create variations of such subjects, using the modish artistic developments of their time. The stance of the figure eased and suggested movement, surfaces altered from smooth to textured, relationships of masses changed, but subjects slavishly remained the same as those used for centuries.

Now, sculptors are bringing to stone a similar inventiveness and a variety of styles and forms associated with contemporary media. They are capturing a unique tendency dictated by the nature of the material, yet they are dictating new directions for the materials to take —directions unthought of, undreamed of, by sculptors only a few decades ago.

From small pebbles to monumental works, artists are achieving sculptures that express today's ideas, psychological incisiveness, attitudes, sounds, and sights, in addition to recognizable objects. They are reflecting their interest in and observation of problems and solutions of modern society. They are totally involved with pushing the potential of stone to its most powerful statement. They are learning how this potential relates to them. One artist may choose granite, a hard stone to carve, because he enjoys the resistance of the material. Another prefers soft stone with which he can realize a form more spontaneously. All are exploring the meaning of plastic composition by direct carving. They are making discoveries bound to have long lasting significance. In this age of "instant everything" a number of sculptors are returning to stone because they feel a need to evolve ideas slowly, painstakingly.

Yet stone sculptures need not take a long time to create. Much handwork is required, of course, but stone sculptors, like those who work in other media, take advantage of technological equipment to facilitate their visual results. The hammer and chisel remain the foundation of all direct carving, but pneumatic equipment greatly speeds up the blocking out of major shapes. Power drills, sanders, saws, and buffing attachments hasten several processes and reduce the energy expended in the mechanical aspects of the creative process.

Stone sculpture in the 1960's has received tremendous impetus and interest by the organized sculpture symposia. Such programs provide sculptors with living subsidies, materials, work space, assistants, audience, publicity, and outlets for monumental work they could not otherwise create without specific commissions. As more sculptors participate in symposia, they

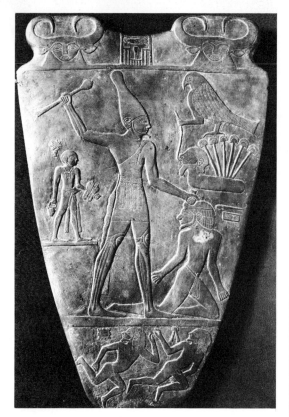

PALETTE OF KING NARMER. From Hierakonpolis. C. 3100 B.C. Slate. 25″ high. Among the earliest Egyptian carvings is this votive offering palette to the Temple in Hierakonpolis to commemorate the conquest of lower Egypt. Humans, birds, animals, and plants combine to give visual symbols that convey exact messages in a form of Egyptian picture writing. The king is about to slay the enemy whom he holds by the hair. A court official at left holds the king's sandals. Two fallen soldiers are at the bottom. The falcon is holding a tether to the head of a man which grows from the same soil as the plants. The entire symbolism portrays the idea that a king, who is as a god, triumphs over human enemies.

Courtesy, Egyptian Museum, Cairo

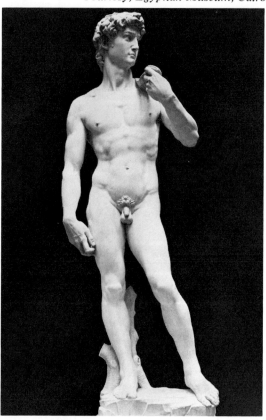

are able to experiment, learn, and exchange ideas with others. They return to their studios with enthusiasm and experience which they disseminate to students, fellow sculptors, and to the art community.

It is a fact that stone sculpture was dropped from the curricula of many art schools as welded metal, plastic, light, and other new materials captured the attention of students, museums, and galleries. Many who could teach stone carving switched to other media. So it became difficult to find instructors who were working with stone.

This situation first occurred early in the twentieth century. The practice of an "artist" working directly with stone was practically unknown for over two hundred years. Journeymen copyists and building masonry workmen carved, but always from patterns and by pointing, limiting their techniques to those required for their jobs. When Constantin Brancusi, Amedeo Modigliani, Ossip Zadkine, and Eric Gill sought new forms for stone they actually had to rediscover the whole technique of direct carving. With their insistence on an intimate involvement with their materials they struggled through with results so avant-garde,

DAVID. Michelangelo. 1501–1504. Marble. 13′5″ high. Academy, Florence. Considered the most famous and the earliest monumental statue of the High Renaissance, David represents the sculptor's visualization of a biblical hero. Michelangelo approached the creation of sculpture as "the making of men," loosely analogous to divine creation. To him a piece of rock held a figure within, much as a mother carries a child in the womb. Michelangelo wrote of an elbow pressing against a corner of the rock. Yet he would sketch and make careful models before he set about "liberating" the figure.

Courtesy, Alinari-Art Reference Bureau

Rock fragments washed down a hillside may suggest many forms. Curiosity in shapes, textures, colors of rocks may be the stimulus for a potential sculpture career . . . and this is the purpose of this book.

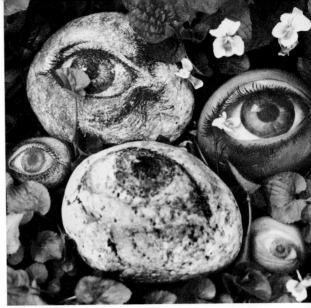

EYESTONES. Russell T. Limbach. 1969. Stones painted with eyes suggest the artist's impression of stone as it appeared in its environment. Stone may be painted with artist's oils, acrylics, and household paints.

Courtesy, artist

they startled the art world. Again, in the last half of the century, this situation is recurring with equally astonishing results.

Because stone is considered a hard material, many people think it is difficult to carve. This is not necessarily true. Often sculptors prefer carving a soft stone to carving wood. One doesn't have the problems of wood: difficult grains, checks or cracks, swelling caused by high humidity. Stone yields as easily to hammer and chisel as does wood, and often more so. It is available in larger blocks than wood so one doesn't have to laminate boards together to make monumental sculptures. Manageable pieces of stone are readily available. Tools required are minimal. For beginner and professional, stone is, as it always has been, a basic, dependable, and enduring sculptural medium.

This book is aimed to present practical knowledge about the use of stone for sculpture. Through direction and examples, it shows tools, materials, and methods of today's carvers. The historical development of stone sculpture continuing through to the creativity of the sixties gives valuable background for understanding the evolution of form. Within each chapter, examples are arranged chronologically so the

reader can follow the development of a specific theme from realism to abstraction. Ancient and primitive examples are chosen because they have provided invaluable stimulus for contemporary forms. Hopefully, they will encourage you to search out and observe other primitive examples in books, museums, and galleries that will excite your own visualization of sculptural form.

There is no "one way" to work with stone; no "best tool" to use, no "easy lesson" that will make you a successful sculptor the first time you put chisel to stone. But the techniques and examples in this book from hundreds of artists around the world are offered to stimulate everyone, beginner and advanced, to take advantage of stone as a potential medium for creative carving.

None of the sculptures is meant to be copied. They are presented so the reader will be aware of the mental and physical creative processes. They are idea stimulators for approaching one's own artistic statements. Art students, historians, and collectors will find material never before presented between covers of a book. They will find names and themes that point to a fresh future for twentieth-century sculpture.

STONE GROUP No. 2. Mary Bauermeister, 46″ high, 40″ wide, 18″ deep. Stones and pebbles, smoothed by action of sea and sand, have been judiciously selected, arranged, and glued in a complex composition combined with painting. Epoxy glues will hold small stones together.
Courtesy, Galeria Bonino, Ltd., New York.
Photo, Lisl Steiner

TAKE-OFF AT DAWN. Anita Weschler. Stones on a weathered wood base. 20½″ high, 28″ wide, 4½″ deep. The composition suggests the tremendous selectivity exercised by the artist in assembling stones that complement one another in shape, size, texture, and color. Gravity-defying positions are accomplished by drilling holes into the stones and connecting them with metal rods held by epoxy glue.

Courtesy, artist

NEW ONE. John B. Flannagan. C. 1935. 6½″ high, 11½″ long. Flannagan was fascinated by the form suggested by an ordinary fieldstone. By removing as little material as possible, he would bring that form out of the stone.
Courtesy, The Minneapolis Institute of Arts

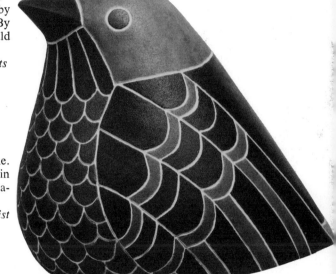

LITTLE BIRD. Cleo Hartwig. Painted limestone. Red, brown, and black inks have been placed in the carefully carved repeated shapes. In its stylization it is beautifully simple, yet expressive.
Courtesy, artist

INDIAN MOTHER. Virginia E. Stemples. 1968. Slate. 13½″ high, 13½″ wide, ½″ deep. A broken piece of thin brown slate from a floor tile installation was lightly carved with wood-carving tools to bring out the subject it suggested to the artist.
Photo, author

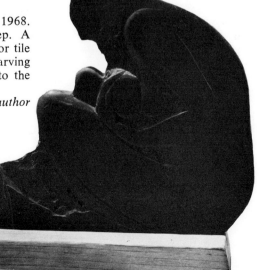

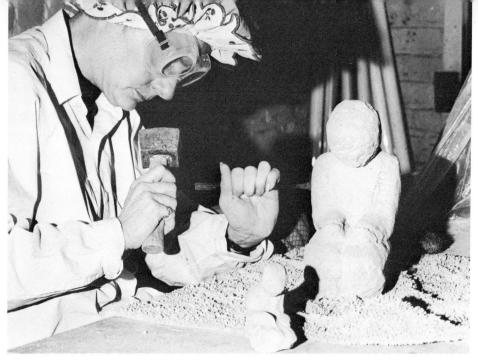

The working area for creating sculptures need not be formal or specially outfitted. Here, a working corner has been set up in a garage. Working from a clay model, the artist uses an old bath rug to keep the stone from slipping and to catch stone chips. A shower cap protects her hair. Safety glasses are essential to protect eyes from flying stone.

Photographed by author at class of Kay Hofmann-Schwartz, Highland Park, Illinois

In the art school classroom larger pieces may be set directly on the floor or on wood 2 × 4's to allow the sculptor to work the bottom portion of the stone. Closed areas require venting to eliminate stone dust.

Photographed at The Art Institute of Chicago

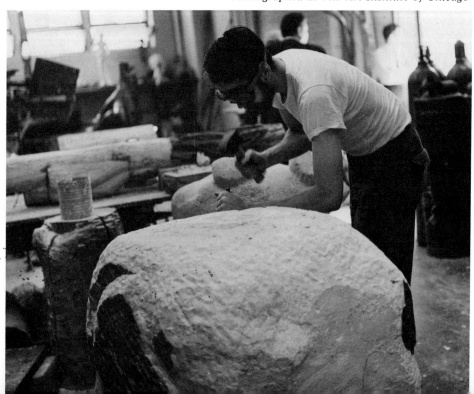

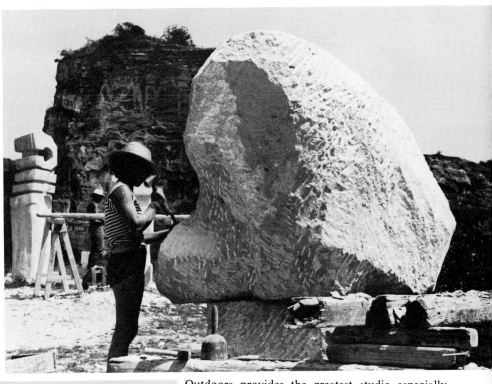

Outdoors provides the greatest studio especially when working with large pieces of stone. Here, Alina Szapocznikow of Poland is shown working at a symposium site in 1961.

Courtesy,
Symposium St. Margarethen Bildhausser

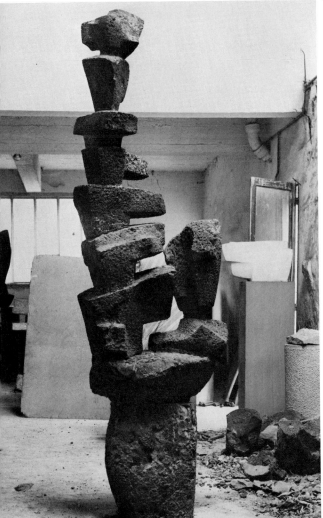

The private sculpture studio ranges from a small garage or shack to store fronts, factories, and warehouses, wherever sculptors can find low rent areas with ample space and light for working. Here, in the studio of Paris sculptor Morice Lipsi, several works are on display, with stones to be carved in the background.

Courtesy, artist

HANDICRAFT DEPARTMENT,
KING ALFRED'S COLLEGE,
WINCHESTER.

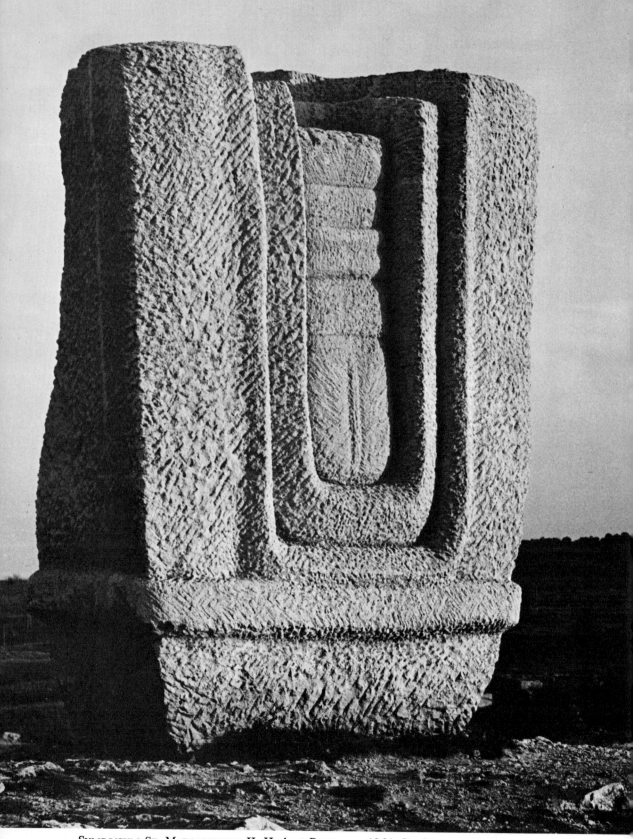

Symposium St. Margarethen II. Herbert Baumann. 1964. Sandstone. 92″ high.

Photo, Helmut Baar

Development of Contemporary Form and Ideas

HISTORY—TO WORLD WAR II

Stone sculptors have created a new language of forms, themes, and styles in the late 1960's and early 1970's. Seeing many of the new forms for the first time, one might think that, like Venus, they developed full blown. But it is not so. Innovations in stone sculpture have as their heritage the background and influences of twentieth-century sculpture in all media. Artists have drawn from the entire panorama of world history, yet their forms are often in open rebellion to stone sculptures of the past.

Toward the end of the nineteenth century artists who were direct stone carvers were almost nonexistent. Stone sculptures created at this time were the cooperative effort of artist and craftsman. The stonemason, using a pointing machine, a simple instrument for measuring exactly a three-dimensional object and enlarging it, reproduced the artist's model in stone. The general result was more decorative than expressive. A model made in clay did not necessarily "fit" a carved stone. Sculpture suffered as a result; it lacked the vital emanating qualities achieved by a creative artist working directly with his materials.

The discovery of the ruins of Pompeii and Herculaneum in the 1700's encouraged the continuing enthusiasm for the ideals of classical realism. Nineteeth-century Italian, French, and American sculptors working in Europe were interested primarily in representation; any sensuous qualities of material were secondary. Highly polished pure white marbles and other monochrome stones were used, and interest was only in form, not materials. Subjects for sculpture most often were literary and biblical themes such as Hercules, Orpheus, Cleopatra, and David. The academic sculptors were influenced by neoclassic and baroque masters such as Bernini, Canova, Thorvaldson, and others. Perhaps the greatest contribution of nineteenth-century sculptors was that they provided the work for twentieth-century sculptors to revolt against.

Impressionist painting during the late 1900's was most significant and had a direct impact on the development of sculpture. Degas, Renoir, and Matisse created some sculptures which reflected their interest in broken light on a surface. Degas' small bronzes, made from modeled clay, had rough surfaces and a great deal of movement. Auguste Rodin exploited this effect in his stone sculpture. He freed himself from the prevailing academic conventions

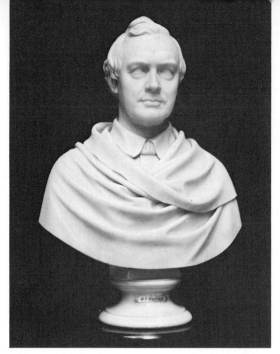

BUST OF WILLIAM P. WILSTACH. William Rinehart. 1870. White marble. An Italian neoclassic style often appeared in sculptures of this period. Rounded forms had a decorative rococo quality.
Courtesy, Philadelphia Museum of Art

THE WHITE CAPTIVE. Erastus Dow Palmer. 1859. White marble. 66″ high. A classical interpretation with a touch of naturalism. She has a relaxed pose and a defiant look meant for the Indians who captured her and tied her to a post. The entire surface is smooth and an obvious contrast to the rough and smooth surfaces used by Rodin and many twentieth-century sculptors.
Courtesy, The Metropolitan Museum of Art, New York

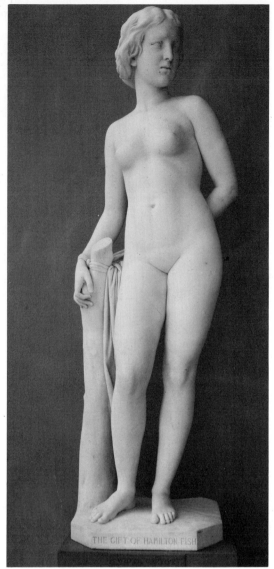

and expressed a movement and realism that were dynamic and powerful. His figures were no longer static replicas of neoclassical works. They were caught in a moment of action at the height of a movement.

Rodin's works, too, were executed by stonemasons from his models and drawings, but he often directed them and added touches and revisions of his own. Inspired by Michelangelo's unfinished marble sculptures, Rodin purposely juxtaposed smooth and rough surface textures that broke up light and created unending interest in the contrasts achieved. Rodin provided the bridge between nineteenth- and twentieth-century sculpture. He directly influenced other romantic realists such as Aris-

tide Maillol and Lorado Taft. They were among a group who continued to develop the figure along Rodin's naturalistic, humanistic style using interplays of rough and smooth surfaces. Art historian Herbert Read points out: "Rodin restored to the art of sculpture the stylistic integrity it had lost since the death of Michelangelo in 1564. Rodin was a humanist whose social and artistic ideas were based in the humanism of the middle ages and always concerned with absolute faith in nature and a realism in the role of humanity."

But Rodin was not the only influence that led to what eventually became known as "modern" sculpture of the twentieth century. There was the role of the paintings by Cézanne. His

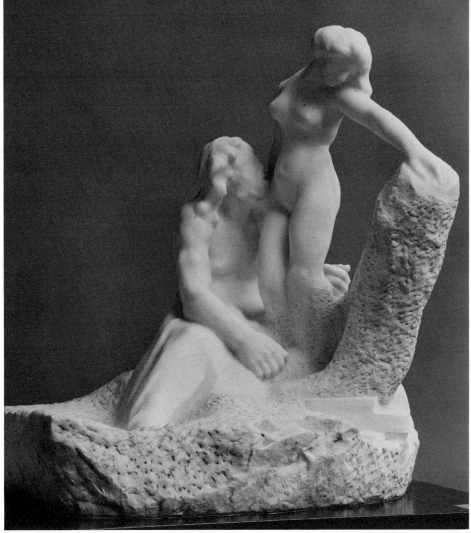

PYGMALION AND GALATEA. Auguste Rodin. Modeled in 1889; executed about 1908–1909. Marble.

Courtesy, Metropolitan Museum of Art, New York,
Gift of Thomas F. Ryan, 1910, in memory of William M. Laffan

reduction of form into cylinders, cones, and cubes, became the basis of abstraction. He, along with Georges Seurat, sought structure, solidity, and organization in depth—factors directly applicable to sculpture. And it was these factors that Brancusi, Archipenko, Zadkine, Lipchitz, and Modigliani utilized to innovate new sculptural forms. Later, Moore, Hepworth, Noguchi, and others carried abstraction even further. So it is from early abstract art that present-day activity inherits its forms combined with the naturalism and humanism of Rodin.

Constantin Brancusi's work is the earliest, most spirited departure from realistic, humanistic, classical tendencies of the nineteenth century. He is credited as the founder of the modern twentieth-century movement in sculpture. He was hostile to the stereotyping of artistic idiom and the then slavish adherence to the characterization of a model. (So real was one of Rodin's bronze sculptures that critics accused him of having it cast directly from the living model.) Brancusi ruthlessly eliminated irrelevant and superfluous detail in an effort to achieve an impersonal, essential form. Using the idea of an embryo, a nucleus, an egg, and the geometric oval, he created various marble and bronze versions of a "Sleeping Muse," an ovoid-like form given different shapes and titles as he reworked the idea into a variety of sculptures. His themes deal with the mystery of creation in various stages of the awakening

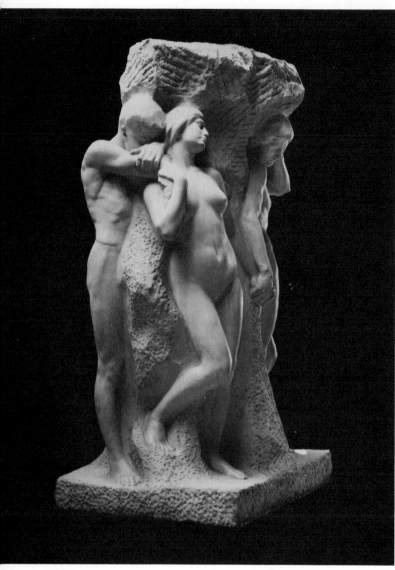

SOLITUDE OF THE SOUL. Lorado Taft. C. 1900. White marble. 8' high. Influenced by Rodin, Taft's figures form a group that emerge from, yet are attached to, the rock which is worked in both polished and rough surfaces. Taft was interested in the circular composition.
Courtesy,
The Art Institute of Chicago

of consciousness. Shapes are plain, egglike with smooth, round, iridescent surfaces, tenderly polished and bathed in light. They have neither beginning nor end and suggest the infinite character of a closed surface.

Brancusi had an innate love of materials. He selected the medium he preferred for its specific contents. He felt that marble lent itself to the contemplation of the origins of life. He believed that a mysterious kind of communication was established between the thought processes of the artist and those of his material. He claimed, "It is while carving stone that you discover the spirit of your materials and the properties peculiar to it. Your hand thinks and follows the thoughts of the materials." Direct carving became a prime factor in Brancusi's art and the polish as "a necessity which derives from the relatively absolute forms of certain materials." Said one reviewer, "His polish gave the work a transcendent transparency that emanates a strange spiritual and spatial power."

Brancusi's later works developed other

PROMETHEUS. Constantin Brancusi. 1911. White marble. The simplified, geometric form was a complete departure from anything carved from stone before. Brancusi purposely represented form that approaches perfection, but does not quite succeed because of details and one end being too narrow for a perfect egg shape. To Brancusi, this symbolized suffering and the inaccessibility of the absolute.

Courtesy, Philadelphia Museum of Art, Collection, Louise and Walter Arensberg

themes all concerned with man, his myths, and the symbols of life. His search for simplified forms stimulated other sculptors to seek escapes from the romantic and pictorial representation of the 1900's. With modern communication, pictures and examples of sculpture from non-Western countries appeared in books, magazines, and galleries. Travelers brought home examples of primitive art from African, Samoan, Mexican, and Indian cultures which opened up new visual concepts. This broader view of world sculpture began to shatter the

binoculars to the Grecian past. Sculptors began to realize the intrinsic emotional significance of shapes instead of seeing them as representational values. It freed them to recognize the importance of materials and to be in sympathy with what a material could do.

As Picasso, Braque, and Léger explored cubist shapes in their paintings, sculptors attempted similar analysis in three-dimensional form. The painter Amedeo Modigliani spent the summer of 1909 in Italy mainly for his health, but also because he was fascinated with

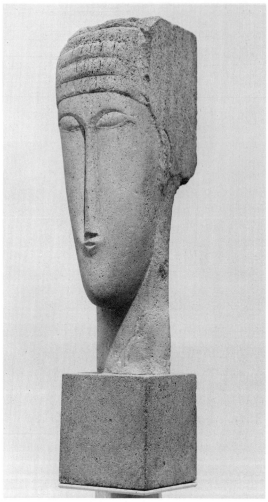

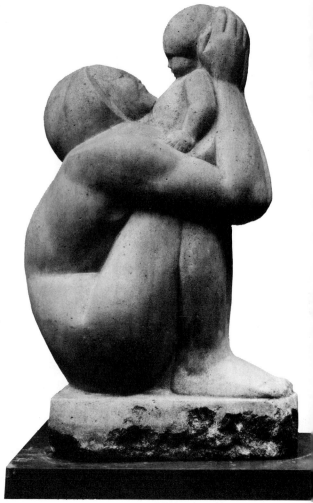

HEAD. Amedeo Modigliani. 1912? Limestone. 25″ high. Elongated oval shapes were inspired by masks being brought to Paris from the Fang tribe of Gabon, Africa. Modigliani was fascinated by the spontaneity of direct carving and the beauty of pure forms.
Courtesy, The Solomon R. Guggenheim Museum, New York

MOTHER AND CHILD. Cecil Howard. 1918. Limestone. 22″ high, 11¾″ wide, 7″ deep. A recurring theme of motherhood is portrayed in a carving that has a massive geometric quality and an absence of details. The broad planes show a continuing interest in simplification of form.
Collection, Whitney Museum of American Art, New York

ideas of direct carving that his friend Brancusi talked about. He went to Carrara, the seat of Italian marble, where he made several carvings. It is believed he was so dissatisfied with them he threw them into the canal. However, in 1912, Modigliani did exhibit a group of directly carved limestone heads that achieved a synthesis of his elongated style with pure Italian tradition and principles of cubism.

Between 1915 and 1920 when cubism was

the avant-garde art of Paris, Jacques Lipchitz and Ossip Zadkine developed figures in stone that echoed simplified planes and volumes of the painters. In sculpture they successfully created geometric constructions far removed from any picturesque imaginings. Neither artist continued to work very long in the cubist manner and in stone. They applied their new language of shape and spatial experimentation to more flowing contours which generally were modeled

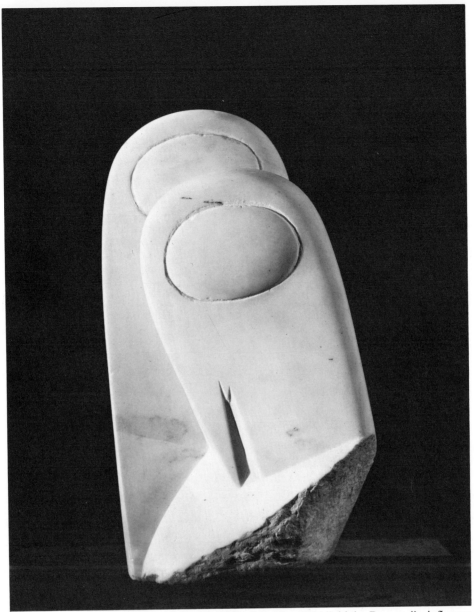

Two Penguins. Constantin Brancusi. 1914. Marble. 21¼″ high. Brancusi's influence on modern sculpture has been enormous. He made people shape conscious. He was able to distill the essence of some human or animal form and present it in a remarkably balanced, simplified statement.

Courtesy, The Art Institute of Chicago

in clay, then cast in bronze.

While other artists sought a variety of media in the 1920's, a small group of American sculptors continued to work in stone. They became even more dedicated to direct carving. Led by William Zorach, an American painter turned sculptor, this group also believed that only direct carving had a spontaneity that resulted in a vital image. They rejected the idea of pure white marble of the past generation in favor of stone with natural color, texture, and veining.

Zorach's sculptures dealt with traditional themes: nudes, torsos, children, animals, motherhood, love of man and woman. He simplified features and shapes, omitting detail, avoiding romantic emotion, and preserving the shape of the original block. Like Rodin, he made great use of contrasting polished surfaces and rough unfinished textures.

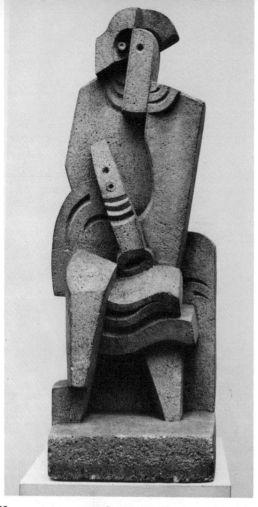

HARLEQUIN WITH CLARINET. Jacques Lipchitz. 1919–1920. Limestone. 29″ high. An interpretation of cubism in three dimensions, Lipchitz's stone compositions of this period were like imaginary architecture. Human figures were rigid, austere, with unnecessary detail eliminated.

Courtesy, Jane Wade Ltd., New York.
Photo, Geoffrey Clements

TWO WOMEN. Ossip Zadkine. 1920. Limestone. 33½″ high. Zadkine, also working in the cubist manner, interpreted shapes with more curves, bends, and obliques. He preferred the rough, uneven, rugged surface to the smooth and highly polished.

Collection, "The Contemporaries," New York.
Photo, Walter Rosenblum

MOTHER AND CHILD. William Zorach. 1927. Spanish rose marble. Many of today's direct stone carvers studied with Zorach who believed that "Direct carving is greater than modeled sculpture, its problems are greater and its possibilities of creative expression are deeper." He created figures in repose with no violent movement or dramatic gesture. Themes have an elemental human meaning: love of mother and child, man and woman, children and animals. Forms are massive and highly simplified.
Collection, Metropolitan Museum of Art, New York. Photo, Peter A. Juley & Son

ARTIST'S WIFE. William Zorach. 1924. Pink Tennessee marble.
Collection, The Zorach Children.
Photo, Peter A. Juley & Son

CHILD AND CAT. William Zorach. 1926. Pink Tennessee marble.
Collection, Museum of Modern Art, New York. Photo, Peter A. Juley & Son

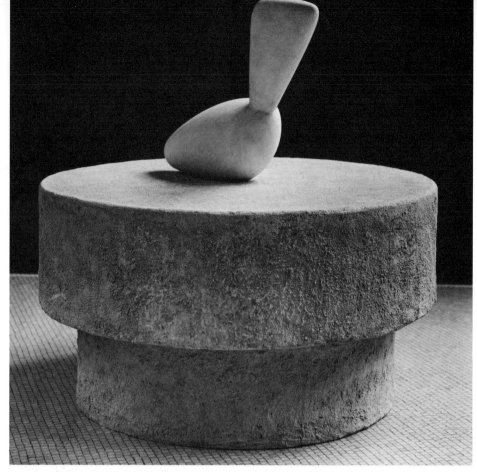

LEDA. Constantin Brancusi. 1924. Marble on a limestone base. 26″ high, 19″ wide. Base 25¾″ high, 40½″ diameter. Brancusi thought of a base as the environment for his sculpture; often it too was a sculpture, not simply a block for presentation.

Courtesy, The Art Institute of Chicago

Among those influenced by Zorach's direct stone carving theories was John Flannagan whose personal statements added to the development of American stone sculpture. Unable to afford marbles, Flannagan sought fieldstones. To him they had an unmatched natural beauty, and he worked with the idea a stone suggested. By removing as little of the material as possible, he produced humorous and touching sculptures of elephants, goats, chickens, dragons, cats, monkeys, and embryonic figures.

By the end of the 1930's, direct carving was attracting more proponents, most in wood, some in stone. The English sculptor Henry Moore is credited with the most significant advances in that decade. Stimulated by simple shapes of pre-Columbian and African carvings, Moore continued to carve directly. He created forms that changed radically from the naturalistic and representational figures of Zorach and his followers to the abstract. He retained all the necessary elements of sculpture: volume, mass, space, and formal coherence. Moore's sculptures emanate from human and natural forms. An important idea in the development of sculpture was Moore's concept of penetrating the material and opening up the sculptural mass. Now sculpture not only penetrated space, but space also penetrated the sculpture. He brought solids and voids into equal and harmonic balance. He said, "The first hole made through a piece of stone is a revelation."

José de Creeft learned direct carving in a Parisian shop where academic plaster models were reproduced in marble. Of Spanish descent, he migrated to America and continued

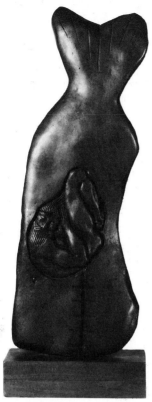

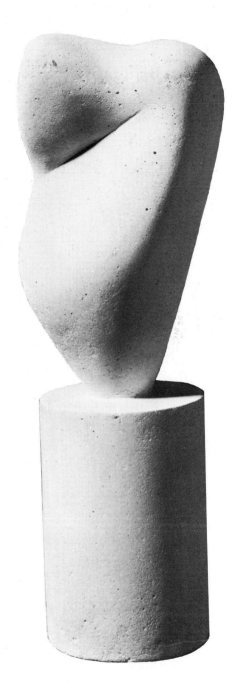

JONAH AND THE WHALE. John B. Flannagan. 1937.
Forced by poverty to use fieldstone rather than
marble, Flannagan's aim was "to produce sculp-
ture with such ease, freedom, and simplicity that
it hardly seems carved but rather to have endured
always."
Courtesy, The Minneapolis Institute of Arts

OWL'S DREAM. Jean (Hans) Arp. 1937. Stone.
Arp's forms are fluid and growthlike, similar to
the abstract tradition of Constantin Brancusi and
Henry Moore. The form appears to have grown
from the base rather than merely set upon it. This
illustrates a continuing solution to the problem of
the base as environment, not presentation.
Courtesy, Philadelphia Museum of Art

Zorach's ideas of direct carving and truth to
materials. But his shapes are apart from those
of his contemporaries; they are full, almost
puffy, with a great sense of fluidity. His unerr-
ing use of the innate texture of stone suggests
an intimate love and respect for his materials.
His insistence on direct carving shows in the
various surfaces and manners in which figures,
sometimes partially hidden, conform to the
shape of the block.

Jean (Hans) Arp, who had created con-
structions and amoeboid forms in wood, be-
gan to work with marble in the late 1940's also,
but the majority of his stone sculptures ap-
peared following World War II, when a great
surge in creativity erupted in the art world.

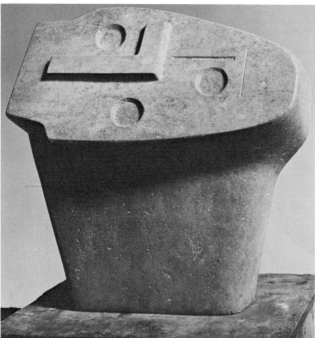

CARVING. Henry Moore. 1936. Travertine marble. 18″ high. Moore is a proponent of direct carving and truth to materials. He combines humanist and organic elements. He believes sculpture has to have a vitality that shapes the form, gives it life.

Courtesy, artist.
Photo, Errol Jackson

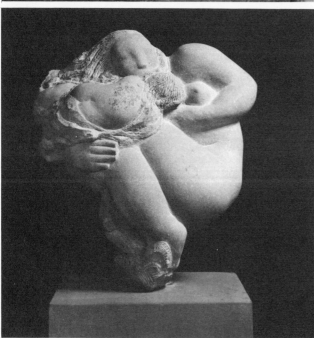

THE CLOUD. José de Creeft. 1939. Green stone. 13½″ high. Soft windswept movement brings an elemental poetry to stone carved with delicacy, an elastic curving line and a love for the material. De Creeft remained oblivious to current art trends and continued to carve unique, individual lyrical forms.

Courtesy, Whitney Museum of
American Art, New York

COMPOSITION. Henry Moore. 1939. Green Hornton stone. 19″ high. Moore began to penetrate form, creating a void within the sculpture. Though this work is small, it has a monumental quality in the bulging, swelling forms that symbolize a recurring Mother goddess theme in Moore's sculpture.

Courtesy, artist. Photo, Errol Jackson

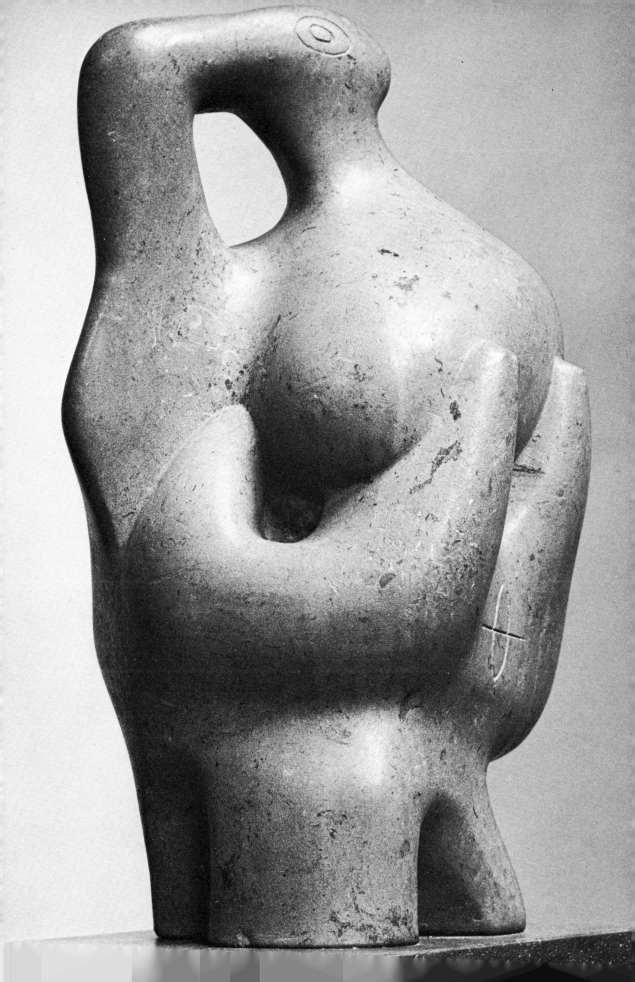

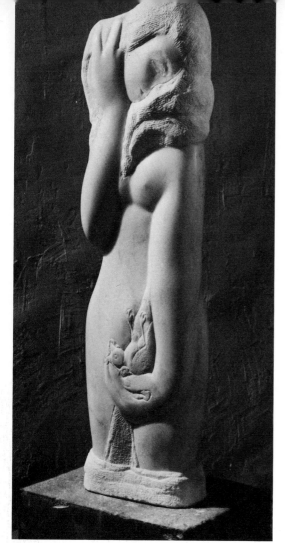

SAD VICTORY. Charles Salerno. White marble. 36″ high. Using symbolism for social commentary, Salerno explains: "This work is the antithesis of the Greek Winged Victory which is happy in spirit. In Sad Victory, I felt there would be no Peace so the dove is dead." A "V for Victory" sign is in the hand holding the hair.

Courtesy, artist

HUMPTY DUMPTY. Isamu Noguchi. 1946. Ribbon slate. 58¾″ high. Formal abstraction is achieved in this revolutionary stone sculpture. It combines carving and construction with stone shapes that are slotted and interpenetrate one another. The sculpture is partly massive, partly open.

Courtesy, Whitney Museum of American Art, New York

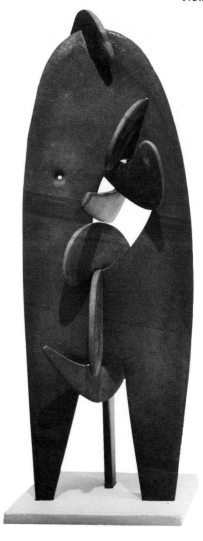

POST–WORLD WAR II

Following World War II there was an outburst of artistic creative energy. New ideas emerged. Artists became socially concerned, tuned to expressing their reactions to events rather than continuing in the humanistic, realistic tradition of their predecessors. They had been involved in the war; they began to put more comment, more bite about man's moral and spiritual world into their work.

Stone carvers such as Charles Salerno combined some degree of representation with a new insight into relationships of masses and volumes in a block of stone. He followed Zorach's philosophy, plus the use of naturally colored stones. His sculptures were often cre-

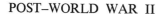

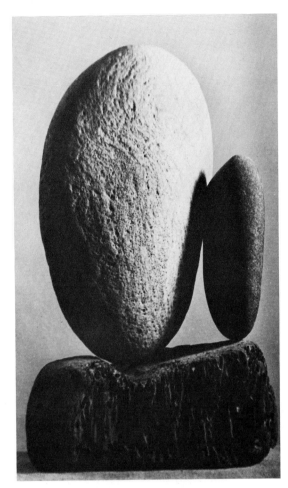

TWO BY THE WATER. Anita Weschler. 1947. Fieldstones on weathered wood base. Stone sculpture collage, using carefully selected materials for shapes, texture, and relationships, emerged as a new sculptural expression.

Courtesy, artist

FORBIDDEN FRUIT. Nat Werner. 1949. Green serpentine marble. 11″ high. Free form, abstract combination suggests a symbolic function. Swelling shapes emerge from one another; a void within allows space to penetrate the form.

Courtesy, Whitney Museum of American Art, New York

ated from oddly shaped boulders that suggested the forms within. Oronzio Maldarelli, Vincent Glinsky, and Chaim Gross continued to work in the direct stone carving tradition, but also developed their styles in other media. Bronze sculpture retained its popularity, but welded metal sculpture captured the interest of a growing number of sculptors.

David Smith's welded and polished metal sculptures were indicative of the new direction sculpture was taking. Forms were reflecting the mechanical tools of industry and commenting on our mechanized society. Isamu Noguchi, a Japanese-American and one of Brancusi's few apprentice-helpers, appears to have taken inspiration from these mechanical forms. His

TRANSFORMATIONS. Day Schnabel. 1956. Yellow Sienna marble. 19¾″ high, 13″ wide. Stone forms extend into space much as those of metal sculpture. Truth to materials was no longer an absolute ideal; artists were free to transform materials to an idea.

Courtesy, Whitney Museum of American Art, New York

work in stone is among the most significant and enduring from this postwar era. His slate sculpture entitled "Man Walking" has flattened stone forms carefully carved; the interlocking slotted parts are assembled so the whole is both abstract and mechanistic with surrealistic overtones.

Anita Weschler's stone assemblages date from this period also. Observing the natural beauty in found materials, she carefully selected fieldstones in varying shapes and hues and combined them with driftwood, thus making a

contribution to the future of sculptural assemblage. Nat Werner's "Forbidden Fruit" is a modern interpretation of a biblical theme. Day Schnabel's sculpture "Transformations" seems to portend the future of stone sculpture. Using a combination of cubist forms and the more abstract swellings and space penetrations of Henry Moore, she synthesizes what has gone before, yet points to new paths artists began to follow. By the early 1950's the basic concepts of sculpture were revolutionized in a trend toward simplicity, openness, extension, and fluidity.

Jean Arp's simplified radiant creations in marble were based on a love for simple, fluid lines and shapes. His bronzes, wood sculptures, and reliefs had become progressively abstract. His stone sculptures, dating from the 1950's, were often worked in white or lightly veined marble. They are given titles based on organic forms, humorous and abstract concepts.

Chaim Gross's figures in a variety of textured marbles are semiabstract compared with the more formal abstractions of Noguchi, Barbara Hepworth, and Jean Arp. During the fifties more artists were exploring the potentials of metals and woods for sculptural forms, but not abandoning stone altogether. Leonard Baskin and Jacques Lipchitz's stone sculptures are an exception to their usual metal sculptures. They suggest that artists still found satisfaction in returning frequently to a traditional medium.

During the 1960's, as sculptors continued to explore new media, an increasing number returned to stone carving. Several younger artists were attracted to stone carving for a variety of reasons. Established sculptors revised their thinking and recognized that stone could be worked into contemporary currents of art. Because news media has yet to catch up with these trends, many sculptors whose work is illustrated have not had great exposure. They are represented by galleries in the United States, France, Italy, Germany, and Canada. Because their work is often monumental and

architectural in proportions, corporations, private collectors, and sculpture symposia have contributed to encourage their creativity. As the trend continues, it can be safely said that the outlook for stone sculpture has never looked brighter.

GROWTH. Jean (Hans) Arp. 1956–1960. Marble. 43″ high. Arp's use of pure white marble gives a quality of mystery, magic, and fantasy to subtle shapes.

Courtesy, The Art Institute of Chicago

NAOMI AND RUTH. Chaim Gross. 1956. Lithium stone. 26″ high. Biblical and classical themes continued with a new expressive use of the medium. Often called a romantic realist, Gross introduced an exuberant, baroque design with semiabstract qualities.

Courtesy, artist.
Photo, John D. Schiff

Throughout the book, one should observe the variety of stone being used compared with the earlier uses of mainly marble and limestone. Also observe the bases used, or absence of them.

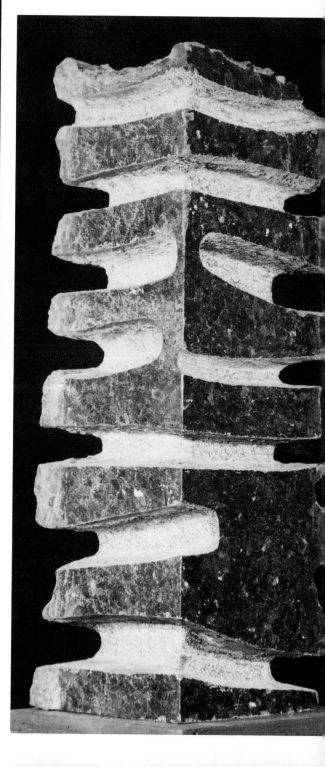

THE DOOR. Kenneth Campbell. 1963. Marble. 54″ high. The early 1960's witnessed a tremendous reawakening to the potential of stone for abstract sculpture. Campbell works in a variety of assembled rectangular forms.
Courtesy, Walker Art Center, Minneapolis.
Photo, Eric Sutherland

UNTITLED. Minoru Niizuma. 1965. Swedish black granite. Forms interlock and flow into each other. There are striking contrasts between the outer polished surfaces and the inner textured areas, and between the soft, flowing shapes and geometrical hard edges.
Courtesy, artist

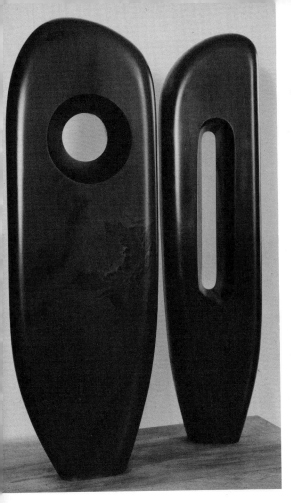

TWO FIGURES. Barbara Hepworth. 1964. Slate. 30″ high. Hepworth relates two softly carved stones that exist in space and have space as an integral part of them.

Collection, The Tate Gallery, London.
Courtesy, Marlborough Fine Art Ltd., London

TRIANGLES. Masami Kodama. 1967. Marble. 17″ high. This sculpture has a feeling of floating in space because it is raised from the base and placed on a rod.

Courtesy, artist

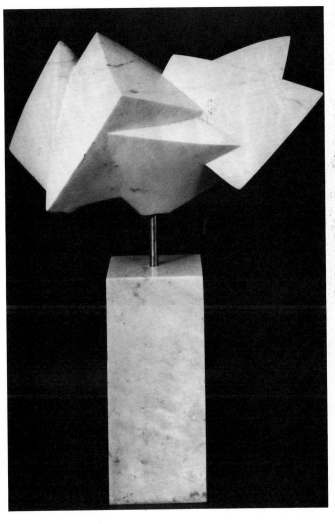

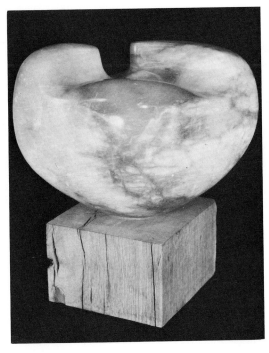

FIGURE. Raffael Benazzi. 1964. Alabaster. 11½″ high, 16½″ long. The iridescent quality of alabaster and its smooth finish is beautifully contrasted by the rough wooden base.

Courtesy, artist

CIRCLE AND SQUARE. Thea Tewi. 1966. Vermont marble. 20″ high, 21″ wide, 7″ deep. Solid marble forms have been opened up by combining shapes of stone, then placing the entire piece in juxtaposition with the transparency and reflective qualities of clear and black plastic.

Courtesy, artist

VIGIL. Lawrence Fane. 1967. Mixed media. Metal and black cement marble worked directly over an armature. Forms are both anatomical and mechanical.

Courtesy, Zabriskie Gallery, New York

HANDICRAFT DEPARTMENT, KING ALFRED'S COLLEGE, WINCHESTER.

COLUMN. Marcelo Bonevardi. 1968. Limestone, 27″ high. Solid, repeated shapes with a single precarious note suggest the classic components of a column with a contemporary twist.

Courtesy, Galeria Bonino, Ltd., New York.
Photo, Peter Moore

SCULPTURE OF TWO PIECES. Barna von Sartory. 1968. Vermont Danby white marble. 11½′ high, 8½′ wide, 8½′ deep. Created at the Vermont Sculpture Symposium. Sartory believes "Less is more." This is an environmental sculpture one is expected to walk through. The 25-ton block was cut diagonally using industrial saws. A space of two feet was removed from the center. Honed marble discs were set into the facing center walls with epoxy.

Courtesy, "Mill 21," Vermont Marble Company, Proctor, Vermont

MORT DU PERE. Ipousteguy. 1968. Marble, 2′2″ high, 12′ wide, 26″ long. Fantasy, surrealism, macabre themes with psychological references describe Ipousteguy's current work in marble and help to emphasize the many trends of contemporary art with stone.

Courtesy, Galerie Claude Bernard, Paris

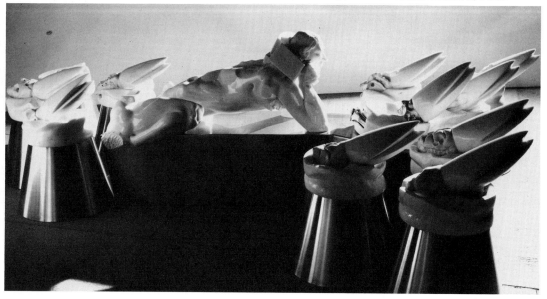

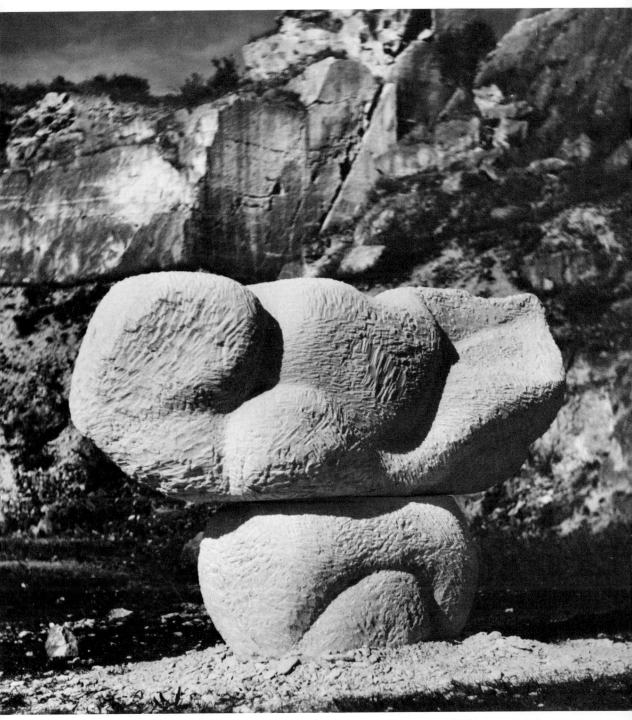

THE GREAT ADVENTURE. Pat Diska. 1966. Sandstone. 6′ high, 10′ wide. Executed at the Symposium St. Margarethen, Austria. Stone sculptures created and set in a mountainous environment have a truly monumental feeling. This work, with the stone chips still at its base, is symbolic of the adventure sculptors are rediscovering in their love affair with this marvelous material of nature.

Courtesy, Ruth White Gallery, New York

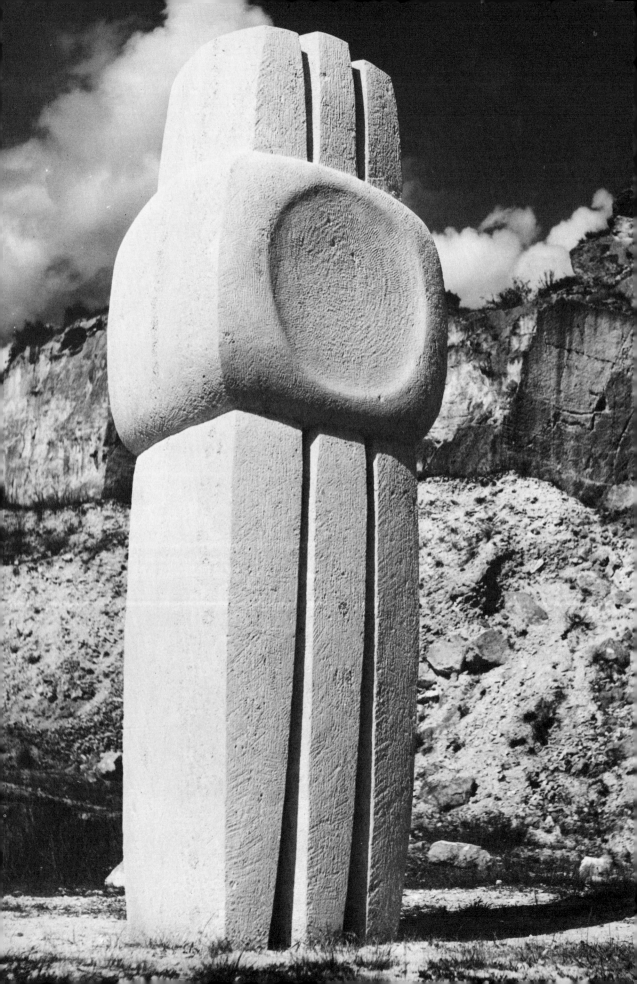

Stone and the Sculptor

For countless centuries, man has shaped stone to his needs. We date the "stone age" from artifacts showing primitive man's harnessing of stone for various implements. Archaeologists have been able to carbon date pebble sculptures back to early Neolithic times. These carved pebbles, often in the form of female figures, are believed to have been used as fertility images.

Quickly progressing in time, we can chronicle the use of carved stone for story-telling devices, for utilitarian objects such as bowls, for spiritual, intellectual, mystical, and decorative purposes. One could walk along the main streets of our large cities today and record stories of man's ideas and activities by observing stone carvings on churches, public buildings, in parks and central squares.

Actually stone carving is about us in many places. We simply must take time to look. Buildings usually have the date they were erected carved in the cornerstone, cemeteries use much carved stone and monuments so that artists often have grave site commissions, eagles are seen soaring from cornices of banks, decorative motifs enhance doorways, figures appear on churches and monuments in public squares. These are only a few examples of the rich forms developed by artists and craftsmen.

Stone has a permanency, workability, and beauty that makes many artists react favorably to it. Barbara Hepworth believes that carving is a rhythmical and marvelous way of working on live, sensuous material. Even if one has two pieces of the same stone, each has its own nature, its own particular live quality of growth and crystal structures. Hepworth says, "Of all activities carving is the most rhythmical; the left hand does all the thinking, holding the chisel, and the right is merely a motor." She speaks of making the forms and contours reveal the state of mind of the artist and what he is trying to express.

An extensive variety of stones is available to the contemporary sculptor. Stones range from soft soapstones, alabasters, and slates that may be scratched and carved with a knife to hard, dense, chisel-resisting granites. Colors, textures, densities, and patterns are as varied as nature herself. Stone is, after all, a product of nature with all the vagaries nature has for producing her materials.

These vagaries are the charm, challenge, and frustration of working with stone. No two stones are exactly alike. In large blocks, one is never sure where flaws and strains may appear. Ultimately, they may affect the form the

◄
SCULPTURE, ST. MARGARETHEN I. Herbert Baumann. 1960. Sandstone. 9'8" high.
Courtesy, artist

sculptor is seeking and cause him to alter it.

Stones most often used for sculpture are varieties of marbles, sandstones, limestones, granites, and mineral rocks. Throughout the book, the reader is encouraged to relate the form and finish with the type of stones used and how they are most often worked. Beautifully grained marbles and translucent alabasters, for example, are most often smoothed and highly polished to exhibit their characteristics to advantage. Coarse-grained limestones and standstones are more amenable to rougher, textured finishes. Granites are usually worked in broad planes avoiding minute details.

Many considerations will affect your choice of stone. Most obvious is availability. If you live near a marble quarry where you can select stones and transport them inexpensively, you will probably favor marble. If you live where pebbles are washed up on shore or where fieldstones abound, you may confine your sculpture to these stones.

In addition to availability, your choice of stone will depend on how you plan to work. One artist prefers to visualize a form first, and then purchases a stone to fit his mental or actual sketch. Another will buy a stone with interesting colors and contours and let the form evolve as he carves directly into the mass. Still another may buy an odd stone, then, using the contours as his guide, sketch a form that can be found within.

Generally, the sculptor is most interested in the carvability of the stone, and the kind of finish he can achieve. One can progress in stone carving without a basic knowledge of geological formations of rock, but such investigation will help you select, identify, and work with stone more intelligently.

CATEGORIES OF STONE

Stone falls into three general classifications: igneous, sedimentary, and metamorphic.

IGNEOUS rocks are formed by the action of molten masses within the earth cooling and solidifying as they approach the surface. Igneous rocks include all varieties of granites and basalts, diorites, rhyolite, obsidian, and similar stones. These are usually hard, most uniform, and compact.

SEDIMENTARY rocks are the result of deposits of sediment, such as fragments of other rocks, transmitted from their sources and deposited in water. Heat and frost alternately cause the rock mass to expand and contract, which fractures it. These fractured sediments are subject to the erosive action of flowing water, and other elements which carry them away. Eventually they deposit in riverbeds, lakes, and oceans where they intermingle with skeletal remains of an infinite variety of organisms from large and small shellfish which contain calcium carbonate. Calcium carbonate becomes the predominant ingredient of sedimental rock which, when consolidated, forms limestones and sandstones used by sculptors.

METAMORPHIC rock consists of igneous and sedimentary stones that have been changed physically by natural forces of pressure, heat, and chemistry. As the earth's crust squeezes, bends, folds, turns, and tilts, heat and pressure cause the limestone to recrystallize and form radically different masses from the original rock. The result is metamorphic rock such as marble, slate, soapstone, alabaster, onyx, and many gemstones.

BECOMING FAMILIAR WITH STONE

One can begin stone carving with very little technical knowledge and only the simplest tools. It may be as simple as finding a boulder or fieldstone and making a few scratches or indentations to get the feel of visualizing and changing the shape. Sometimes an awareness of rocks and stones and what a sculptor can do with them will awaken a new approach to three-dimensional form. Artists, accustomed to

Rough-sawn blocks of marble appear like this in the stone supplier's yard. Larger blocks are also available on order. They may be bought directly from a quarry if one lives close to the source.

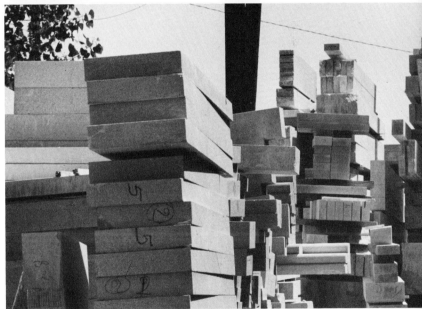

Various sizes of limestone. When shipped, addresses are usually marked directly on the stone so no packaging and wrapping are necessary.

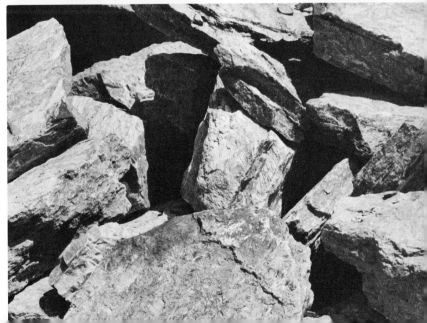

Uncut pieces of stone are usually piled up like this in a stone yard. For an idea of the polished finished color, wet the stone. Sculptors often buy such stones, live with them, study them before a shape is suggested. Or, if a sculptor has decided on a form, he might find the proper shape boulder from which he can develop his sculpture in such a pile.

seeking something "different," often neglect the potential of more familiar media and lose what may be another approach to form for its own sake and for what it may lead to in the future.

The beach is an ideal place to kindle an awakening to the beauty and myriad colors and forms of stone. Wade along the shoreline and observe the colors of wet stone, select a few attractive ones and observe the color change when they are dry. (Sculptors always wet a dry stone to determine what the polished color will be.) Pick up larger stones already washed ashore and wet them to see the colors change. Scratch them with a knife or simple tool, or your fingernail. You may find some so beautifully shaped and grained that polishing and mounting them on a base will result in a natural sculpture.

An interest in stone can reveal a whole new world. When you're driving in parks, along mountains, in hilly areas, notice the stratified ridges and types of rocks. America's national parks are a field study in themselves. Observe the differences in color and density of rock formations. And always observe the effect of light on the surfaces of rocks.

A quick way to learn basic information about a variety of stones is in stone yards and rock shops that cater to lapidarists. (You can find them listed in your phone book.) Here, rocks are presorted and, after a few browsing sessions, you will begin to recognize certain characteristics of different stones. There is no substitute for observing stones, handling them, and working with them to learn their intrinsic natures.

Visit museums that display stone sculptures of the past from non-Western cultures. Jane Wasey consistently finds herself drawn to

FANTASMA. Thea Tewi. 1967. White alabaster, 18″ high, 14″ wide, 12″ deep.
Courtesy, La Boetie, Inc., New York.
Photo, O. E. Nelson

This rough boulder of alabaster, when carved, smoothed, and polished, will look like the photograph at right.

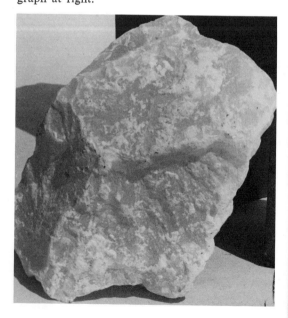

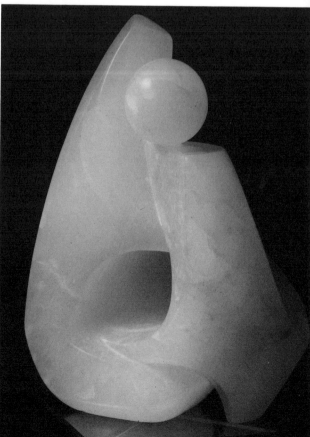

ancient Egyptian carvings; they are serene, majestic, noble, moving, yet without sentiment. Brancusi is known to have studied the simple forms of Cycladic art, and one of his pieces carved in 1906 entitled "Ancient Figure" has the rough and broken look of a sculpture that might have been buried thousands of years before and recently excavated. Henry Moore confesses inspiration from the broad planes found in pre-Columbian works. Chaim Gross, who has a huge collection of African art, cannot help but be influenced by some of the simplified approaches to sculpture that these primitive peoples have.

CHARACTERISTICS OF SPECIFIC STONES FOR SCULPTURE

MARBLE AND OTHER METAMORPHIC STONES

The metamorphic stone family consists of marble, alabaster, onyx, travertine, serpentine, and so forth, which are most popular for sculp-

Joy II. Ruth Andris. 1968. 10″ high. Blocks of African wonderstone, a fine-grained medium to dark gray stone. In the polishing stages, swirling striations of various shades of gray appear. The stone is soft, easy to carve, and polishes to a rich, warm, satiny finish, as in this sculpture.

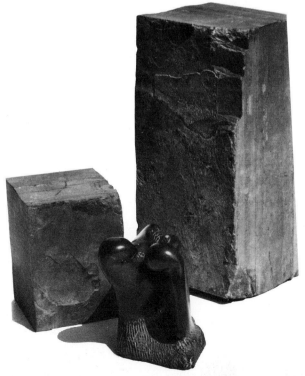

ture. They are relatively soft, easy to carve, and available in an infinite variety of grains and tones. They may be smoothly polished and beautifully finished. Marbles have been among the most favored stones since the ancient Greeks gave them a name meaning "shining stone"; they are composed of tiny crystals that reflect light and result in a sparkle.

In America, many domestic varieties of marble are available from the Appalachian regions of the eastern states beginning at the Canadian border in northern Vermont, extending south through western Massachusetts and eastern New York. It appears again in western New Jersey, southern Pennsylvania, and extends southward through Maryland, Virginia, North Carolina, Tennessee, Georgia, and Alabama. The Marble Institute of America, Washington, D.C., lists the color ranges of 295 marbles currently available from around the world.

From Europe, Italian marbles are best known. Carrara marble was used by Michelangelo, and the Carrara mountains have been an attraction for carvers ever since. An excellent black marble from Belgium is very hard, with no veins or other markings, and polishes to a jet black brilliant surface. One disadvantage of Belgian black marble is that it emanates a strong "rotten egg" odor while it is being carved. Greece and Canada also produce some marble for export. France quarries an estimated 250 varieties of marble, but little is exported.

The marble used will depend on availability and cost. Finer grades of American and European marbles are preferred. At the time of this writing a 55-pound block of white Carrara marble with streaks of gray, measuring approximately 6 by 6 by 15 inches, lists in a sculpture supply catalog for $12.85 or about 25 cents per pound plus shipping charges. A larger piece, requiring crating, adds $4 to the charge.

Alabaster, a soft stone for carving, is available in pinks, crystals, marbleized effects,

Wetting a stone while selecting and working will simulate the appearance of the stone after it is smoothed and polished. Jane Wasey wets green verde marble she is developing into an abstract fish form. When dry the stone appears gray, when wet, it is green. Note the sandbags used for holding the stone while working.

and translucents. Prices range from 35 cents to 45 cents per pound. Rare alabasters such as agate and gabbro rosso are 85 cents per pound, but are not always available. Alabaster, when carved, produces a dust which some people are allergic to; it causes nose and throat swelling and a choking sensation.

Excellent stones for beginners and professionals include African wonderstone and soapstone (steatite) that cost 35 to 45 cents per pound. The cost of working in one of these stones is comparable to work in other art media; for instance, the piece of wonderstone used in the carving demonstration costs about $40, including shipping from New York to Chicago. A painter could easily spend as much on canvas, paint, and framing. If one can find stones from old buildings, the cost of producing a stone sculpture is minimal.

The metamorphic stones are worked with points, chisels, rasps, and files, then sanded and polished with abrasive powders, then waxed. Marble tends to flake when carved, and tools are held at about a 45° angle. See chapter 4 for complete carving methods.

GRANITE (IGNEOUS ROCK)

Granite, like marble, may be smoothed to a high polish. Otherwise, it has many differences so far as the sculptor is concerned. It may be carved with hand and pneumatic tools, but tools for granite are heavier than marble tools and not so pointed. They are often carbide tipped for the greater hardness required

for hitting the stone. Granite is carved by pulverizing, rather than flaking, and requires that the tool be held at a 90° angle to the stone. Often the granite turns white from pulverizing, but when you use a scraping tool, the original color returns. The nature of granite is such that fine detail should be avoided and forms should be kept rounded and compact with a broad treatment. When carving granite in a closed area, adequate ventilation and an exhaust arrangement are essential since granite dust contains silicates which can cause damage to the lungs.

Granite varies in color from very white, light to dark gray, and black. There are also pinks, blue-grays, and blue-whites. Granite contains quartz and feldspar crystals large enough to be seen with the naked eye. One can study them on polished surfaces of granite blocks used in monuments and buildings. The quartz has a transparent glass appearance. The feldspar crystals are more or less rectangular and colored a dull white, gray, or pink, like fine porcelain. The grains are so smooth that they reflect sunlight, giving the entire stone a bright, reflective quality.

A dark granite called "granite porphyry" is coarse grained with larger crystals of feldspar, one to several inches long scattered through the mass of ordinary crystals. They look somewhat like angular almonds scattered in coarse sugar. Because of its changing tones in light, porphyry is a popular stone for sculpture and monuments.

Granite used for sculpture is quarried in Vermont, Minnesota, Wisconsin, Massachusetts, California, Georgia, Rhode Island, North Carolina, New Hampshire, and Maine. Finland exports a popular red granite. Granites are usually named for the area where they are quarried. Barre granite from Barre, Vermont, is hard, compact, finely textured, highly durable, and ideal for outdoor sculpture. Derby gray is a fine-grained, blue-gray stone. Maine granites may range from medium white and gray to a dark gray, with some pink stones also.

For listings of companies selling granite, consult a volume in your local library called the Thomas Registry. A card or letter to specific firms will bring you catalogs with information and illustrations of complete hand- and power-carving equipment. Industrial stone companies and the United States Geological Survey Department, Washington, D.C., also are excellent sources for up-to-date, continuing developments in the field.

LIMESTONES AND SANDSTONES
(SEDIMENTARY ROCKS)

Limestones and sandstones usually are quite porous, soft, and rougher textured than marbles and granites. Therefore, while easy to carve, they are not so often polished. They cannot be brought to as high a finish as marble and granite. They are used for forms enhanced by a surface texture.

Limestone

Most limestone is gray or buff color, but variations can be found in cream, yellow, red, green, brown, and tinted black. Impurities within the mass may cause a stone to change color; for example, blue limestone may change to yellow or brown-buff tones. Some limestones can be polished to a degree of luster depending upon the density and grain of the specific variety. Closer grained stones will take a finer finish than coarser grained ones. Denser varieties with luster potential should be polished with a rubbing mixture of fine sand and water.

When seeking limestone for sculpture, look for a "statuary" quality. This means an oolitic limestone that is compact and fine grained. Lithograph stone, often used by the graphic artist, is also suitable for sculpture because of its close porosity.

American oolitic limestones are quarried in Indiana (the most favored), Alabama, Kentucky, Minnesota, Missouri, Texas, Arkansas, and Wisconsin. From France, one of the most popular limestones is "caen" stone, much used by Henry Moore. It is fine grained, a beautiful buff color, and easily carvable.

Sandstone

Sandstones are fairly porous. Their sedimentary makeup is fine grains of sand bound together in varying degrees of firmness by a cementing material such as quartz, iron oxide, calcite, earth-clay, and crystalline forms of calcium carbonite.

Harder varieties of sandstone are almost pure quartz, and the amount of quartz determines a stone's carvability. The greater amount of quartz in a rock, the harder it is to carve. When too little quartz is present, the stone is apt to fracture very easily.

Sandstone most preferable for carving is called "freestone." It may be found in gray, yellow, buff, red, brown, green, and black. The stones are named for their colors, hence, bluestone, redstone, and so on. Sandstones, like limestones, are worked with marble tools. They tend to wear out tools more quickly than do other stones.

American varieties include those from Ohio (Berea sandstone), considered the most durable, Connecticut for Portland brownstone, Kentucky, Pennsylvania, and Wisconsin. English sandstones, such as those quarried around Devonshire and Cheshire, are excellent for sculpture though quarried mostly for the building trade. France and Canada are also producers of quality sandstone suitable for sculpture.

OTHER GOOD CARVING STONES

From the examples in this book, you will note materials not specifically mentioned above. Slate, for example, is used with interesting results. It does tend to fracture and split, but with care it will give delightful results. It is easily available from stone, garden supply, floor tile companies, and broken blackboards. It is soft enough to be carved with woodcarving tools and may be brought to a high luster by melting beeswax on it in the sun and then buffing.

Lava rock, also called feather rock, is a very porous soft stone often associated with garden sculpture. It is very rough and workable with chisels, files, and rasps. Its color varies from beiges to grays and blacks. This stone must be worked in broad surfaces.

MINERAL STONES

A variety of mineral stones with fascinating textures, patterns, and densities are ideal for small sculptures. These include jade, lepidolite, quartz (in several colors), malachite, fluorite, and rhodonite, which are readily available from rock shops and lapidary suppliers. They may be worked with a variety of small power tools and are ideal where working space is at a minimum.

Alabaster, in the gypsum family, is available in snow white, delicate pinks, clear and veined whites. All take a high polish and many have a magnificent translucence. Denser varieties may be confused with marble in a finished sculpture. Veined alabasters may be used for sculpture, but they do have a tendency to fracture due to chemical impurities that cause the veinings. When encountering a vein or soft streak, try to work it into the composition logically. Carve close to the vein but not the vein itself, even if it means letting the vein protrude slightly.

For quick identifying characteristics, refer to *Rocks and Minerals,* a paperback guidebook. Mineral stones can be found within other rocks, and many people go on "rock-hunting digs" purposely to locate unusual stones.

From this discussion, it should be apparent that there is no one stone that is better for carving than any other. Given two carvers, two blocks of the same stone, one can produce a piece that is vital and seems to have emerged from his stand with a life of its own. The other sculptor using the same size and type of stone and tools will create a form that may be simple and lovely, yet somehow it is a lifeless lump, dull and deadly in its appeal. It is not the stone, not the tools that make the sculpture; it is the sculptor. No matter how beautiful a stone, if the form is not successful, the beauty of the stone will be lost. Conversely, if a stone has no inherent beauty of color, texture, or veining, it can still become a thing of beauty by the sculptor who is able to express something of himself within the stone.

WHERE TO GET STONE

In interviewing sculptors it is amusing to learn an earlier incarnation of their materials. Vincent Glinsky pointed to an upright whimsical marble squirrel and said, "That used to be the pillar of a famous New York railroad terminal." Another sculptor confided that he felt sacrilegious because he had carved a voluptuous nude from a piece of stone that had once been a pillar in a church. Many pieces of scrap granite used for gravestones become beautiful forms under the talented hammers and chisels of sculptors.

Good pieces of used marble, granite, limestone, and sandstone are relatively easy to secure in this age of tear down and rebuild. Large and small blocks may be purchased reasonably from wreckers at a building site or from their wrecking yards. Often, for a token fee, you can have a stone if you can haul it away.

Stone quarries will sell direct to sculptors. Quarries usually have small scraps about, remaining from large industrial jobs, which they are happy to practically give away. Where large pieces of stone are ordered, cost will increase depending upon shipping. If you can

put a stone in your car or on a truck, you will save money.

Stone companies and rock shops, already mentioned, are a good source for small, but adequately sized, stones for carving. Sculpture suppliers stock marbles, soapstone, wonderstone, alabaster, onyx, and so on. They are priced by the pound and available in rough boulders or blocks cut to order.

Whether to order a boulder or a specific sized block depends on what you plan to do with it. If you know what size you want and what you wish to make, you can order a stone cut. If you plan to live with a stone, handle it, look at it under different lights until it suggests a form, then you may as well purchase a boulder. Many artists speak of falling in love with a piece of stone that is inherently beautiful. Parisian sculptor Morice Lipsi feels a dialogue established with the form within. When he begins to work, it is as though he is wresting a secret from the stone and bringing to light the latent form the stone holds hidden within. He says of a block of stone, "I know what it wants to become. It's like sensing what that stone eventually will be."

TESTING STONES FOR IMPERFECTIONS

Because stone is composed of layers of material laid down over thousands of years, it is likely to contain flaws such as cracks, soft streaks, veins, rust streaks, and stratifications. Such flaws might cause the stone to deteriorate quickly and also to interfere with a preconceived form. When an undetected flaw appears beneath the surface of the stone, the sculptor has two choices. He can scrap the piece or alter the form to take advantage of the flaw. The David of Michelangelo is of a fourteen-foot piece of marble which originally was owned by another sculptor and discarded because of a flaw. Michelangelo carved around the flaw and made use of the carved out area.

There are two tests to apply, neither absolute, but 90 percent better than no test at all. First, tap the stone lightly with a steel hammer. If the sound rings clear, the piece should be all right. If a dull thud emanates, the stone is "dead" and unsuitable for carving. Try this on three or four stones at the same time until you learn to detect the differences in sound. Second, wet the entire stone with water. A deep-grained dark streak which appears to go all the way around or through the piece usually indicates a crack or layer that may cause the stone to break in the same way as layers of a cake.

Pebbles, pockets, and fossils that become embedded in a stone should be avoided as they cause soft areas which may necessitate a change in the direction of the carving.

TESTING FOR SOFTNESS

The beginner, unfamiliar with the carvability of stone, is wise to begin with a soft stone. A stone's softness can be tested by taking a rasp and rubbing it across the stone. If the stone powders or flakes easily, the stone is probably soft and carvable. One word of caution about white marbles that have been exposed to weathering: They become "sugary" and so powdery that they practically deteriorate under the chisel. It is easy to confuse such a stone with being soft. With a little experience you will learn to evaluate the softness of a stone by scratching it with a point or by hitting a tiny corner with a chisel. If the corner yields easily, the stone is soft.

TRANSPORTING STONE

One of the sculptor's greatest problems is transporting large stones. He encounters this when he brings raw stones from his source to his studio, and when he must ship finished sculptures to galleries, exhibits, and buyers. Any sculpture over two feet high and wide is heavy. When one works larger pieces of stone, the logistics of moving the piece often require as much ingenuity as carving it requires creativity.

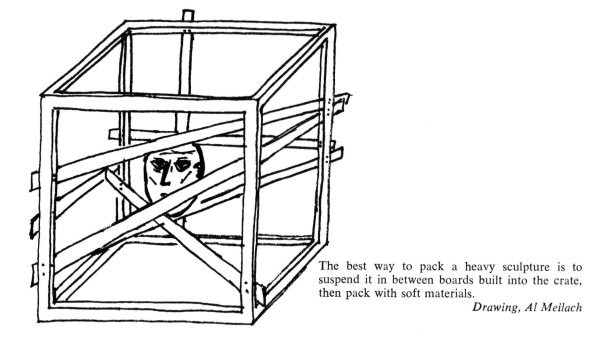

The best way to pack a heavy sculpture is to suspend it in between boards built into the crate, then pack with soft materials.

Drawing, Al Meilach

A few general rules must suffice, and then the sculptor must solve his own problems. The principal rule is to learn how to move things without injuring yourself. Always wear gloves when handling stone. Gloves will also protect marble from absorbing grease and oils from your hands which may leave dark streaks on the stone.

When placing large stones in the trunk of a car, set them on a couple of 2 by 4 foot boards or on an old automobile tire so as to distribute the weight over the entire trunk. Try to avoid direct lifting. Use wedges and roll the stone wherever possible. Quarries and stone yards have automatic lifts that will put the piece where you want it. Always take advantage of mechanical aids. Use a handcart to move stones, always padding soft stones with blankets. Use block and tackle equipment with a hoist that you can make from pipes or perhaps borrow from a gas station. You can also build a small platform with wheels for moving the stone about easily.

Stone can and must be moved by careful planning and not by exerting unnecessary strength. One realizes the validity of this when discovering how many small, utterly fragile looking women seem attracted to stone sculpture.

Sending your sculpture to market takes similar planning. A finished piece represents hours of work. It must be carefully protected. There are movers who will crate and ship a sculpture, but cost and insurance, when available, are high. You can crate a piece yourself, but always try to suspend a heavy sculpture with boards built into the crate, then cushion the sculpture and the boards with packing paper, plastic bubble sheets, or paper wrapped excelsior. With this system, any severe jostling and blows to the outside of the box will be only slightly delivered to the sculpture. Don't use sawdust because it mats, does not give adequate protection, and the sculpture can work its way to the sides.

Carvings with delicate protrusions such as fingers should be "shipping planned," which means leaving a little extra uncarved stone to act as a webbing and support for the protrusions. Final finishing can be accomplished when the piece reaches its destination.

Sculpture returned to the artist presents another nightmare because inevitably the sender does not have the same respect and affection

for the piece as the sculptor does. Try to insist before a show, in writing, how you wish the work returned and be specific about packing and insurance. When sculptures are broken by mishandling, there is little one can do except write letters of complaint and refuse to show at that place again. Local movers can be trained to crate and move your sculptures, and their services should be tapped where applicable.

STONES TO BE PLACED OUTDOORS

Stone sculptures have endured outside for centuries. Egypt's Sphinx and figures at Abu Simbel, the rock cut caves of India, and thousands more still stand, yet weather does take its toll on stone. Dry, hot climates are kinder to stones than changeable weather conditions. Where moisture freezes within a stone, expansion and contraction can cause the stone to rot and flake. Wind and dust erode surfaces of stone. Sun may change its color, especially marble. Soot and smoke particles are particularly injurious. Intense heat will cause chemical changes damaging to many varieties of stone. Marble, when burned, converts to lime.

Sculptors should seriously consider the climate and airborne chemicals that exist when stones are to be placed outdoors. Commemorative statues in parks, cemeteries, garden sculptures, monumental sculptures, water fountains, friezes for architecture and architectural commissions all require more attention than a small indoor piece.

Highly porous stones are not so desirable for outdoor use particularly in damp cold and changeable climates. Today's technology, however, has developed many preservatives that will retard weathering stone. Silicone products are applied to highly porous travertines for building façades. So long as the preservative penetrates the pores of a stone to prevent moisture from accumulating, it will do a reasonably good job. It may have to be reapplied every year or two.

Igneous varieties of stone are extremely dense and have a longer outdoor endurance potential than more porous stones. Therefore, granite is more frequently planned for outdoor sculptures. There are variations within stones, but granites usually have a porosity of 1/1000 percent compared with that of limestone and sandstone with a porosity varying from approximately 1 to 10 percent. Denser marbles may be expected to last longer than porous ones. Of course, there is no absolute rule on how long any stone will last under any given set of weather and air conditions.

Questions about weathering stone preservatives should be discussed with the manufacturers of products you consider using. Laboratories of such firms often will conduct tests of their product on a specific stone under controlled conditions. The necessity for the sculptor to tap the resources of industry cannot be overemphasized. Builders, architects, stone companies, and marble quarries are extremely cooperative.

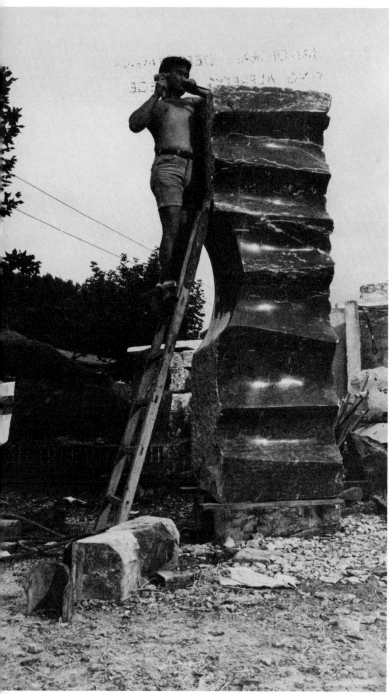

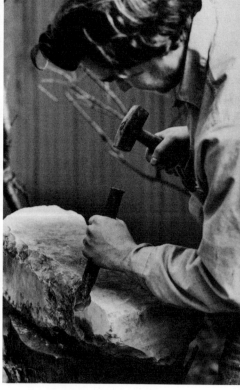

Whether you work large or small, the principle of direct stone carving is the same. Using chisels and hammers you remove pieces of stone to release the form envisioned within. Above, Minoro Niizuma chisels a huge block of Spanish red marble. The block is propped aboveground on two supports which allows him to work the bottom edges. At right, Andrew Weiner uses the same approach on a small black marble stone. His worktable? A tree trunk. Here the stone appears gray on the outside, but where his chisel has smoothed the surface, the stone is black, the color of the final polished sculpture.

HANDICRAFT DEPARTMENT,
KING ALFRED'S COLLEGE,
WINCHESTER.

Hand Tools and Methods

Direct carving is accomplished by chipping, scraping, fracturing, flaking, or, in the case of granite, by crushing and pulverizing the stone to be removed. *Chipping* consists of breaking away small pieces a little at a time to reduce the shape of the stone mass. To *scrape*, one rubs over the stone with a sharp instrument. *A fracture* refers to breaking off large chunks or through an entire thickness. *Flaking* occurs in some stones where thin layers rather than chips break away. *Pulverizing* means hitting the stone repeatedly until a powdery, granular material results and disintegrates excess stone.

One begins to carve by placing the raw stone on a suitable working surface, then applying tools until the stone is developed into the desired shapes and forms. The tools are shaped much like those used by primitive man, but tempered steel and modern sharpening devices make them more efficient.

There is no single standardized way to approach stone carving. One may work indoors or outdoors in any improvised area. One sculptor uses half of a garage; another works in a lean-to shed in a backyard, another out in the open. One insists that only hand tools should be used; another combines hand and power tools. About the only thing on which there is

agreement is that no matter what the tool, material, or technique, one needs the inspiration of a dream, a myth, a fantasy, or something uniquely human.

For a quick introduction to the use of hand, pneumatic, and industrial tools for stone carving, a visit to a stonecutting company is a revelation. Here, you will see huge saws with running water to reduce friction cutting through large slabs of stone as effortlessly as one slices bread. Stonecutters use tools as an extension of their hands. Most important to observe is the amount of stone dust in the air, on the workers, everywhere, which should convince the beginning carver of how important it is to wear respirators and safety masks.

The novice is encouraged to experiment with a scrap stone to familiarize himself with what tools will do. Decide for yourself the most comfortable way to hold a tool, the differences between chipping, scraping, and fracturing. Once you are at ease with tools, you are free to concentrate on the forms you wish to evolve.

Always work a piece under various light sources. Sometimes a single light source will give a feeling of form that will appear entirely different, and often not so satisfactory, under other lighting conditions.

THE WORKSTAND

The workstand should be a comfortable height, usually lower than your elbows so the forearm drops below the elbow with the hammer. It should be sturdy enough to keep the stone from falling or wobbling when hammering. A tree trunk, a barrel weighted with rocks, a wooden box lined with a heavy cloth, a modeling stand with a rotating top, or a stationary table are suitable. Any stone over a foot or so is heavy to move about, but you can shift its position more easily by placing an old bath rug or layers of burlap beneath it. Then by twisting the fabric, you manipulate the stone. Canvas sandbags are used to prop the stone in different positions for working comfort, and until one decides where the actual base of the sculpture will be. These materials and bags also cushion the stone from the shock of the hammer blows.

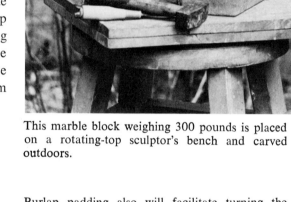

This marble block weighing 300 pounds is placed on a rotating-top sculptor's bench and carved outdoors.

Garage turned studio is outfitted with assorted worktables. An old shag rug enables students to turn the sculpture about. The rug also catches some chips and dust.

Burlap padding also will facilitate turning the stone and will cushion it. Sandbags can be pushed and manipulated to prop the stone for more convenient working angles. Bags may be purchased or made from closely woven canvas filled with sand and then triple machine sewn on all edges.

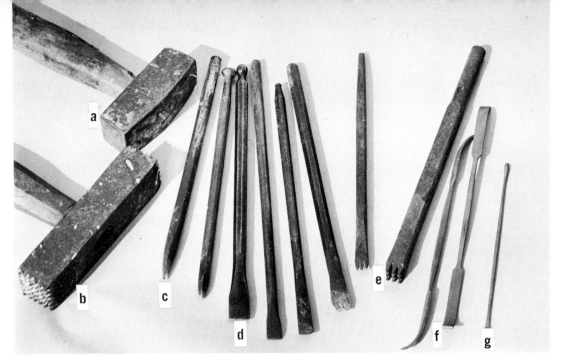

Marble hand cutting tools used for all soft stones include:

(a) iron hammers made in weights from ¼ pound to 4 pounds
(b) bush hammer
(c) points
(d) flat chisels
(e) toothed chisels
(f) rifflers
(g) rasps and files in varying sizes and shapes

All tools, except hammers, are hand-forged, tempered steel. For complete ranges of sculpture tools, consult art supply catalogs.

Granite carving tools are heavier than those for marble and other stones. Points have essentially the same shapes, but they are not so tapered. Granite tools can have tungsten carbide tips which are harder than tempered steel. Granite tools may be used on marble, but the reverse, using marble tools on granite, will dull and break them quickly.

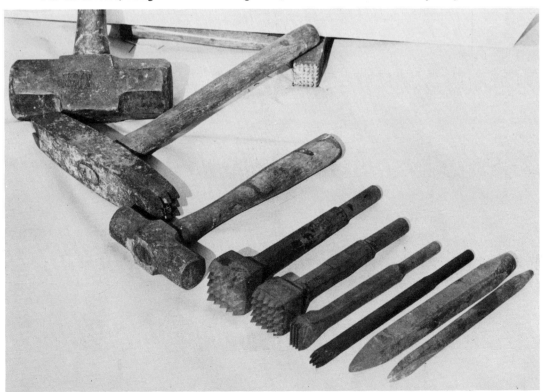

HOW TO HOLD TOOLS

The point is the first tool usually used for general roughing out of the shape and removing large and small masses of stone. Although each artist insists his way of holding the tool is best, there are basically four different positions as shown below. These positions apply to all tools held that are to be driven by the hammer. Tools you work without a hammer, such as rasps, bush hammers, files, and so on, should be held in any way comfortable. Hammer driven points and chisels should be held firmly but not clutched too tightly. This allows enough freedom so the point can bite into the stone accepting the full impact of the hammer blows. Never force a point into a stone or it may wedge, break off the tip, and fracture the stone.

At first, the point is held at about a 75° angle to the stone, but after the block has been roughed out, the angle becomes more oblique. Avoid working a point at a 90° (right) angle especially in marble. Besides possibly breaking the point, such an impact "stuns" the marble, that is, it causes a serious disruption of the crystalline structure around the chisel stroke. This is seen as a frosty, opaque area radiating from the point of impact. This "stunning" can go an inch or so into the marble and will always be evident on the surface even if the stunned area does not flake out. Flat chisels also are worked at an oblique angle to the stone. Toothed chisel working angles differ depending upon the number of teeth and the effect to be achieved.

Until you get enough practice hitting the chisel end with the middle of the hammer, you may wish to wear a heavy work glove with fingers cut out, except for the thumb and possibly the second finger where a knuckle often impedes the hammer's progress. Wrist straps will also help keep wrist muscles from tiring until they become accustomed to use.

SHARPENING TOOLS

New tools generally have to be sharpened. Used tools should be reedged as often as needed, and usually only a quick touchup is required. Steel tool edges may be reground with a bench grinder mounted with an alumi-

Hand positions include thumb around tool shaft; thumb behind tool shaft; thumb in either position with little finger either behind or around shaft. Find the most comfortable position for optimum guidance of the tool.

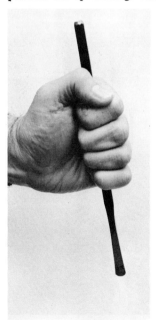 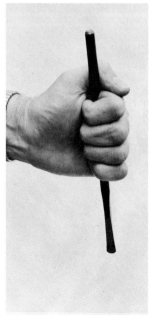

num oxide silicone carbide or carborundum wheel, but a belt sander mounted with a fine grit aluminum oxide belt is the most accurate, quick, and safe method. *Always wear safety goggles when grinding.*

Always attempt to retain the original shape of the tool edge. With a bench grinder, hold the tool firmly but not too tightly, using the small grinder shelf for a tool rest and guide. Use the edge of the straight wheel only. (Grinding on one side might groove the wheel and weaken it.) If you wish to grind on one side of the wheel, use a steel reinforced wheel or cup wheels.

Use a coarse wheel for wearing metal down quickly, then a finer wheel for a smoother surface. Work and cut slowly, never taking so deep a cut or applying so much pressure that blue spots appear on the metal. Spots indicate that the temper of the metal is being drawn. *Friction produced by grinding causes the steel to heat up so it is essential to dip tool edge in water frequently so tempering will not be lost.* The sharpness of tools depends on personal preferences, use of tool, and stone to be hit.

Toothed tool edges are touched up as shown, then a knife file is used for sharpening edges of teeth.

Tungsten carbide tools are usually returned to the manufacturer for sharpening; however, a vitrified silicone carbide wheel will work. Always sharpen tungsten carbide tools slowly or they chip.

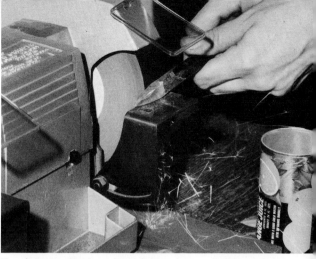

To sharpen, hold tool straight against wheel, rest on guide ledge of bench grinder.

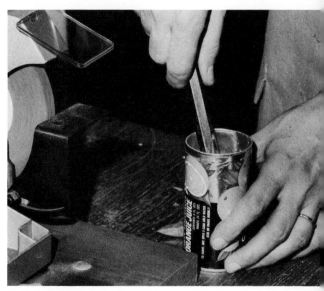

Grind slowly to avoid steel from heating up or dip tool in water frequently to cool and avoid tempering loss.

Teeth are sharpened with a knife-shaped file.

Sharpening tools with a stationary belt sander equipped with a fine-grit aluminum-oxide belt. Procedure is the same as for bench grinding.
Photo, Dennis Kowal, Jr.

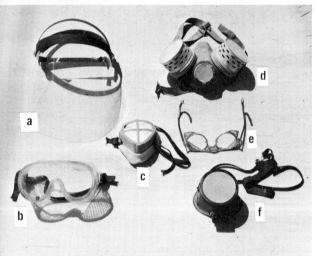

Safety masks, goggles, and respirators with replaceable filters are essential when carving.
Photo, Dennis Kowal, Jr.

TEMPERING TOOLS

After repeated regrinding, tools may lose some of their tempering or hardness. They may be retempered with an oxyacetylene torch or sent to a commerical sharpener.

To retemper, heat the point of the tool about two inches up until it turns a cherry red; then quench or dip in water only about three-quarters of an inch up. Immediately run a file along the tool, making a narrow path in the fire scale to see the colors. Hold the tool upright (since heat rises), and watch the colors rise from a dull red, to blue, to straw color. As the straw color is almost at the top, quench the tool again. This leaves about a millimeter of straw color on the tip which is average temper for stone tools.

Generally, the end of the tool that receives hammer blows should not be tempered too hard or it may cause the tool to bounce away, depending upon the hardness of the

hammer. If a soft end mushrooms from hammering, it may be filed off. Eventually tools become too short to be used.

MAKING TOOLS

Tools are relatively easy to make when one has access to a forge or an oxyacetylene flame. Round or octagonal rods of tool steel are cut to eight-inch lengths with a hacksaw. Heat the end until it glows, then hammer on an anvil to a rough point. Cool. Grind to desired shape on a grinding wheel: point, flat chisel, and so on, as in the sharpening instructions. Then temper. Many sculptors fashion toothed chisels for special effects. Octagonal or square shaped rods are usually easier to grip than round rods.

SAFETY AND HEALTH

The greatest dangers to the carver are injuries to eyes and face from flying bits of stone and lung ailments from stone dust. For protection, one should always wear a plastic safety mask or goggles and respirators available from sculpture suppliers and industrial equipment suppliers.

The full face mask (a) straps around the head and protects the entire face from flying chips. This is especially important during the initial roughing out stages when tools are hit with enough force to send particles of stone flying at high speeds and great impact. Goggles (b) and (e) are important when carving all stones, but especially igneous varieties that are harder and sharper than others. Face masks and goggles may be worn over eyeglasses. Most have replaceable plastic lenses.

The workroom should be equipped with eyewash and cotton swabs for removing particles from the eye. Keep telephone numbers and addresses of emergency medical service available should eye injury occur.

Respirators (c), (d), and (f) should be worn to prevent stone inhalation which may cause pneumoconiosis. Granite and rocks containing silica and quartz produce a fine dust that lodges in the lungs and may cause silicosis. Respirators have replaceable filters that should be changed frequently. Closed rooms should be properly vented with exhaust systems to remove stone dust, or a dust collecting system. A shop vacuum cleans dust and chips more efficiently than a broom and dustpan.

Because wood handles expand and contract with humid and dry weather conditions, hammerheads will loosen and tend to fly off when swung. (Never permit anyone to watch you carve from the front or rear.) For a temporary cure, soak the wood handle in water to expand it so it fits more tightly in the hammer. Fit in a steel wedge, then soak in linseed oil to tighten permanently.

When using pneumatic equipment, power saws, drills, sanders, and so on, always follow manufacturer's instructions. Never wear clothes or articles that dangle such as long neckties, scarves, loose sleeves, long hair, or jewelry that might catch in moving blades and drill bits. Don't reach across machines while they are running. Never touch a moving part to slow it down!

GENERAL CARVING PROCEDURES

Carving procedures are sometimes categorized as "indirect" and "direct." Both involve carving stone directly, but the approach is different and does affect the final result.

"Indirect" carving means the artist has developed a small model of his sculpture from wax, plaster, soap, or clay. This model is then reproduced on a larger scale by the "pointing" method. Using a pointing device or a caliper, the model is mechanically enlarged by a stonecutter. It is usually brought to within a thin skin of what the final surface is to be. Then

either the stonecutter under the sculptor's direction, or the sculptor, will work the stone to the skin, duplicating the final touches as in the model, perhaps adding individual textures and nuances.

This indirect approach has advantages and disadvantages. It reduces the time and effort required by the artist to produce his work. It eliminates the roughing out process. The artist really doesn't have to know how to carve.

The disadvantages equal characteristics that Constantin Brancusi, Henry Moore, Eric Gill, and other early direct carving proponents rebelled against. Often, the nature of stone is lost. The sculptor, working in clay or wax, is actually modeling, not carving. He is unaware of "time" as an element of creating a stone sculpture. He is concerned only with the material of his model; he may not be designing

for a particular piece of stone, and much of the stone may be wasted. Because the model originates in another material, the vitality and life that seem to emanate from a direct carving are lost. When reproducing a model and a flaw occurs in the stone, one may have to discard the stone. The spontaneity of working into and around a flaw is lost.

Another disadvantage is caused by the natural play of light on stone and how it reacts as the work is being carved. In a model, one cannot anticipate the effect of light on areas of specific stones. Nor can one anticipate the directions of veinings that may distort the direction of a shape.

"Direct" carving then really has two meanings: the artist is *directly* involved in the creation of his sculpture from beginning to end *directly* in the stone. He visualizes the form

Initial sketch for sculpture, ACROBATS. Ruth Ingeborg Andris. One might make several quick sketches to use for reference. Invariably, the sculpture will be different than the sketch.

Outline of figure is sketched on block with charcoal pencil. Cross-hatching indicates stone to be removed initially and approximate placement and angle of point.

PROCEDURE I. BLOCKING OUT

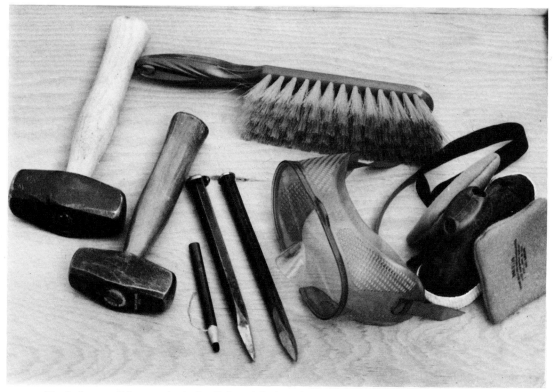

Tools for roughing out include: lightweight iron hammers 2-2½ lbs., charcoal pencil for sketching on stone, points in two or three sizes, soft brush for removing chips and dust while working, plastic safety goggles, respirator. Tools are kept handy on a wooden tray.

within and removes the unwanted stone. He is able to change direction, revise, take advantage of inherent vicissitudes of the material and forms. He may make sketches on paper, in clay, wax, or plaster, but these are only sketches, not models. They may help him think in the three-dimensional manner required for stone carving, but the finished sculpture may have only some resemblance to the sketch. Even if someone else helped with the roughing out, the sculptor is always in control of his work.

A three-dimensional sketch, or drawing, is recommended so the beginner avoids a tendency to chip away at the stone until little material remains. He is encouraged to sketch on the stone so he can integrate the form on all sides. He should habitually observe objects and how they exist in three-dimensional space. Items on a desk, in kitchens, and in nature, such as flowers, trees, and so on, exist in space in three dimensions. Think of them as being carved from stones, not simply drawn as outlines on paper, and you will understand the problem.

Study sculptures, preferably the best examples available, to learn how other artists have solved and evolved an answer to the relationship of sculpture to space.

In the following demonstration, Ruth

Ingeborg Andris shows the complete development, from idea to finished piece, of her sculpture "Acrobats" in African wonderstone. For this piece, she had the idea, made the sketch, and ordered a stone the size she wanted.

Carving soft stones may be broken down into five procedures:

1. Roughing out
2. Shaping with toothed chisels
3. Refining
4. Final smoothing
5. Polishing

All carving develops along these procedures with one or both of the last two eliminated, depending upon the roughness of the stone or the texture desired. Any tools may be substituted. Power tools (described in chapter 5) may be used, but procedures remain the same. The tool to use is the one that will do the job. Techniques are applicable to any stone carving, with necessary revisions depending upon the problems to be solved.

Regardless of the size of the sculpture or the stone, these photographs emphasize that the procedures are the same. Mechanical methods and the working environment may impose different problems. Examples in this book offer various approaches and solutions to working setups.

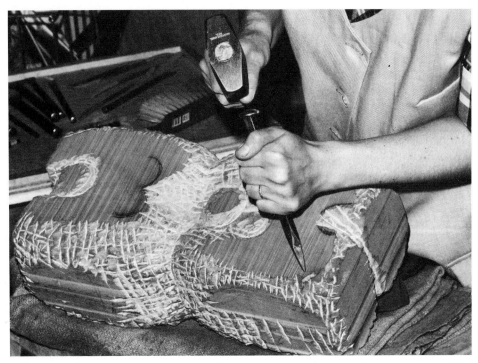

Roughing out is accomplished with the large point held at an oblique angle working from the mass to about one-half inch of the edge and struck with a medium blow. Work edges and corners first in parallel lines at right angles to each other, creating a crosshatch effect that results in a feeling of hills and valleys in the stone. This removes stone in a relatively even manner. It is the procedure used all the way down to the finer surface with smaller tools.

To avoid the real danger of breaking off too much of the edges, never work too close to them; and carve parallel to an edge rather than perpendicular, being extra careful at corners. (Marble and more brittle stones are better worked from the corner into the mass of the stone.) If chips larger than desired break away, switch to a smaller point or to a toothed chisel, working the area slowly with less force on the hammer.

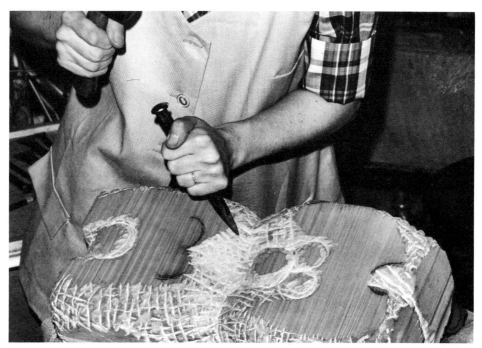

The point is in the "sensitive" hand, the one that does the mind's bidding. It is like a direct line of thought and action from the mind's eye through the hand, by way of the tool to the stone. Observe how the parallel lines created by cross carving continually create hills and valleys, or highs and lows: This is the technique for removing stone evenly.

Loose stone chips are brushed away. The stone is placed on layers of burlap which cushion the stone and absorb shock. It facilitates swinging the stone around and propping it at angles as you work. Stone should be placed on a sturdy table that you can walk around.

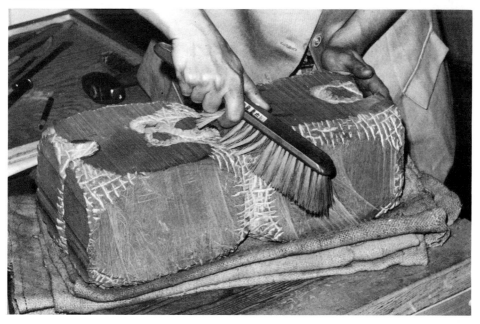

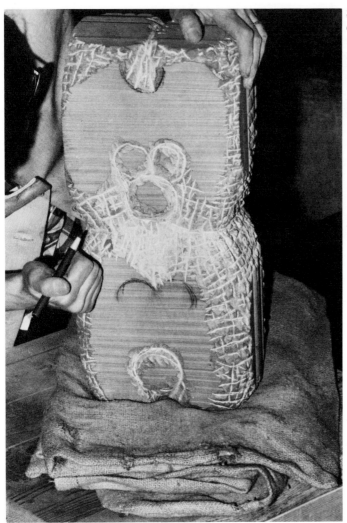

Step back and observe the progress often, resketching where necessary, and carving until the block is roughed out. Shaping begins with toothed chisels. It is wise to leave the work occasionally and come back to it with a fresh, more critical viewpoint.

PROCEDURE II. SHAPING WITH TOOTHED CHISELS

Toothed chisels, also called frosting chisels, are made in several widths and numbers of teeth. They are used with the same iron hammers as the points. In addition to these flat toothed chisels, there are square-headed tools with as many as nine teeth as shown on page 75. Teeth vary from widely spaced to finely spaced depending upon the amount of stone to be removed and the texture desired.

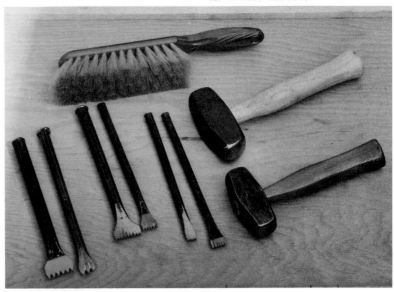

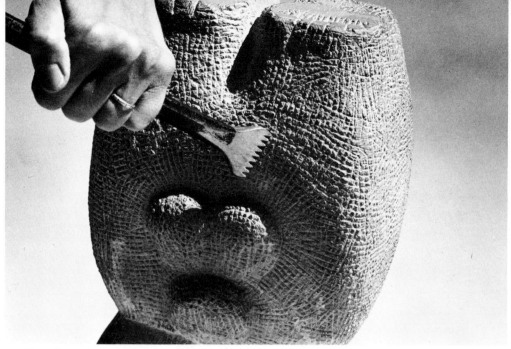

To refine the shape from rough to smooth, you progress from wide-toothed chisels to fine-toothed chisels. Chisels are held at a rather oblique angle, generally working from high planes downward. Generally, you follow the direction of the roughed-out forms, working the tool in parallel lines as with the point, then crossing those lines to remove stone. The crosshatch pattern, or hills and valleys, are now finer.

This gives you an idea of the type of cutting made by each tool. As you work, you may pick up tools previously used to redefine an area. There are no rules as to which tool to use when. The only rule is to use the tool that does the job at any stage of the work.

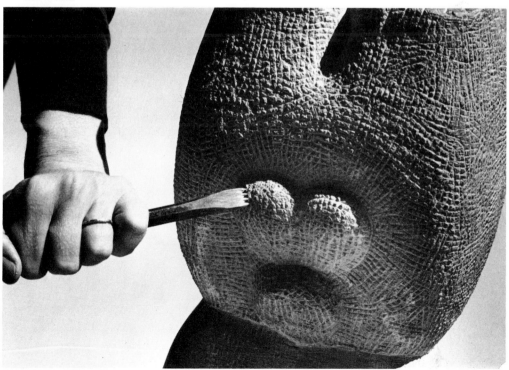

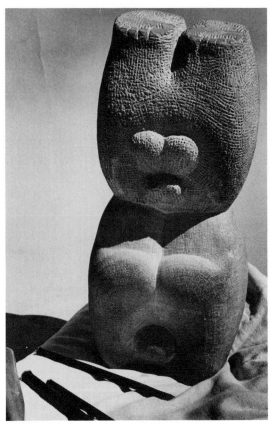

All ridges are removed with a serrated flat chisel or a straight flat chisel depending upon preference. These tools move quite smoothly across the stone and are gently tapped with the hammer. One simply continues to follow the original form.

This shows the difference in surface treatments at this point of shaping. The top half is still rough from the broad-toothed chisel. The bottom half has had all hills removed until it is quite even and ready for further refining.

PROCEDURE III. REFINING

Cabinet rasps, riffler rasps, and files in assorted sizes and shapes are used to further wear down the stone. The coarser rasps are for initial refining when a good amount of stone can still be removed and sections changed. Finer rasps and files are for further smoothing. This procedure often is most satisfying because it involves the subtle, gentle working of the stone without harsh blows from the hammer to develop the forms being sought.

Soft bristle brushes are used to clean loose particles and dust from stone. A small wire brush is essential for removing stone chips and dust from clogged teeth and grits of the tools.

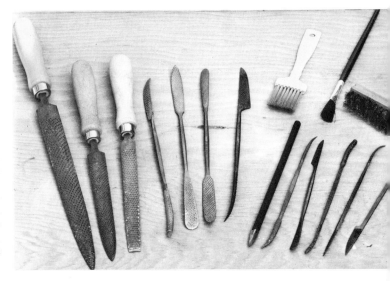

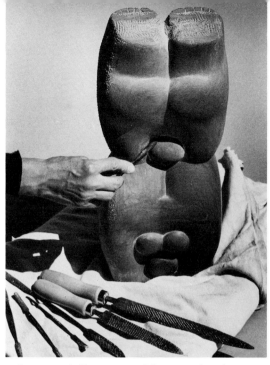

Rasps and files are used in an order that progresses from coarse to smooth. Rasps have points that form prominences for cutting; they are coarser than files. Files have raised parallel lines for a more abrasive smoothing operation.

Small riffler rasps (note the teeth on this tool) are used for working around smaller areas and getting into crevices. These same procedures with personal variations are used for wearing down stone.

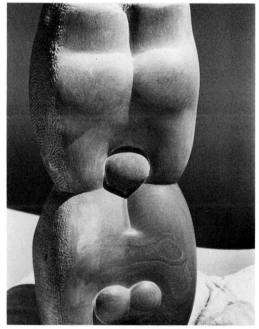

Here a riffler file (note the raised lines on the tool) is used for further finishing and for very fine detail work. Because wonderstone is comparatively soft, files are used in spots for cleaning up shapes along edges and for fine details. Steel wool may also be used. Harder stones often require more filing.

With this stage of smoothness, natural swirls in the stone begin to appear. Compare the stone at this stage with the one on page 56. Now it is ready for final smoothing.

Carborundum stones are also used to bring the stone to a smooth surface. They are available in coarse to fine grits and may be used on any stones from marbles to granites. Pieces of scrap stone being carved are also good for smoothing.

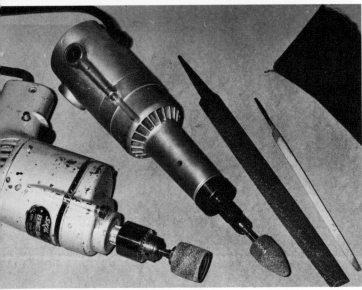

Also a boon to the sculptor are drills with carborundum-wheel attachments in a variety of grits. They are invaluable for working interior cuts and hard to reach areas.

PROCEDURE IV.
FINAL SMOOTHING

For stones that are to be worked to a smooth, highly polished finish, you will need garnet paper or waterproof silicone carbide-coated paper usually called wet/dry paper. Grit numbers range from coarse to fine: from numbers 60 (coarse) to 600 (fine). Final high-gloss polishing is done with a pumice powder such as tin oxide or seltex, stannic oxide, cerium oxide, or aluminum oxide. Clean-up is easy if you place a piece of plastic over the burlap cushion, work over a sink, a drain, or outside. For wonderstone, wet/dry paper beginning with 220 grade is worked with water. Rubber gloves will protect hands.

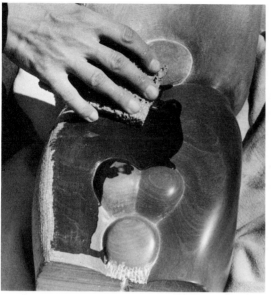

Wet the stone in small areas at a time with the sponge. Use plenty of water and work each grade paper to its fullest capacity, removing all scratches remaining from rougher papers with the next finer grit. Use sponge to wipe away particles. Dry occasionally. Check surface under good lighting.

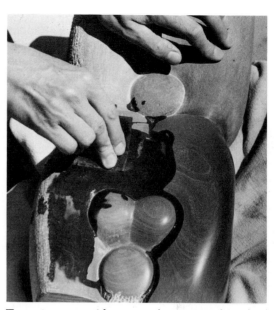

Tear or cut wet/dry paper into convenient-sized pieces, dip into water, and with sufficient pressure rub over stone, generally moving in a circular motion until you have worked to the finest abrasive.

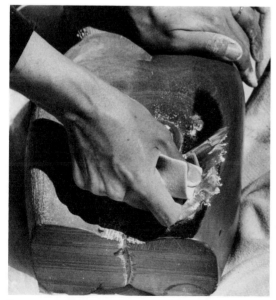

Putty powder, tin oxide, or other polishing powder will polish the surface absolutely smooth. Wet a portion of a white felt pad (colored felt tends to come off on the stone), pick up some putty powder, apply to stone and rub!

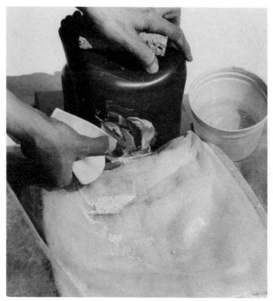

Powder should be applied generously using only a very soft cloth for rubbing. Rinse thoroughly with water and allow stone to dry. Buff with a soft cloth. Wonderstone now should have a satiny smooth polish.

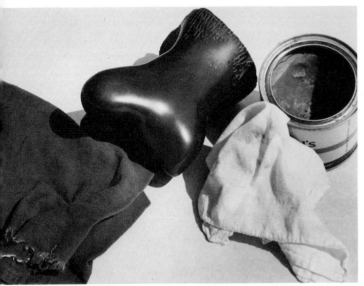

PROCEDURE V. WAXING

To protect the finish and heighten the polish, apply a thin coat of wax. Depending upon the stone and the gloss required, one may use furniture and automobile waxes available commercially —beeswax, silicone, oil stains, and so on. On marbles avoid waxes with oil bases; the pores tend to absorb oil and discolor the stone. As the density of a stone varies, its absorption of wax will vary the color.

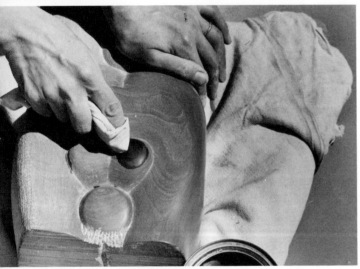

Apply wax with a soft cloth. Allow to dry, or follow the directions of the specific product being used. Almost all protective coatings affect the color of stone so it is wise to experiment earlier on a "scrap" piece. Color may be applied with enamel, lacquer, epoxy, or vinyl, but it will tend to chip off if struck.

Buff to a high gloss with a soft, lintless cloth. If no base is to be used, cut a piece of flannel to the shape of the bottom of the stone and glue. Or design a base that fits the sculpture. (See page 68 for a discussion of bases.) Felt may be glued on the bottom of the base for furniture protection.

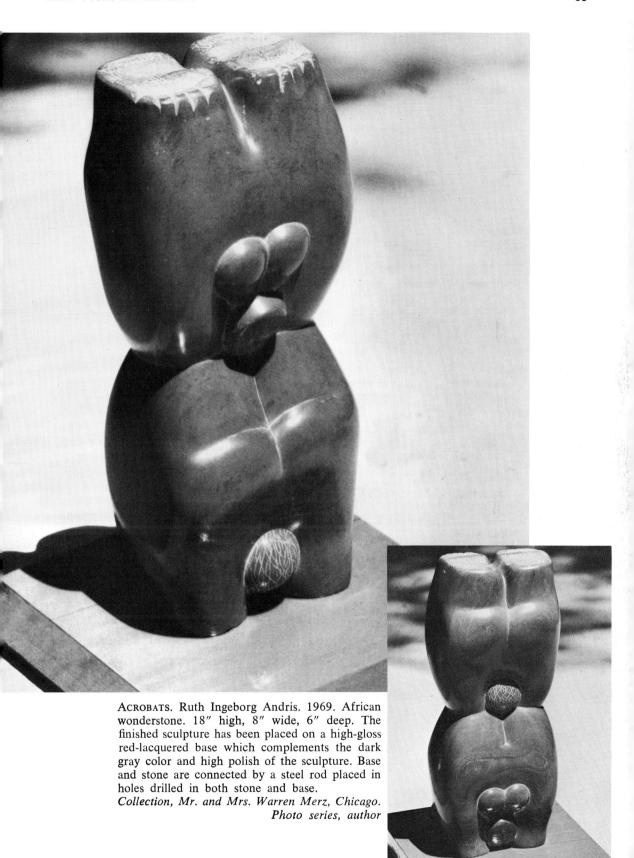

ACROBATS. Ruth Ingeborg Andris. 1969. African wonderstone. 18″ high, 8″ wide, 6″ deep. The finished sculpture has been placed on a high-gloss red-lacquered base which complements the dark gray color and high polish of the sculpture. Base and stone are connected by a steel rod placed in holes drilled in both stone and base.
Collection, Mr. and Mrs. Warren Merz, Chicago.
Photo series, author

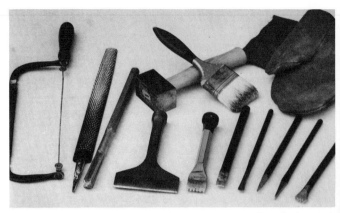

Regardless of the stone, the same assortment of tools is used with variations mostly devised by the sculptor. For rough feather rock (also called lava stone), sculptor Ralph Hartmann uses leather gloves and long sleeves so the rough, sharp particles will not touch his skin. The stone, which ranges from light gray to black with some beiges, is so porous it may be cut with a saw and wood rasps, available at hardware stores.

Rasping brings the stone to a smoother surface quickly. Because of the roughness of the stone, it should be worked in broad areas without details. It cannot be polished as can wonderstones and marbles.

MOTHER AND CHILD. Ralph Hartmann. 1968. Feather rock. 23″ high, 11″ wide, 8″ deep.

THREE-IN-ONE. Ralph Hartmann. 1968. Feather rock. 24″ high, 16″ wide, 12″ deep.

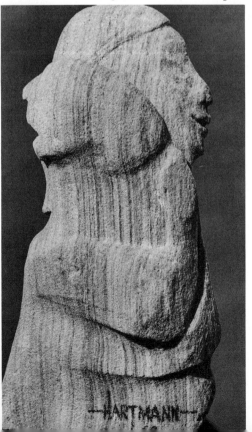

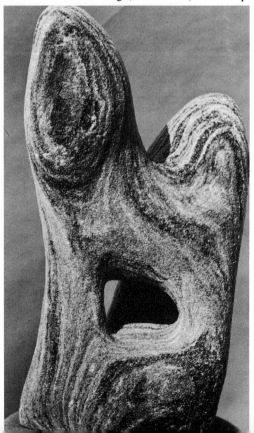

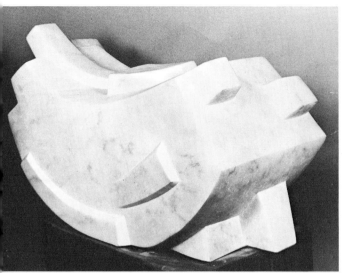

THE ARK. Leonard Agrons. 1967. Marble. 12″ high, 24″ wide, 15″ deep. Direct carving was first "sketched" with clay. This is simply another working method among many employed by sculptors in the development of three-dimensional forms.

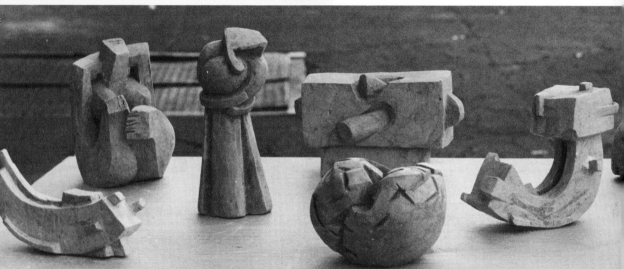

Sketches are plasticene clay, carved from a block and not modeled. By carving a block of clay, Agrons simulates the carving technique in stone. The stone may be quite different from the model in the final stage so far as details are concerned. Bottom left model is a sketch for THE ARK, above.

Agrons at work. Many sculptors keep several pieces going at a time and move from one to another rather than continuing one piece from beginning to end before starting another. They feel this gives them a fresh viewpoint. The stone is propped on a piece of wood for a comfortable working height. A studio flooded with natural light is ideal.

Photos, courtesy artist

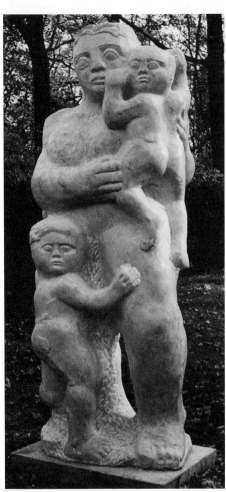

Abbott Pattison has sketched out the main shapes for his sculpture. He wears a face mask and respirator while working with mallet and points to prevent chips from flying and injuring him. A roughly built platform enables him to reach the top; a crude lean-to provides shade.

MOTHER AND CHILDREN. Abbott Pattison. 1954. Marble. About 8½′ high. Below, the sculpture in progress.

Courtesy, artist

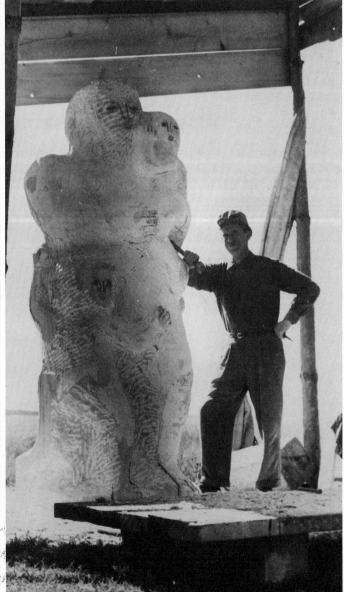

At the St. Margarethen Symposium, 1966, Hiromi Akiyama also sketches shapes directly on the stone, then blocks out with hammer and point. In both sets of photographs, you can see the parallel lines made by the point at right angles to one another as the surface is worked down. Akiyama has built scaffolding he can sit and walk on around his sculpture. Only a hat protects him from the sun.

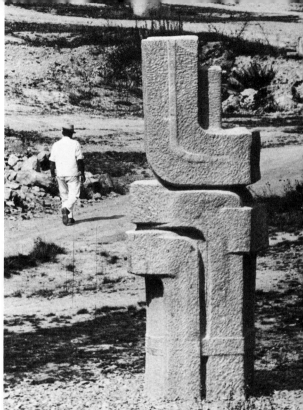

SCULPTURE. St. Margarethen. 1966. Hiromi Akiyama. Below, the sculpture in progress.
Courtesy, Symposium St. Margarethen

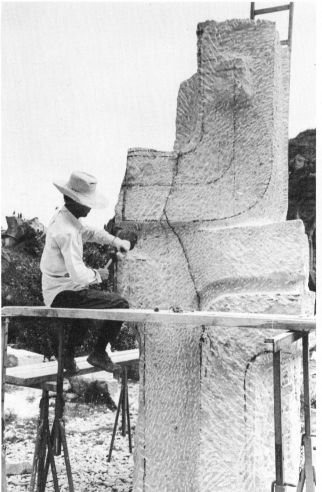

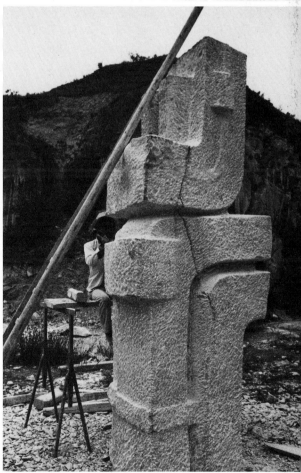

BASES FOR SCULPTURE

The evolution of the base for a sculpture has a history all its own. Bases in the past were often pedestals designed mainly to hold a sculpture at viewing level. Monumental bases in the 1900's were often so baroque and decorative as to be ludicrous by today's standards. Brancusi and Arp created bases that were an integral part of the sculpture. Noguchi believes a base forms a "fictional horizon"; therefore, he also attempts an integration of sculpture and base: "bases that bite into a sculpture, sculpture that rises from the earth." Today, a base may be eliminated entirely; the stone may simply be set on the floor.

The base serves the same purpose as a frame for a picture. It is meant to set off and enhance the sculpture. Its size, color, texture, and material must be considered. Sometimes a stone is developed so the base is included in the overall design. One should observe the bases used in examples throughout the book. They may be the same kind of stone as the sculpture or they may be wood, metal, rough stone, plastic, and so on.

When a small stone is placed on a base, it should be mounted either permanently or made movable for easy transporting. A connecting rod is used. Drill a hole in the stone with a carbide tipped masonry drill bit or an electric hand drill. The hole diameter will depend on the size of the stone. In "Acrobat," it was a ½-inch diameter drilled 1½ to 2 inches deep. Drill for very short times, removing the bit from the hole and brushing the dust out to assess your progress. Do not force the drill into the stone or let it overheat. Pour water constantly into the hole while drilling. Work slowly and patiently so as not to fracture the stone at this final point.

Drill a similar hole into a wood or stone base. Cut a steel rod the same diameter as the drill bit·to fit into the holes. Cut it the combined length of the holes in the stone and base. Cement the rod firmly in the base with epoxy. For transporting, do not cement the stone itself, so it can be lifted off the base. Small stones should have both base and stone epoxied to rod. Larger sculpture may be removable from the rod for easier handling. Some may require more than two rods, one sturdy one for support and a lighter one to prevent the piece from turning.

Metal, wood, or other bases are handled in the same way. Plastic bases require special adhesives available from a plastic dealer.

REPAIRING FRACTURES, CRACKS, ETC.

Damaged stones sometimes can be salvaged. An unplanned fracture, for example, requires the artist to revise the form which may turn out to be even more successful than the original design.

Small cracks or soft veins may be made homogeneous with the rest of the stone by pulverizing scrap chips of stone and mixing them with clear epoxy. Make a pasty mix and apply with a pallette knife or putty knife. The epoxy dries clear, hard, and waterproof; it may be sanded and polished. Epoxy cements may be used successfully when a stone breaks clean.

Several commercial products are available. Italian stonecutters have used a material called "akine" for years. In England, sculptor Alan Collins used SBD Certite structural resin jointing for repairing the large Kennedy memorial stone that had been broken by an explosion. Repair methods depend on the stone, the kind of crack, weather conditions, and other factors. Again, one should tap the resources of builders, architects, and other commercial sources for continuing developments and better methods for working with specific materials.

To repair the stone monument, the broken sections and shattered fragments were coated with Certite resin jointing. Sections were clamped and cured for three hours.

After final repairs were made and cracks filled in, the lettering was cleaned up and one could not tell where the break had been.

Courtesy, Alan Collins.
Photo, John Laing and Son Ltd.,
London

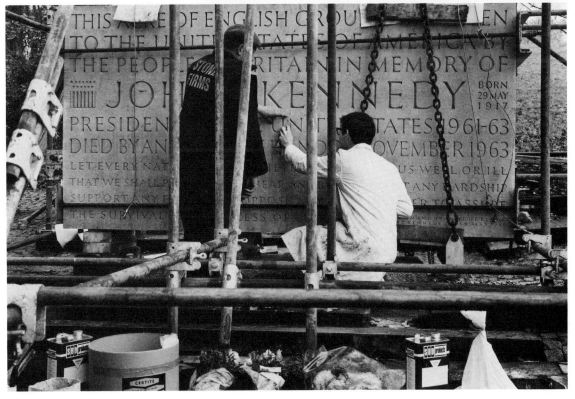

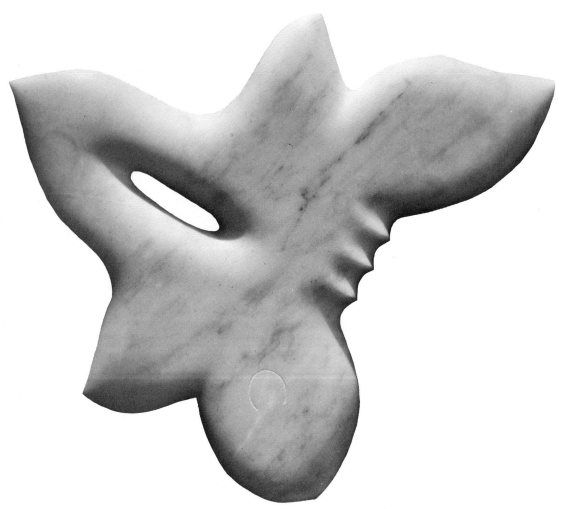

BIOTIC MYTH. Dennis Kowal, Jr. 1968. Marble. 16″ high.
Courtesy, artist

Power Tools and Methods

PNEUMATIC—ELECTRIC

For the shaping of stone to create sculpture, a variety of power tools may be employed. Power tools accomplish essentially the same tasks as hand tools: carving, grinding, sanding, polishing, and buffing. They have advantages and disadvantages. Few artists work solely with either hand methods or power methods, but combine the two. Generally, they use the tool that does the best job and that they enjoy using. Some sculptors do prefer to work with hand tools only believing that the slower development results in a more subtle development; but for larger, monumental sculptures, power equipment facilitates completion of the work and saves time and energy.

Power tools fall into two categories: (1) pneumatic tools are those which have power driving the tools supplied by compressed air generated by a gasoline or electric motor. The tools are used for carving, and the air pressure activates the pneumatic hammer that repeatedly hammers the chisels into the stone but with a higher rate of blows possible than with hand equipment. (2) Electric tools produce the same result as pneumatic tools with the exception of the pneumatic hammer. Electric ham-

mers are available but they are not as versatile as the pneumatic hammer and are heavier. They are less costly initially but not for extended long term use. Sawing, grinding, sanding, drilling, and polishing operations can be done with electric tools such as the flexible shaft, belt sander, body grinder, drill and disk sander. Actually, so few tools have been developed specifically for stone carving on a domestic level that one must be imaginative and improvise tools to do a job.

Pneumatic equipment is excellent for harder stones and for roughing out initial forms when large blocks are used. The components are costly compared with hand tools. The pounding action of the blows over a prolonged period of time can cause damage to the human circulatory system. They are noisy, and carvers believe that eventually they may effect one's hearing. Because of the force with which the tool hits the stone, chips fly with great velocity and one must wear protective equipment. They create a great deal of stone dust and dust masks are essential.

When carving with pneumatic tools remember that any blow to a piece of stone makes a fracture mark depending upon the stone, tool used, and the force of the blow.

71

Air compressors are powered by gasoline motors where portability and outdoor use are required or electric motors when more stationary installation exists. One- and two-cylinder models vary in the amount of air pressure delivered. For portability, compressors may be mounted on boards and placed on a platform with wheels. Special trailers to fit the units are available and resemble a boat trailer.

Parts of the compressor and their care. For optimum operation:

1. Check the belt adjustment and oil level in the pump periodically.
2. Drain storage tank of moisture after each day's use.
3. Check air pressure regulator for proper adjustment for tools used.
4. Check oil level in oiler.
5. Oil each air tool used with a drop or so of oil through the back of the tool after a day's use. Use only pneumatic tool oil.
6. Follow instructions supplied with the compressor.

Drawing, Al Meilach

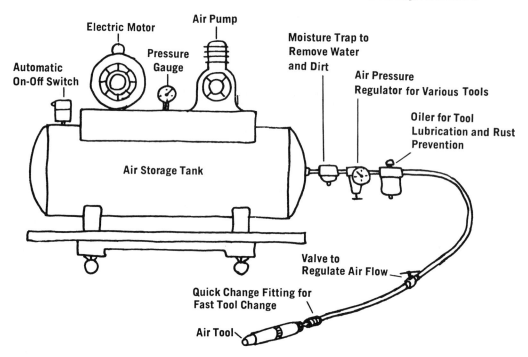

Gauges include the moisture trap (left) to remove dirt and water. The air pressure regulator is changed for the amount of pressure required for different tools (center). Oiler for tool lubrication and to prevent rust (right).

Air pressure valve regulator adjusts air flow. It is placed close to the tool handle for convenience. Observe hand position for guiding broad chisel.

All photos, Dennis Kowal, Jr.

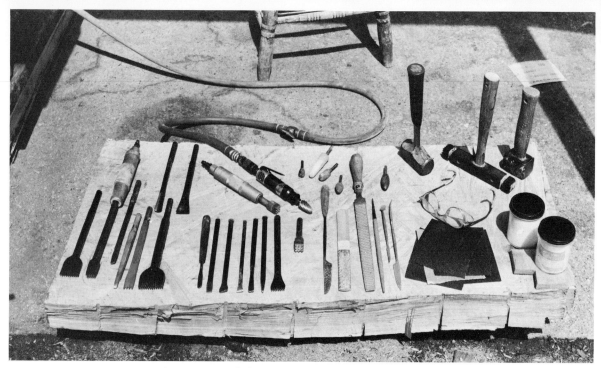

To work a stone from start to finish with a combination of power and hand tools, the following tools may be used: (from left to right) curved, straight, and toothed chisels for the pneumatic hammer, hand chisels, points, and bush-toothed chisels, rasps, files, and rifflers, various carborundum tips for power drills (behind files and rasps), iron hammers in different weights, and a bush hammer, safety goggles, garnet or carborundum paper, polishing powders, and sponge.

Pneumatic photo series, courtesy, Dennis Kowal, Jr.

Types of carving blades are numerous as one can see from this "working" assortment. Any of the pneumatic tools may be used by hand also. They vary in width, shape, and number of teeth.

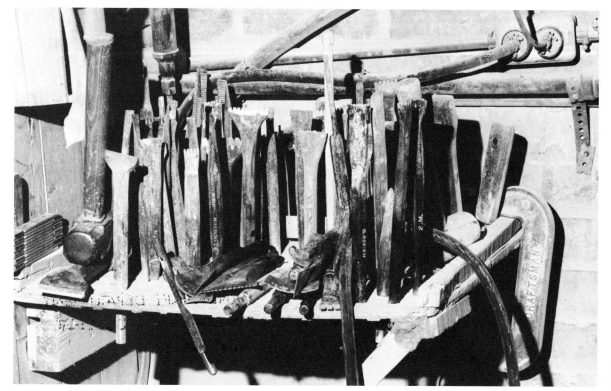

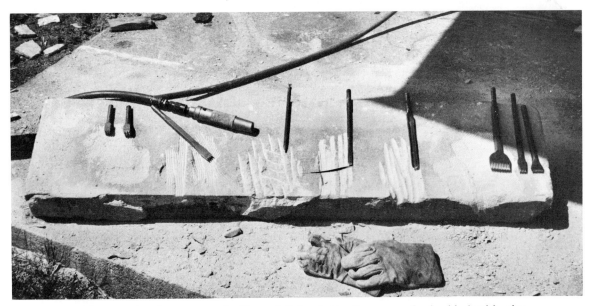

Each tool makes its own mark. From left to right: the square bush chisel with nine teeth, straight-toothed chisel, point, straight chisel, curved gouge, toothed gouges of different widths.

The fracture may extend into the stone as far as ¼ inch and be seen as a light spot. The best advice is to understand that each piece of stone is unique and must be handled accordingly. This is learned by experience.

The pneumatic tool is held with both hands, the bottom hand giving support and direction. The top hand helps steady and guide the tool. Chisels can be worked in any direction, depending upon the grain of the stone or as need dictates. Wearing work gloves will help avoid blistering that often results from the rapid action of the tool. In the following demonstrations, observe the positions of the hands and the directions and angles of various tools against the stone.

OTHER POWER TOOLS

Tools manufactured for a variety of purposes may be adapted to stone. Portable electric hand tools are available in many sizes, designs, and powers to do a multitude of jobs. Some stones are as soft as soft woods and may be cut with woodworking blades. For lengthy sawing operations, water should be run over the blade and on the stone to reduce friction and generate heat. Following are several tools associated with other materials that may be successfully used with stone. Hardware dealers continue to be a good source of information for solving many mechanical problems of stone shaping.

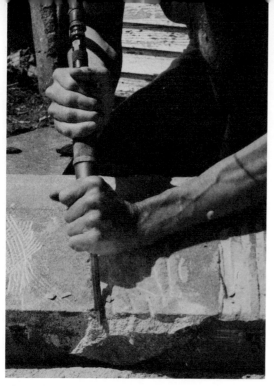

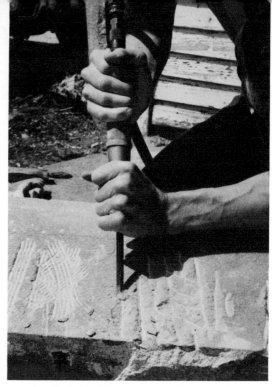

The point is held at *about* a 45° angle and makes straight, narrow impressions and . . .

. . . worked at right angles or in parallels cross-hatched to create hills and valleys.

THE CURVED GOUGE.

The square-headed toothed bush hammer is held so its head hits flat against the stone to wear away the higher ridges that the point made.

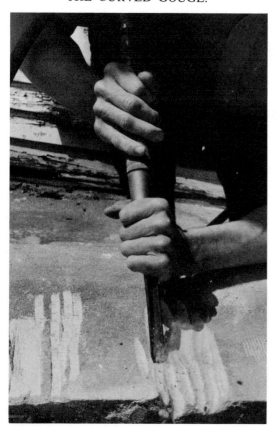

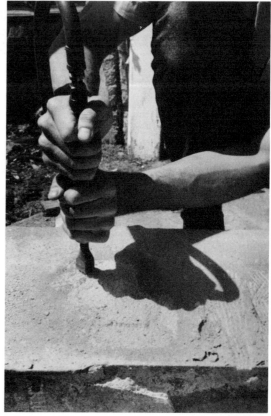

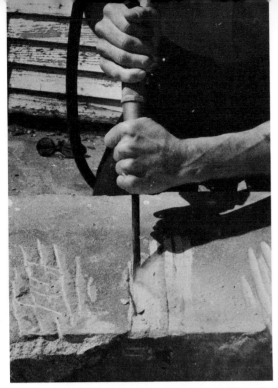

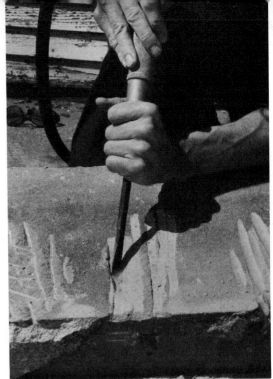

The flat chisel is also held at *about* a 45° angle. It can be used as a surface-finishing tool for sandstone, limestone, and marble.

Photos, courtesy, Dennis Kowal, Jr.

The flat chisel may be held straight or on an angle, depending upon the depth of carving desired. It is an excellent tool for working low, broad surfaces of relief carvings.

Toothed chisels of different widths and number of teeth wear down the stone and create an all-over, closely tooth-marked texture.

Toothed chisels should be cleaned frequently by brushing the tool with a wire brush to remove clogged stone particles.

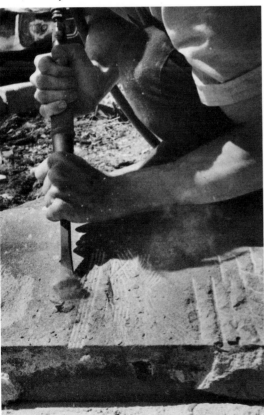

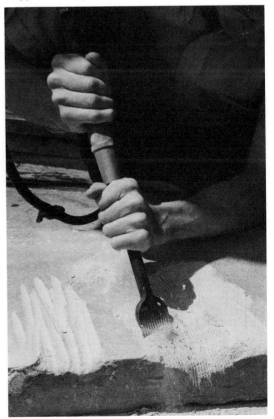

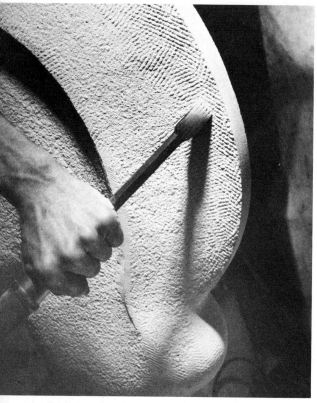

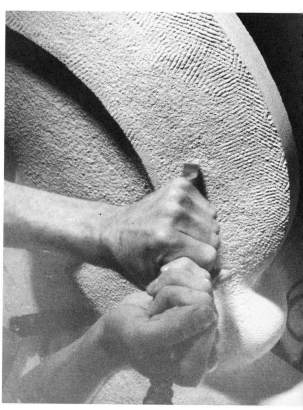

Both hand and power tools are used to develop a sculpture. Here a pneumatic hammer with a toothed chisel is being used.

A flat chisel reduces the markings of the toothed chisel.

A grinding attachment is used for further smoothing.

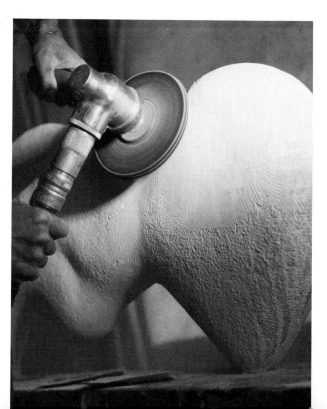

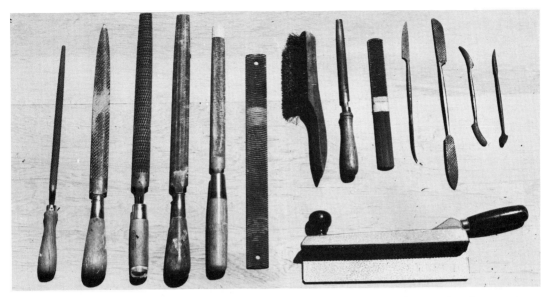

A variety of files and rasps may be used, including many intended for wood and metal, because tools specially designed for stone are limited. From left to right: round file, wood rasp, half-round rasps and files with smooth and rough surfaces, vixen file, brush, contoured rasps, and a plane.

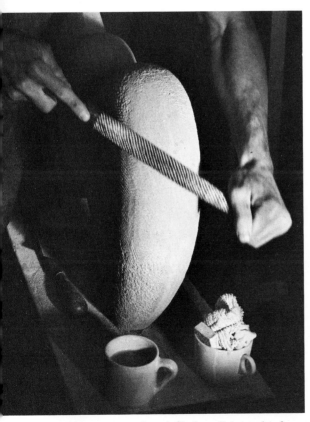

The stone is rasped and filed until brought down to a smooth enough surface where wet/dry papers, pieces of stone, and pumice powders are used (see page 61).

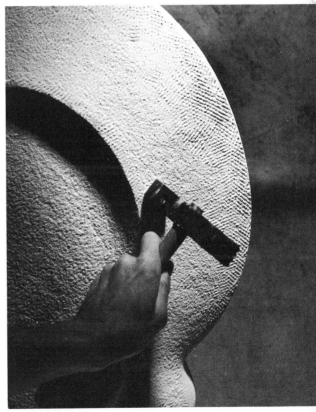

At any point, a bush hammer or any other tool may be reused for subtle shaping.

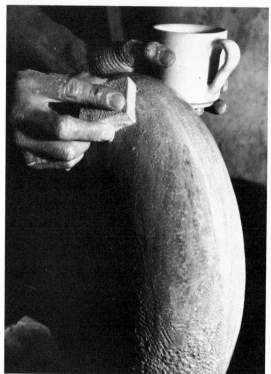

For final polishing, wet the stone and continue to work with each grade of wet/dry carborundum or garnet paper from 200 to 600. Work through every grit from coarse to medium to ensure a homogeneous surface before the final polishing. This may seem laborious, but it goes quickly and is well worth the effort.

The final polishing may be done with the aid of machines, using any of the polishing powders: stannic oxide, pumice, cerium oxide, tin oxide, or aluminum oxide. These are mixed with water to form a creamy consistency, then polished with a hard white felt pad or cloth. Oxalic acid may be used with tin oxide to clean or repolish a stone surface. Let the oxalic crystals dissolve in water first. When machine buffing, use low speeds and don't buff in one spot too long or a burn spot will result. Use a hard felt pad for buffing, but avoid a colored felt that may leave color in the stone.

Portable saws have assorted blades that may be adapted to stones of varying hardness.

Large saws used in commercial stonecutting operations have a constant feed of water to cool the blade. They may be seen in operation at a stonecutting company. The procedure is an education in processing stone.

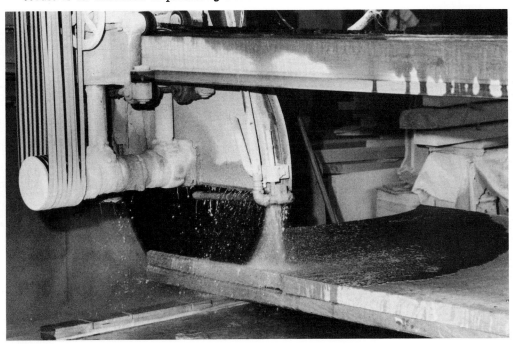

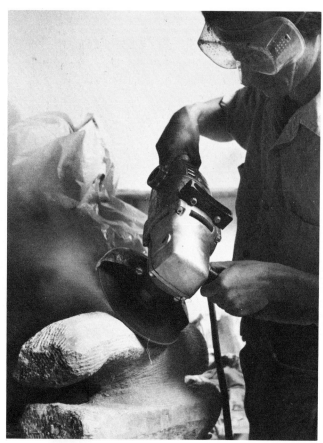

A body grinder is primarily used for metal, but fitted with a silica-carbide masonry wheel and a guard on the grinder, stone may be cut and formed with considerable speed. Most body grinders operate at about 4,000 to 6,000 rpm. They throw large amounts of dust into the air, and a suck-out fan should be used and a respirator worn.

Portable electric sanders speed up smoothing operations and are especially good on flat surfaces. They may be fitted with all different grits and types of abrasive papers.

Use a star drill or carbide-tipped bit in a portable drill to make holes needed for mounting sculpture. This may also be used to start a hole for internal carvings. Bits vary from one-quarter inch up depending on chuck size. Some large drills are equipped with smaller shanks so they can be fitted into a small chuck.

Abrasive and cut-off disks, and cup-shaped grinding wheels may be used on body grinders and on flexible-shaft grinders.

Photos, Dennis Kowal, Jr.

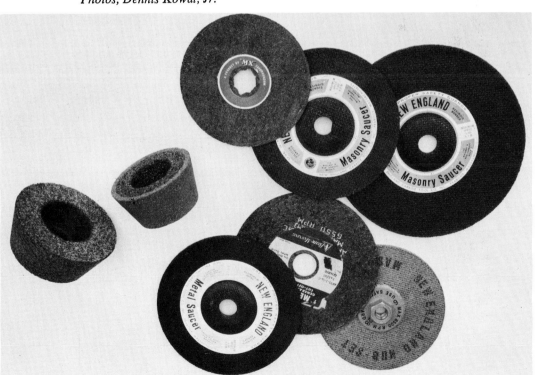

4

POWER TOOLS AND METHODS

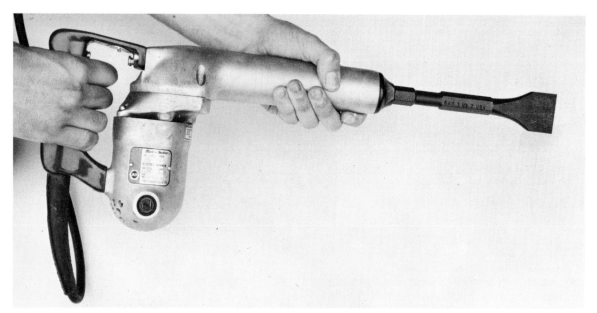

Several manufacturers make electric hammers such as this one. They may be fitted with a straight chisel, point, bush hammer, and so on.

Photo, Dennis Kowal, Jr.

Miniature power tools with interchangeable handpieces and a variety of tips are for grinding, polishing, marking, drilling, cutting, and carving. They adjust to different speeds. This unit works from a flexible shaft. Units without flexible shafts are also available.

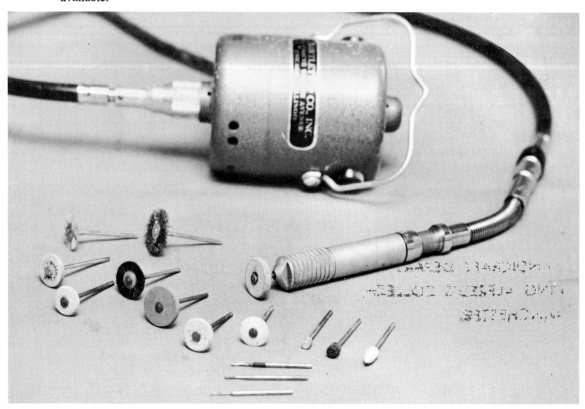

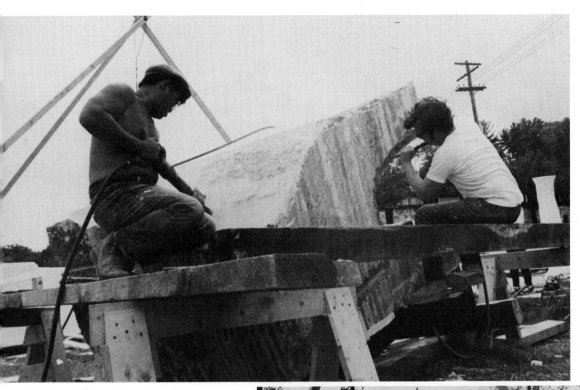

Minoru Niizuma's series of photographs demonstrates many of the processes and problems the sculptor meets during the creation of a sculpture. Using pneumatic tools, Niizuma (left) and his assistant rough out the stone.

Smoothing is accomplished with a body grinder which makes the process faster than hand smoothing when such a large stone is involved.

HANDICRAFT DEPARTMENT,
KING ALFRED'S COLLEGE,
WINCHESTER.

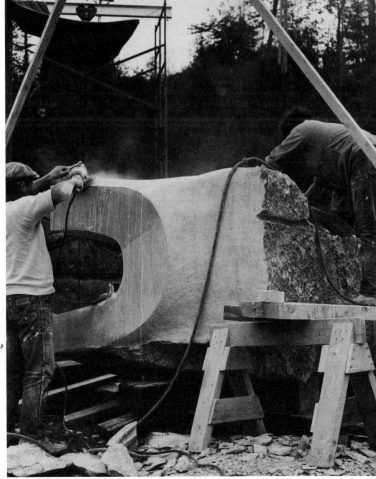

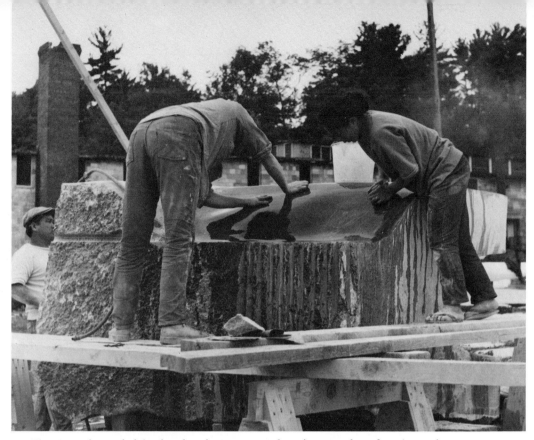

The stone is sanded by hand, using water and various grades of carborundum paper. Note that the stone appears gray where it is dry and black where it is wet. The wet area will be the color of the finished, polished stone.

Lifting is carefully planned, using wedges and a jack.

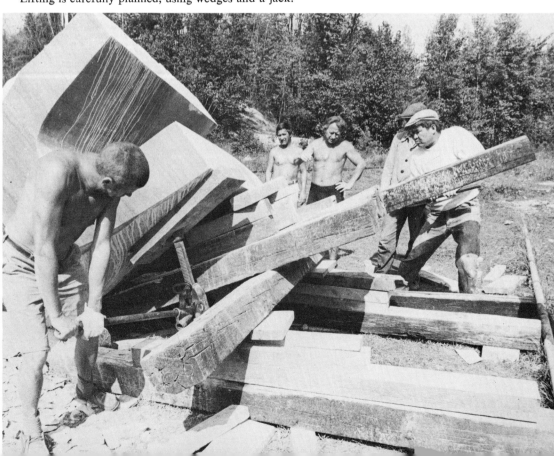

BLACK SEA. Minoru Niizuma. 1968. Vermont radio black marble. Approximately 4½′ high, 5½′ wide, 8½′ deep. In summer . . . marvelous for children to climb about.

In winter . . . an oasis of warm beautiful, flowing form amid the snow and barren trees.
Photos, courtesy artist and Howard Wise Gallery, New York

THE BLONDE NEGRESS. Constantin Brancusi. Combined materials form the geometric head and parts of the body. Head and neck are white polished marble on a body of polished black marble, white travertine, and wood at the bottom. Approximately 66″ high with base. Front view and profile.

Courtesy, The Art Institute of Chicago

Form and Subject—
Human, Animal, Plant

THE FULL FIGURE

Sculpture is an art that occupies space in three dimensions. It requires more visual and actual use of space than a two-dimensional art such as painting. The painter suggests an illusion of space by the placement of objects in relation to one another, but the sculptor must actually utilize space.

Just as the architect's building exists in space, so does the sculptor's sculpture. A building is seen from many sides and angles under varying light conditions. It has volume, mass, contour, surface treatment, and so on. The sculptor's problems are very much like those of the architect. The finished work must be integrated from all sides with all planes and surfaces flowing logically into one another. He is, in essence, taking the painter's two-dimensional world and making it exist as three-dimensional reality. (This is exactly the opposite of the cubists' drawings which attempted to capture a three-dimensional object and show it on a flat surface.)

The work of the sculptor and painter differ in another respect . . . the way the art is experienced. The impact of a flat painting is almost completely visual. One doesn't usually think of touching a painting; he steps back from it to view it in its entirety. But sculpture almost invites one to touch it. One wants to feel its movement, its surface, its texture, and the temperature of the material. This tactile quality suggests a sensuousness directly related to the surface. Highly polished warm toned woods and stones are irresistible to the touch. A sculpture invites the viewer to walk around it. In the case of environmental sculpture, one may also walk into and through it.

The sculptor must also recognize problems of mass and weight and how they affect and dictate form, something the two-dimensional artist never considers. Materials that exist in three-dimensional space have a force of gravity reacting on them. The sculptor must plan his work to hold up, balance, and not be so weak at the bottom that the top will fall.

Stone sculpture, perhaps more than metal, clay, bronze, or wood, dictates a solidity, a concentrated volume, and mass. Protrusions jutting out in space are not compatible with the material as they might be in welded metal. One does not think of laminating stone to achieve a larger block as with wood. Stone parts are not conducive to motorizing, so kinetic examples are rare.

Despite man's exploding technology and

90

PRE-COLUMBIAN FIGURE. 8″ high. Simple curves, rough-textured stone, and abstracted features are characteristic of the primitive quality twentieth-century sculptors adapted.

Collection, Ben Lavitt, Highland Park, Illinois

FIGURES ON TEWKESBURY ABBEY, exterior. Darsie Rawlins. Clipsham stone. 4′ high. This English abbey, in the Norman style, originally built in 1087, requires stone figures often re-created by contemporary artists.

Courtesy, artist

broadening world view, it is interesting to observe that representational human figures and animals predominated as traditional subjects for stone sculpture. Their mass and solidity lent themselves to formal considerations of space and volume. As artists' interests, purposes, and styles changed, the portrayals of subjects gradually changed from idealism and humanism to more abstract shapes, still utilizing the figure as the point of departure for form. In the examples that follow, one can observe the evolution of figure and animal forms.

Throughout the distant and near past, the figure has represented strength, beauty, charm, sensuousness, love, maternity, spirituality, and bravery. The infinite approaches to the figure in stone illustrate the artist's continuing ability to innovate even within one never-tiring subject area.

Further study of the figure should be made in natural history and primitive art museums and exhibits of ancient art. The contemporary sculptor inevitably returns to these sources of inspiration for simple, uncluttered planes, magical, ritualistic, and basic themes. Modern art tends to be eclectic and innovative in creating form from a kaleidoscope of past fabrics.

BODHISATTVA LOKESHVARA. Twelfth-thirteenth-century Cambodian. Sandstone. 45″ high. Bulkiness and heavy columnar legs attest to the problem of gravity or weight with which the artist sometimes must contend. The figure is rigid and frontal; the expression of the face has a religious serenity.

Courtesy, The Art Institute of Chicago

BODHISATTVA. Tang Dynasty. 618–906 A.D. Limestone with traces of color. 5′ high with base. Tang Dynasty artists were able to achieve a figure with a sway and movement. The swelling softness in the neck, chest, and the abdomen suggests breath and life within. Drapery folds are suggested as though lengths of rope. Features are simple planes.

Courtesy, The Art Institute of Chicago

ANCIENT FIGURE. Constantin Brancusi. 1906. Limestone. 22¼″ high. Brancusi actually re-created the broken quality of an ancient stone that had been excavated. It repeats the blockiness of an ancient scribe found in an Egyptian tomb (below).
Courtesy, The Art Institute of Chicago

GRAVESTONE FIGURE OF A YOUTH. From Kerameikos Cemetery, Athens, Greece. C. 380 B.C. 31″ high.
Courtesy, The Art Institute of Chicago

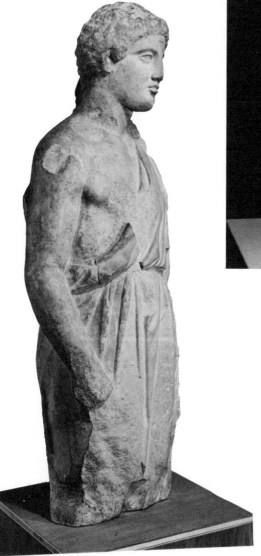

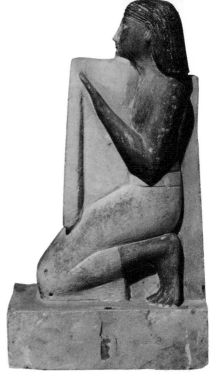

THE SCRIBE AMENHOTEP. Egypt. Eighteenth Dynasty. Stone.
Courtesy, Field Museum of Natural History, Chicago

THE KISS. Constantin Brancusi. 1908. Limestone. 23″ high, 13″ wide, 10″ deep. Brancusi abandoned the esthetic conceptions of Rodin whose "Kiss" provided the theme for this work. The character of the block is retained, but gesture and energy are not shown. The bodies have none of the classic, realistic sensual modeling of Rodin's sculpture. They are reduced to a simple pattern with hair lines etched, arms distorted, eyes placed nonrealistically; yet the theme is suggested beautifully in its simplicity.

Courtesy, Philadelphia Museum of Art

SEATED FIGURE. Jacques Lipchitz. 1917. Limestone. 34″ high, 14″ wide, 12″ deep. The figure is a cubist interpretation.
Courtesy, The Art Institute of Chicago

MADONNA AND CHILD. Henry Moore. 1943–1944. Hornton stone. 59″ high. This religious symbol is a completely revolutionary form compared to the one shown on Tewkesbury Abbey, and illustrates the changes the artist has made in his conception of the figure. This figure is life size but has a monumental appearance because the forms closer to the viewer are enlarged. The sculpture retains the blocky, rectangular feeling of the Egyptian scribe on page 92.
Collection, Church at St. Matthew,
Northampton, England.
Courtesy, artist

HARLEM DANCERS. Margaret Brassler Kane. 1936. Tennessee marble. 30″ high, 14″ wide, 12″ deep. The shapes are so flowing that one loses the idea of the block. Two views.

Courtesy, artist

RECUMBENT FIGURE. Henry Moore. 1938. Green Hornton stone. 55" long. In the late 1930's, Moore began to pierce the mass of the sculpture allowing space itself to become an integral part of the form. Swelling repeated curves advanced the idea of the abstracted figure. The horizontal line along the torso suggests that this sculpture may have been made of two pieces of stone.

Collection, Tate Gallery, London.
Courtesy, artist

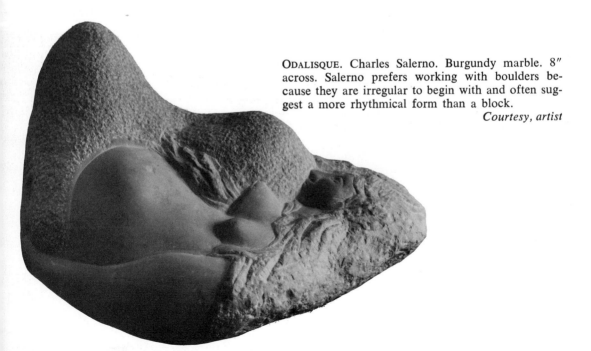

ODALISQUE. Charles Salerno. Burgundy marble. 8" across. Salerno prefers working with boulders because they are irregular to begin with and often suggest a more rhythmical form than a block.

Courtesy, artist

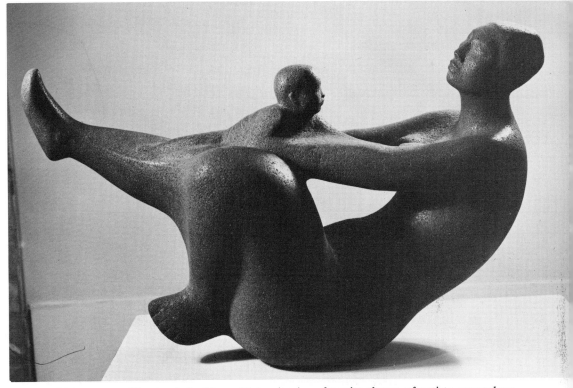

MATERNITY. Alberto de la Vega. Maternity is a favorite theme of artists everywhere. The Mexican art movement was characterized by solid, sturdy forms that remained faithful to sources of Mexican tradition.

Courtesy, Museo de Arte Moderno, Mexico City

THE HAMMOCK. Francisco Zuñiga. 1950. Zuñiga has been a representative of Mexican sculpture for years. His work is carved in compact masses and exhibits a quiet strength.

Courtesy, Museo de Arte Moderno, Mexico City

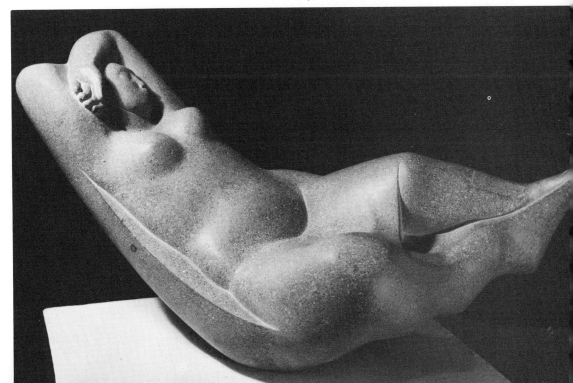

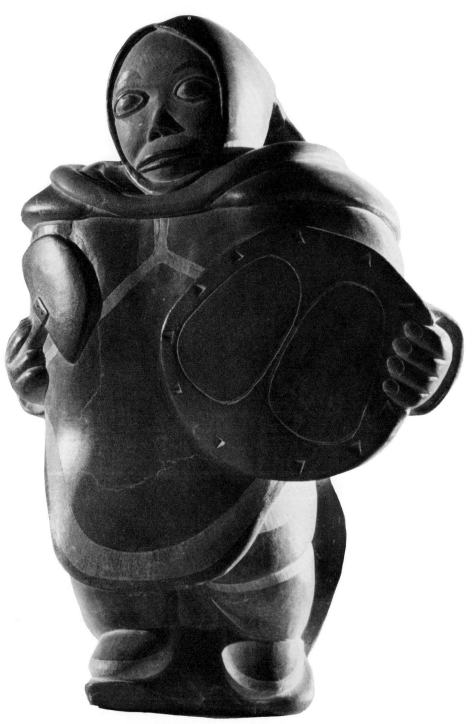

WOMAN AND SKIN. Koom of Povungnetuk. Soapstone. 12″ high.
Courtesy, The National Film Board of Canada

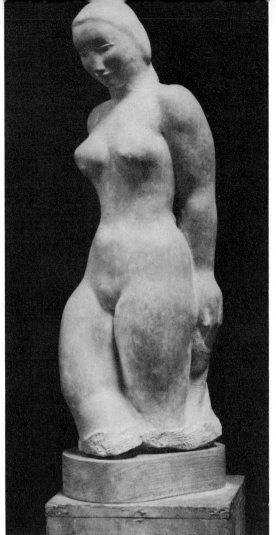

CARESS. Oronzio Maldarelli, 1944. Burgundy marble. 27″ high.
Courtesy, Whitney Museum of American Art, New York.
Photo, Peter A. Juley & Son

TORSO. Egon Weiner. 1955. Marble. 30″ high. Observe how the figure emerges from the base of the same stone.
Courtesy, artist

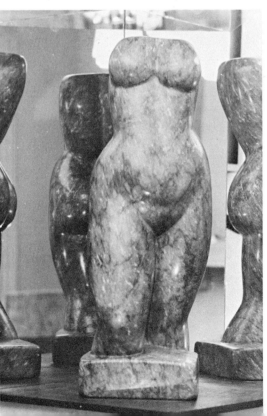

TORSO IN REFLECTIONS. Egon Weiner. 1968. Gray marble. 24″ high. Mirrors are part of the sculpture and reflect the image.

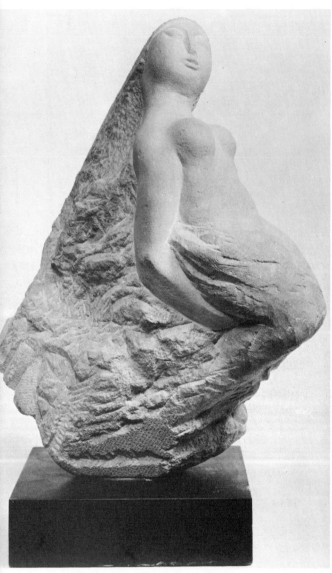

CARAVELLE. José de Creeft. 1964. Limestone. 24½" high, 18" wide.
Courtesy, Kennedy Galleries, Inc., New York

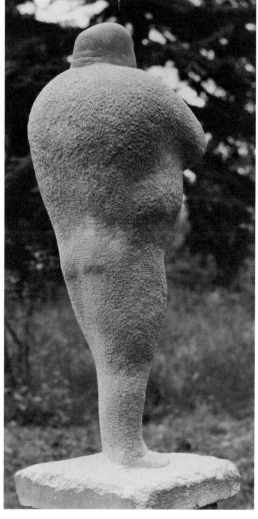

THE GUARDIAN. Leonard Baskin. 1956. Limestone. 27" high, 9" wide.
Courtesy, Grace Borgenicht Gallery, Inc., New York

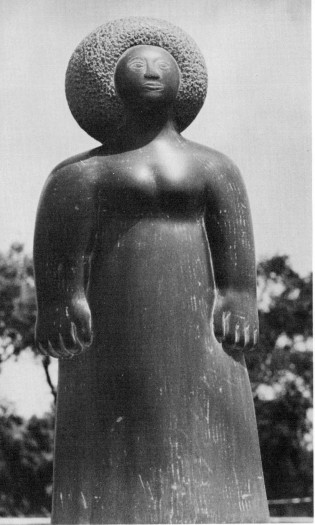

PROUD YOUNG WOMAN. Ruth Ingeborg Andris. 1968. African wonderstone. 15″ high, 7″ wide, 6″ deep.

Photo, author

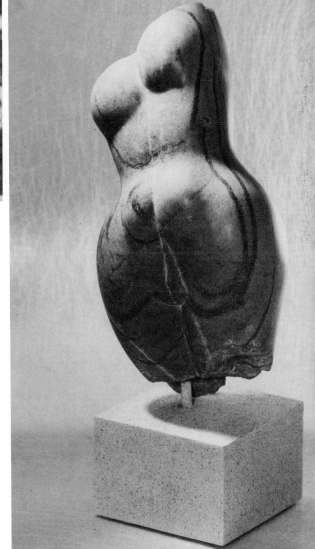

TORSO. Eldon Danhausen. 1960. Green serpentine. 20″ high.

Courtesy, artist

SEATED FIGURE. Masha Solomon. (Two views.) Pink alabaster. 17½ " high.

Courtesy, Ruth White Gallery, New York.
Photo, Eric Pollitzer

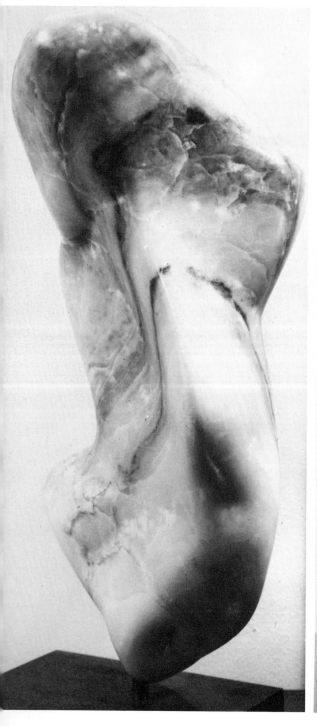
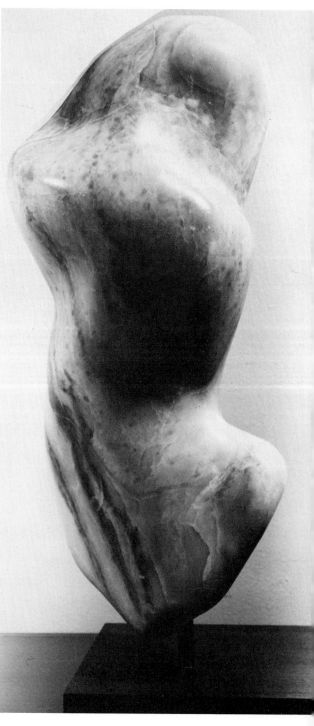

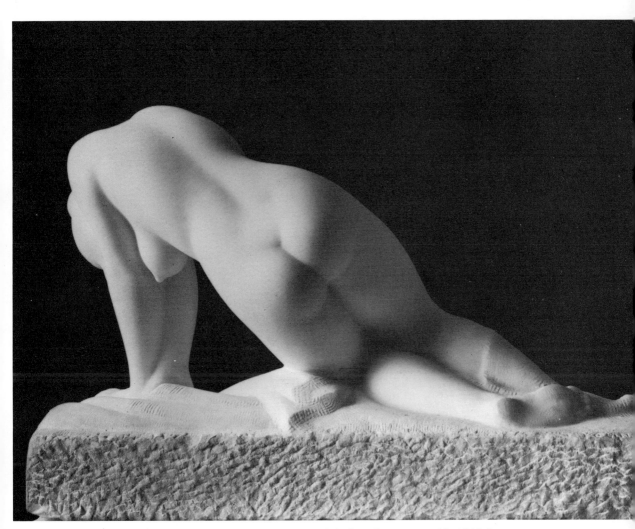

THE AWAKENING. Vincent Glinsky. Carrara marble. 24″ long.
Courtesy, artist.
Photo, Walter Russell

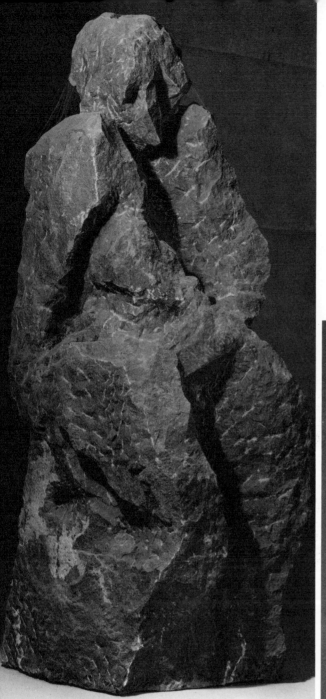

SEATED. Dodeigne. 1965. Soignies stone. 7'2" high. A blue stone left in a rough form with patterns hammered all over. They appear immobile as timeless human monuments.
Courtesy, Galerie Jeanne Bucher, Paris.
Photo, Florin

STANDING. Dodeigne. 1965. Soignies stone. 7' high.
Courtesy, Galerie Jeanne Bucher, Paris.
Photo, Florin

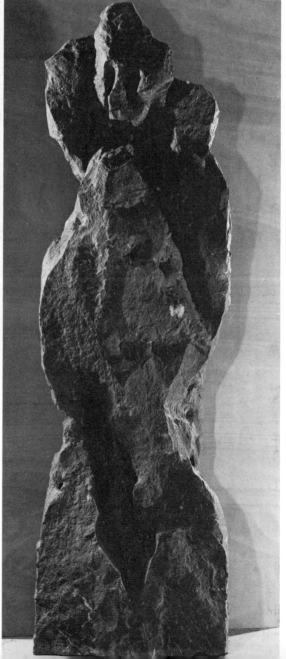

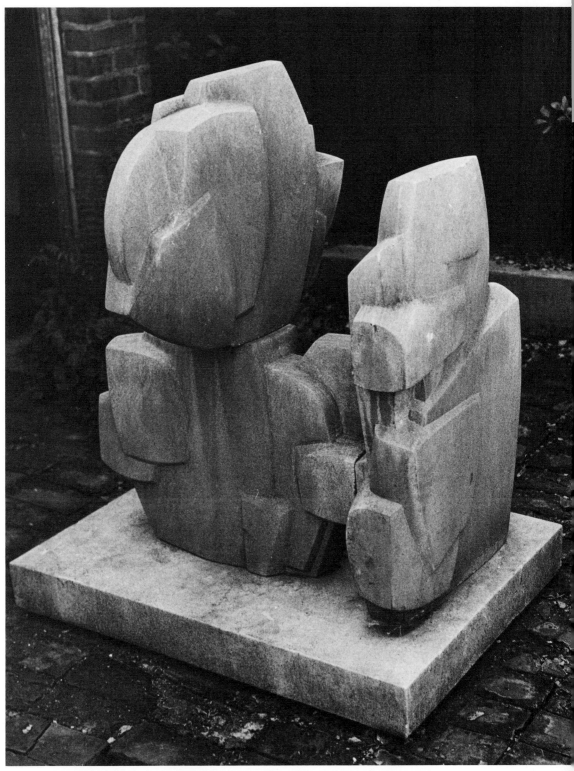

THREESOME. Kay Hofmann-Schwartz. 1968. Limestone. 48″ high.
Courtesy, artist

DRAPED TORSO. Charles Salerno. 1965. Alabaster.
(Three views.) 15″ high.

Courtesy, Weyhe Gallery, New York

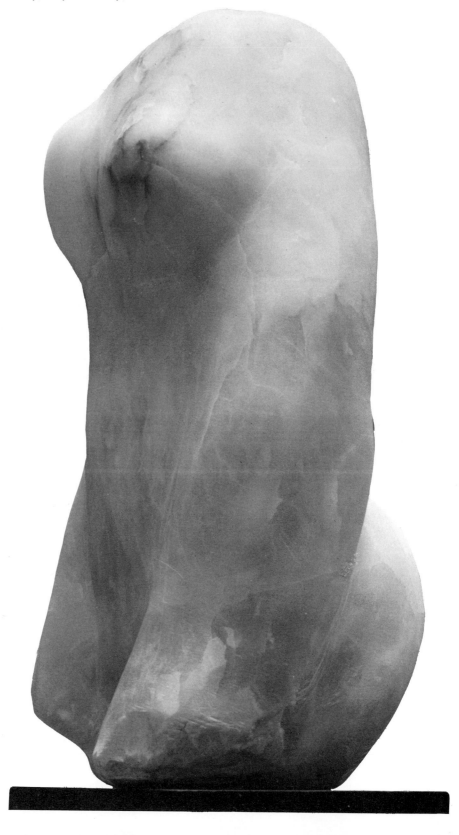

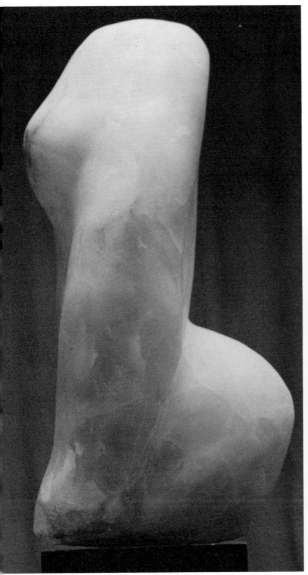

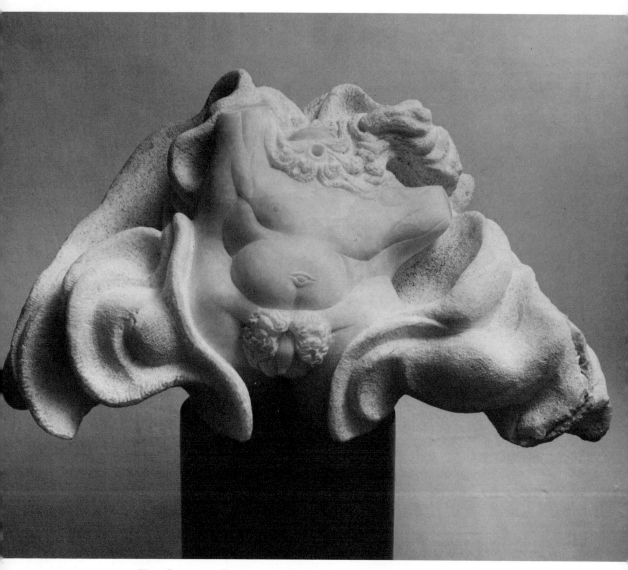

THE CLOAK OF DEINEIRA. Richard Boyce. 1962. Marble. 27″ long.
Courtesy, Landau-Alan Gallery, New York.
Photo, Oliver Baker

PANDORA. Pietro Cascella. 1968. White Carrara marble. 18″ high.
Courtesy, Galeria Bonino, Ltd., New York.
Photo, Peter Moore

MYTH. Elisabeth Model. 1956. Alabaster. 14″ high.
Courtesy, Bodley Gallery, New York

TORSO I. Elisabeth Model. 1963. Marble.
18″ high.
Courtesy, Bodley Gallery, New York

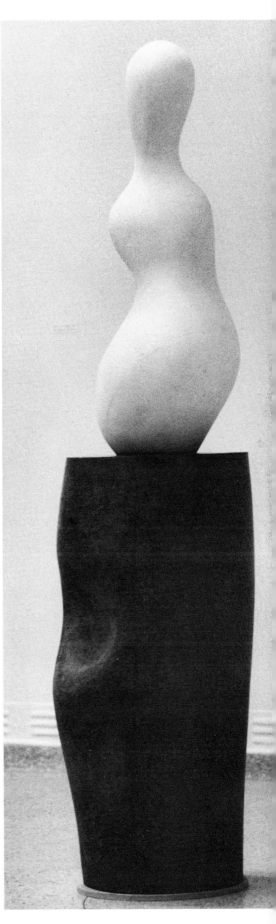

DEMETER'S DOLL. Jean (Hans) Arp.
Marble figure on carved granite base. 5′
high with base.
*Collection, Emily B. Staempfli,
New York*

HEADS AND PORTRAITS

The head has always been an important and expressive subject for the stone sculptor. Portraits of specific persons or symbolic heads have been carved for centuries. Kings and queens left their portraits in stone; religious persons were carved as images for prayer and adulation. Such carving still remains popular. Heads may be so realistic, one might think a sculptor cast them from the person himself; others are suggestive of a person's qualities, and some are outright caricatures. Through a study of heads of the past we know how people looked, how they dressed, how they were thought of by their peers. We see representations of literary characters in every style from early Greek to Roman to Renaissance, Baroque, Victorian, and so on.

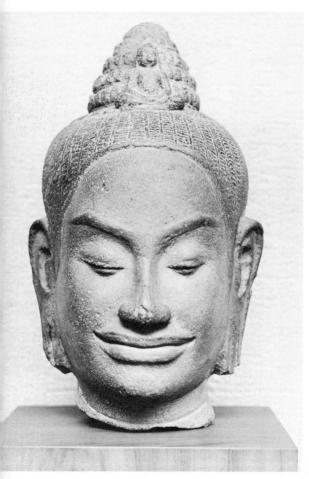

HEAD OF BUDDHIST MEMORIAL FIGURE. Chinese Cambodian. Twelfth century. Limestone. Characteristics of the head of Buddha were established by canons prescribed from the beginning of the religious imagery. Although certain changes occurred in the appearance of the head in different countries and centuries, it is always recognizable as the Buddha.
Courtesy, The Art Institute of Chicago

VENUS. Antonio Canova. C. 1800. White marble. Canova was famous for his portrait busts and statues, often commissioned by leading patrons of the arts of his time. Classical and mythological figures on pedestals were fashionable. As in classical Greek art, many of his sculptures, though three-dimensional, are conceived as a relief to be viewed from the front.
Courtesy, Walker Art Center, Minneapolis, Minnesota

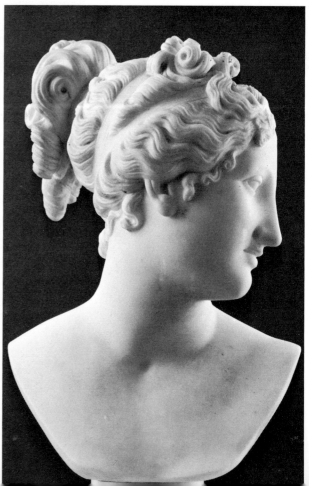

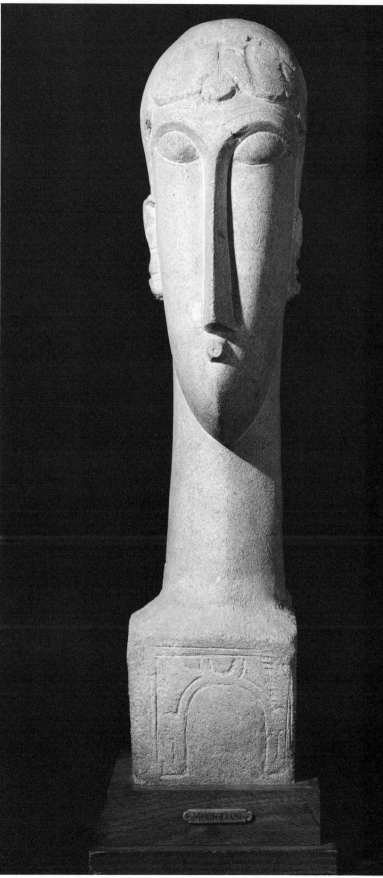

STONE HEAD. Amedeo Modigliani.
C. 1912. Stone. 25¾" high. Mo-
digliani had studied with Brancusi
and, though he had carved in wood
(the sculptures are now lost), he
was intrigued with direct stone
carving. The elongated linear forms
that characterize Modigliani's
paintings are carried into his sculp-
ture. The simplified eyes, brow, and
nose line can be traced to influ-
ences of primitive sculptures that
he also admired in the works of
Picasso, Lipchitz, and others.
*Courtesy, Philadelphia Museum
of Art*

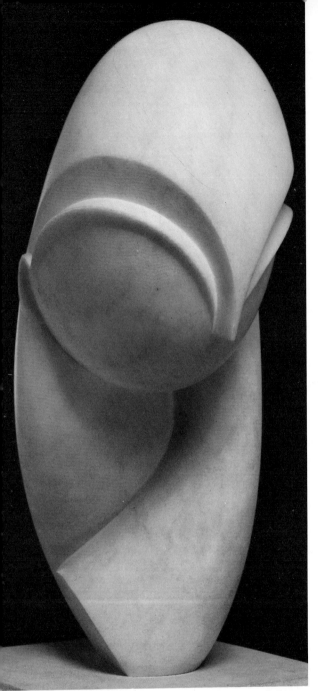

Today's sculptor is more likely to create a head that is first and foremost an interesting shape Brancusi's simplified ovoid heads of Mlle. Pogany set the stage for the elimination of minute details to catch the essence of a person's character. Masami Kodama's "Egyptian Portrait" is both a satirical and serious use of ancient ideas for today's statements.

To create a head from a block of stone one requires a thorough study of the relationship of the planes and curves of the face and head. The face is a very small portion of the entire head with high and low areas that flow into one another. There is no substitute for sketching the head and making carved models in clay before attempting to produce a specific portrait head in stone. Our supposed familiarity with the head belies the problems involved in working the form in three dimensions.

MLLE. POGANY. Constantin Brancusi. 1912. Pencil sketch. From this sketch, we get some idea of Brancusi's working methods.
Courtesy, Philadelphia Museum of Art

MLLE. POGANY. Constantin Brancusi. 1931. Marble on limestone base. 17¾″ high without base, 11½″ wide, 7¼″ deep. Brancusi did five versions of the portrait of Mlle. Pogany, each time simplifying the form more. In the drawing for the 1913 version, one can see the hands, head, and hair as separate entities. By 1931, when this marble sculpture was carved, the arms, head, and hair all flow together in unison. He said, "The curves sweep up from the base like a growing plant, enveloping the neck and giving the theme of the whole composition."
Courtesy, Philadelphia Museum of Art

VISION I. Elisabeth Model. 1963. Marble. The marble is carved as though there is a haze enveloping it; features are soft and not sharply defined. Observe the rougher texture and feeling of the outside of the stone as a contrast to the delicacy of the face.

Courtesy, Bodley Gallery, New York

HEIR. Charles Salerno. 1946. Italian alabaster. 11″ high.
Courtesy, Weyhe Gallery,
New York

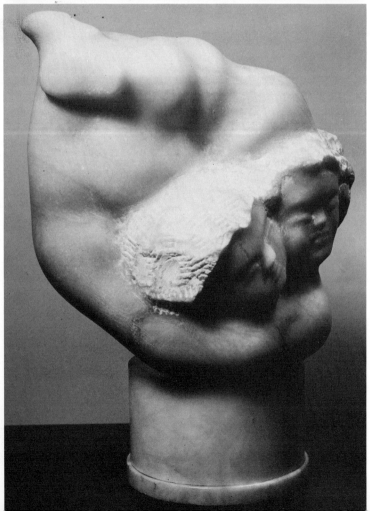

TWINS. Chaim Gross. 1953. Pink alabaster. 14″ high, 10″ wide.
Collection, Herbert Steinmann,
New York.
Photo, John D. Schiff

LANTERN. Pat Diska. 1969. Alabaster with light inside. 12″ high. *Courtesy, Ruth White Gallery, New York*

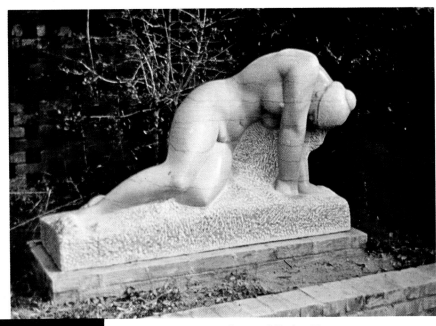

AWAKENING. Vincent Glinsky. Tennessee marble. 5′ 10″ long. *Courtesy, artist*

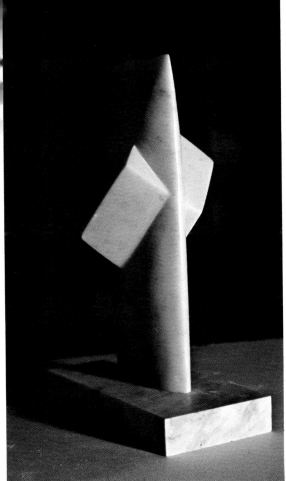

MAN. Winslow Eaves. 1969. Anondaga limestone. 4′ high. *Courtesy, artist*

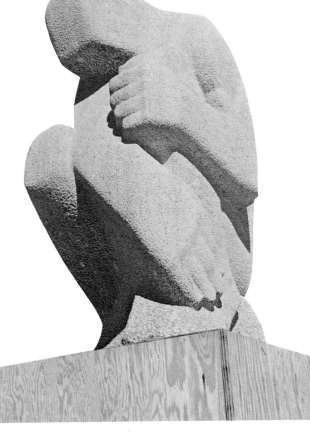

GEOMETRIC FORM. Masami Kodama. 1969. White marble. 12″ high, 6″ wide, 6″ deep. *Courtesy, Stephen Radich Gallery, New York*

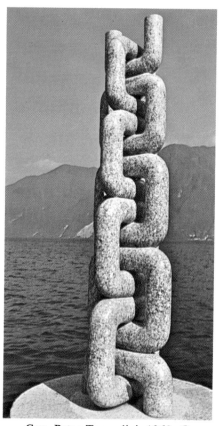

CAT. Peter Travaglini. 1968. Gran-
ite of Wassen. 78¾″ high.
Photo, Earl Elman

RELIEF IN RED. Thea Tewi. 1969.
Marble. *Courtesy, La Boetie, Inc.,
New York*

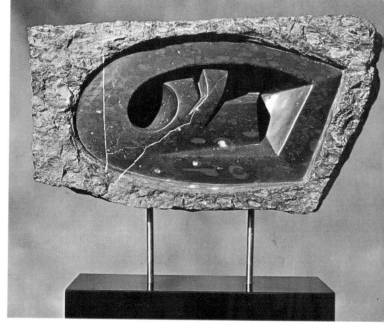

STONE MYTH. Dennis Kowal, Jr.
1969. Marble. *Courtesy, artist*

HEAD OF A YOUNG GIRL. Radau's Vanja. 1953.
Marble. 13" high.
 Courtesy, Moderna Galerija Zagreb, Yugoslavia

STEVEDORE. Frances Mallory Morgan. Limestone.
 *Collection, International Business Machine
 Corporation.
 Photo, Soichi Sunami*

THE MARTYR. David Hostetler. 1958. Alabaster. 18″ long.
Collection and courtesy, Miami Museum of Modern Art, Miami, Florida

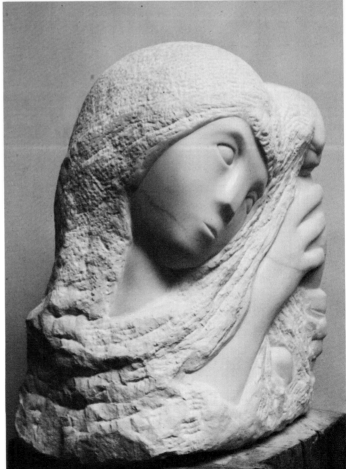

ALICE IN TUSCANY. Charles Salerno. 1967. White Carrara marble. 16½″ high, 14½″ wide, 10″ deep.
Courtesy, artist

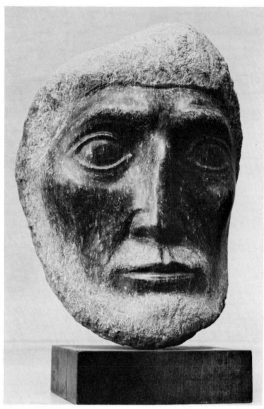

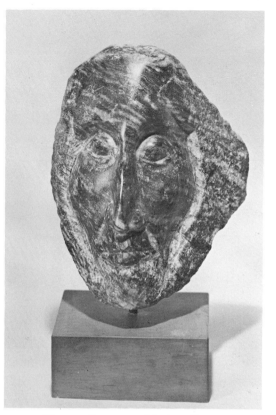

HEAD OF MICHELANGELO. William
Zorach. 1957. Porphyry.
Collection, Syracuse University,
New York.
Photo, Geoffrey Clements

WEARY PROPHET. Marian Dwyer.
1969. Maine limestone. 10″ high.
Courtesy, artist

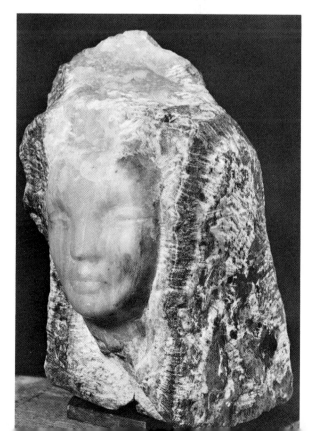

SOUL OF THE ONYX. Nasson Abisk-
hairoun (Gobran). 1958. Ameri-
can onyx.
Collection, Miss Cathy Cain,
New York.
Photo, Ray Manley

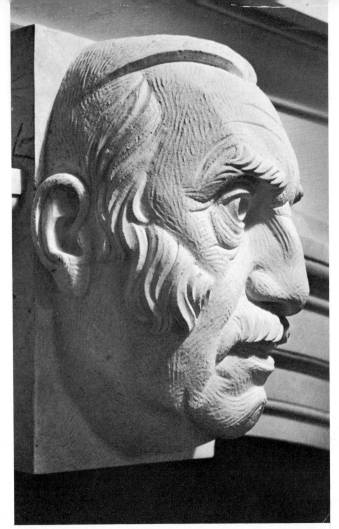

COLONEL WILLIAM DOVE. Alan
Collins. Portrait on keystone;
Church of St. Mary-le-Bow, Cheap-
side, London.

Courtesy, artist.
Photo, John Jackson

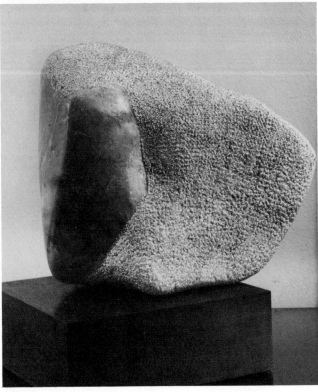

HEAD OF A GIRL. Masha Solomon.
1969. Green steatite (soapstone).
12″ high, 13″ wide.
Courtesy, Ruth White Gallery,
New York

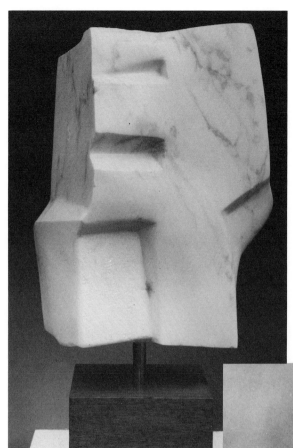

EGYPTIAN PORTRAIT. Masami Ko-
dama. 1967. Marble. 24″ high.
Courtesy, Stephen Radich Gallery.
Photo, Peter Moore

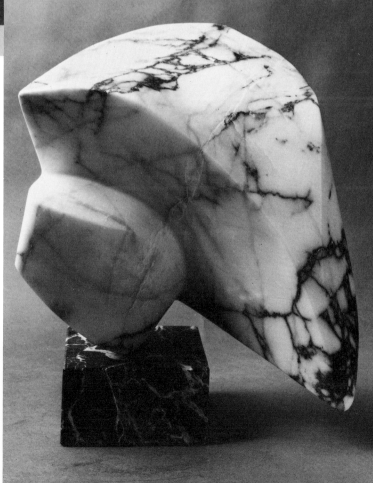

HEAD OF A GLADIATOR. Tadeusz
Koper. 1968. Paonazzo marble.
Courtesy, Grabowski Gallery,
London

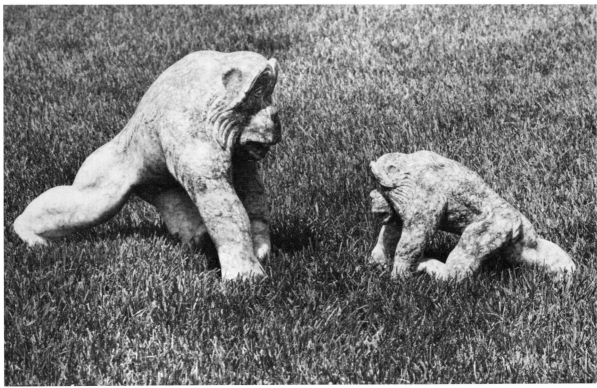

PLAYFUL GORILLAS. 1969. Gray alabaster. 18″ high.
Collection, Ben Lavitt, Highland Park, Illinois

ANIMAL AND PLANT FORMS

As far back as one can reach into history animals have been a top priority subject for sculpture. Whether their outlines were lightly etched in caves for hunting omens, or whether they were distorted into oddly swirling movements on the pots of the Chinese, they appear everywhere.

Because of the varying types of animals and the many contortions and subtle movements their bodies assume, almost any oddly shaped rock or boulder may be worked into an animal form with a little imagination. This was John Flannagan's forte in creating his animals from fieldstones. Cleo Hartwig, one of today's most prolific animal sculptors, says that within every stone there is an animal lurking, waiting to be released.

The beauty of creating animals is that often the stone itself will have veining or spots characteristic of a specific animal, and the ability to integrate the natural pattern with the form becomes an ultimate challenge for a carver. Abby Wadsworth will work a stone with a grinder until the patterns in the stone suggest the natural coloring of an animal; only then does she decide on the animal she will create. In Jane Wasey's "Moth," the stone's pattern appears as real, as though nature had intended it to be a moth. The same is often true for plant forms.

Animals permit latitude for expressions such as ferocity, playfulness, serenity, humor, surprise, pathos. They may be real, distorted, abstracted, and the result is almost always appealing, providing the work has all the sculptural essentials.

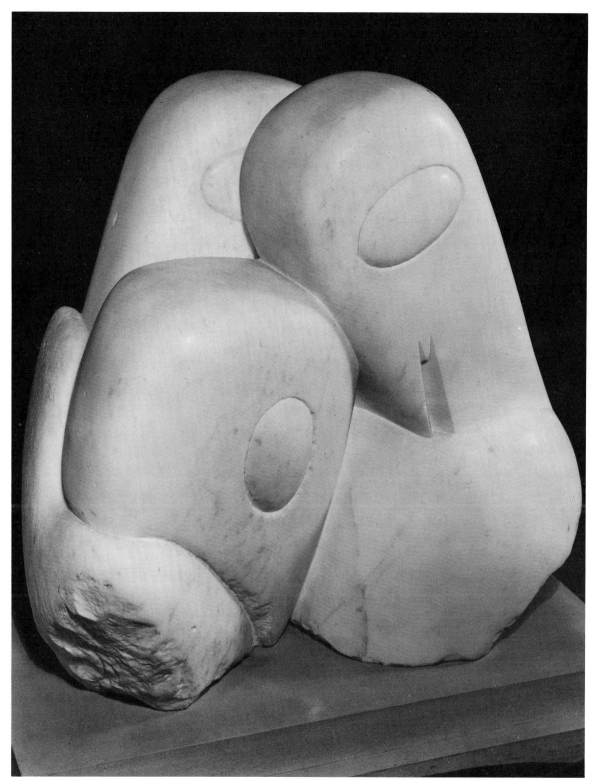

PENGUINS. Constantin Brancusi. 1914. Marble. 22½″ high, 12″ wide, 8¾″ deep.
Courtesy, Philadelphia Museum of Art

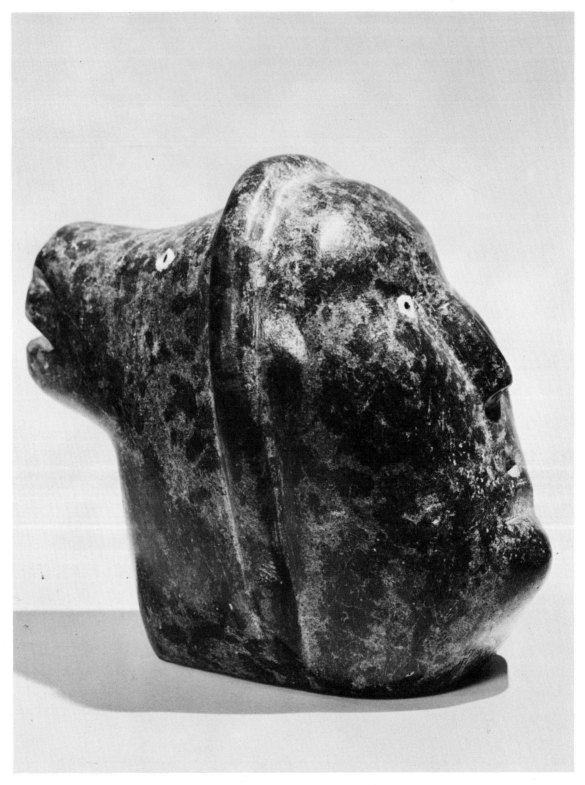

MAN AND DOG. Eskimo sculpture. 1968. Steatite (soapstone).
Courtesy, The National Film Board of Canada

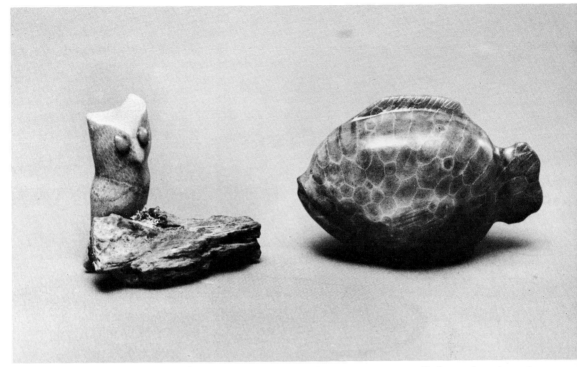

Owl and Fish. Abby Wadsworth. 1969. Owl is Iowa honeycomb on petrified wood. Fish is Michigan Petoskey. 4″ high.

Raw bauxite and Michigan Petoskey stones from which animals (above and next page) are created, using the same procedures as shown for hand carving, chapter 4. The artist employs tools which she has improvised for the purpose. Many are used by gem carvers.

To create animal forms from fist-sized rocks, Abby Wadsworth uses a polishing-grinding lathe with interchangeable wheels. Behind it is an exhaust system connected to a vacuum for exhausting the dust. She uses a mask and respirator when working because the stone dust is so fine and is thrown by the wheel.

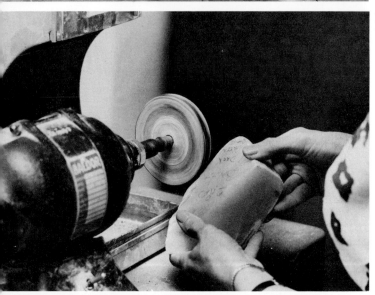

Press stone gently against grinding wheel until the form unfolds. If a flaw appears, as it did in this piece, the stone must be ground down much smaller than first anticipated. The sculptor may work for days on the grinding wheel to develop a form slowly. Oil or water is applied to the wheel while grinding to keep stone from heating and falling apart.

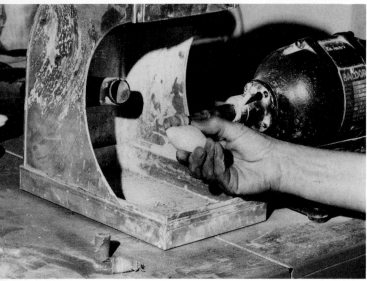

Either end of the lathe may be used with attachments that will handle large or small areas. Here the sculptor sands the bird shape with a sanding disc.

Next is to refine the shape with a hand drill using necessary discs to work up the shape of a wing, a bill, and other details. Water must be used with the drill to prevent burning the stone. The sculptor works at her kitchen sink.

A polishing unit used for lapidary work is perfect for polishing small sculptures. Water feeds from the trough above to keep the wheel and stone cool. A felt wheel is used with polishing powder (tin oxide), and because it sucks up water so rapidly, an extra sponge is used to add water as needed. A muslin wheel gets into small cracks and crevices. Very porous stones may require a silicone sealer.

FINISHED BIRDS. Abby Wadsworth. 1969. Bauxite and Michigan Petoskey. The grains are worked to resemble the natural coloring of the birds. They are mounted on wood or stone bases with clear epoxy glue.

Photos, author

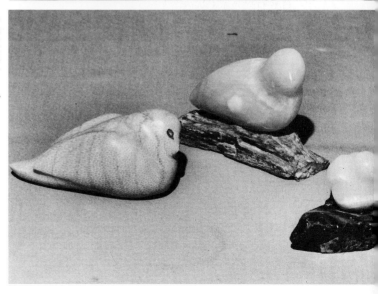

HANDICRAFT DEPARTMENT,
KING ALFRED'S COLLEGE,
WINCHESTER.

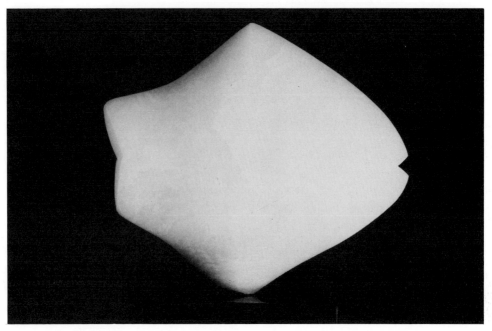

Fɪsʜ. Lobo. 1964. Green onyx. 16″ high, 18″ wide, 7″ deep.

Courtesy, Villand & Galanis, Paris

Rᴇᴄʟɪɴɪɴɢ Cᴀᴛ. William Zorach. 1941. Black Maine boulder.

Courtesy, Zorach children.
Photo, Peter A. Juley & Son

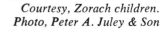

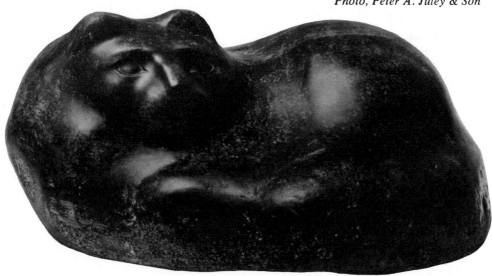

Moon Fish. Margo Liebes Harris. Vermont marble. 24″ long.

Courtesy, artist.

Caterpillar. Cleo Hartwig. Black marble. 24″ long.

Courtesy, artist

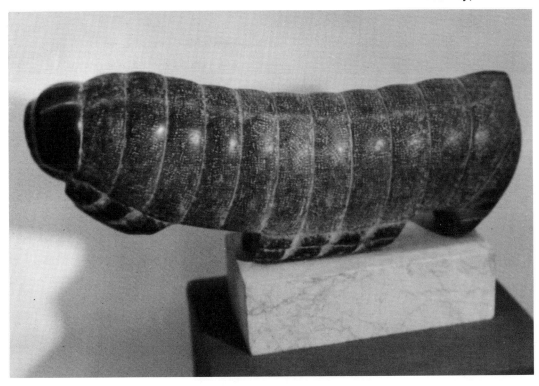

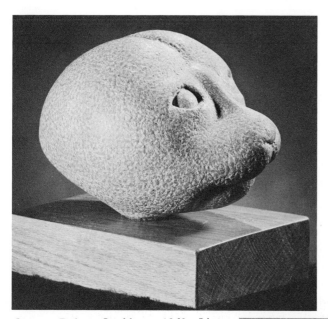

OTTER. Robert Lockhart. 1969. Lime-
stone. 8″ high, 10″ wide.
 Courtesy, Kovler Gallery, Chicago

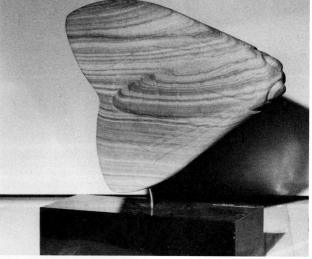

MOTH. Jane Wasey. 1968. Limestone on
black Belgian marble base. 9½″ high,
12″ long, 3″ deep.
 Courtesy, artist

PELICAN. Walter C. Driesbach. 1960.
Vermont marble. 20″ long.
 Collection, Mr. and Mrs. Harold
 Maloney, Kalamazoo, Michigan

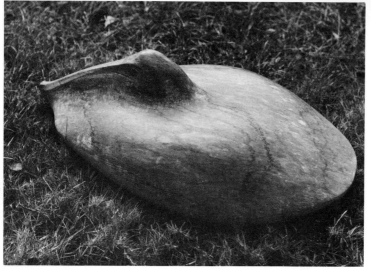

MOTH. Cabot Lyford. 1968. Granite beach stone. 14½″ high, 8½″ wide, 8″ deep.
Courtesy, Joan Peterson Gallery,
Boston, Massachusetts

SQUIRREL. Cleo Hartwig. 1967. Tennessee marble. 12½″ high.

Courtesy, artist.
Photo, Soichi Sunami

MUSHROOMS. Abby Wadsworth. 1969. Michigan Petoskey stones on wood bases.

◀ PLANT FORMS. Arline Wingate. 1968. Brownstone. 20″ high, 16″ wide, 16″ deep.
Courtesy, artist

PLANT FORMS. Arline Wingate. Brownstone. 20″ high, 16″ wide, 16″ deep.
Collection, Hirsch and Co., New York

LEAF OR BIRD. Jean (Hans) Arp. 1959.
Black polished marble on rough white
stone base. 24″ high.
Collection, Detroit Institute of Arts

DREAM FRUIT. Jean (Hans) Arp. 1965.
White marble on black marble base. 15″
high.
Collection, McCrory Corporation,
New York

HANDICRAFT DEPARTMENT,
KING ALFRED'S COLLEGE,
WINCHESTER.

FORMS. Juan Dolcet. 1969. Stone.

Courtesy, Galeria Juana Mordo, Madrid

chapter 7

Nonrepresentational Sculptures

The often posed question "What is a good sculpture?" is difficult to answer. A "good" sculpture might be more adequately termed a "successful" sculpture. Acquiring an appreciation for successful sculpture is more than a matter of taste or knowledge that the artist achieved what he set out to do. One learns to recognize successful sculpture by observing so much in museums and art books that he detects an unsuccessful one intuitively.

A successful sculpture exhibits sculptural characteristics including an original approach to the subject, shape, use of surface texture, lighting, and composition. It integrates all essential elements in such a way that there is a rhythm, a flow, an emotion, and a dedication of the artist to the idea he wishes to express. If space permitted and artists weren't sensitive, it would be revealing to illustrate unsuccessful pieces along with successful examples. Lacking these, the reader is advised to seek his own catalog of successful and unsuccessful examples. He should visit art galleries, local art fairs, and art schools, and train his powers of observation and comparative analysis. A comparison of the overornate sculptures of the eighteenth and nineteenth centuries with those

created by today's sculptors are so obvious in their differences that one feels a sense of personal discovery and revelation in the ability to analyze them.

Stone carvers have come a remarkably long way in their development of form in the twentieth century, and especially in nonobjective form. In this chapter, the illustrations should be approached with the idea that successful sculptures need not be recognizable as something. They may be interpreted in many ways. For instance, Dolcet's sculpture "Forms" might suggest flowing clouds or waves, or may be subtly suggestive of male and female. Andrea Cascella's interlocking shapes have a mechanistic feeling, yet they too interlock and nestle suggesting man and woman. The ovoid stark, geometric smoothness of Brancusi's "The New Born" might be considered symbolic of the birth of a new style in sculpture as well as of birth itself. Minoru Niizuma's magnificently developed stones have a quiet, solid, meditative mood, yet there is a flow and movement as of waves blown across the surface. They suggest immobility and mobility. They are designed to take advantage of changing light sources. There are rhythm, movement,

135

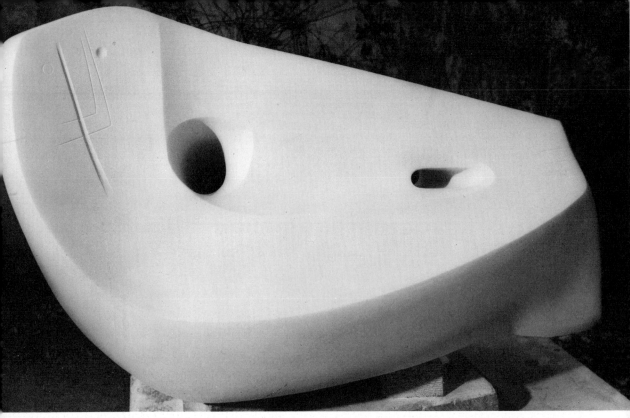

PASTORALE. Barbara Hepworth. 1953. White marble. 45″ long. Hepworth is dedicated to direct carving and is a great proponent of penetrating the mass of the material. This piece has a subtle flow of planes and an absolute perfection of surface. Basically, it is a geometric form.

Collection, Rijksmuseum Kröller-Müller, Holland.
Courtesy, Marlborough Fine Art Ltd., London

flow, emotion, contrast, all elements that combine for the success of a particular piece.

Herbert Baumann's forms explode and return to a central core and, though based on geometry, Baumann utilizes the square and circle in unique presentations. Though the mind knows stone is hard, Karl Prantl's sculptures fool our vision and completely negate the long preached philosophy of "truth to materials." His stones appear soft as a pillow, warm, inviting, and he calls them "meditation stones."

Leonard Agrons often works landscapes and a countryside into one stone, not in architectural detail, but with the suggestion and unerring placement of forms on a block that could be the earth itself.

The Japanese sculptors—Isamu Noguchi, Minoru Niizuma, and Masami Kodama—impose on stone a simplicity, serenity, quietude, and respect for materials that emanates from centuries of controlled oriental thought and action. Theirs is a presentation stripped of non-essentials and flourishes. One is drawn to them as irrevocably as one is drawn into a Japanese landscape.

Max Bill's geometric forms are emphasized by the stone he selects, almost equal in hardness to the bold idea presented. He has an unerring sense of scale and of knowing when to leave his stone alone. Jack White and Marie Taylor's mechanical images illustrate the use of the figure as a take off for concepts of man's environment and its meaning.

The French sculptor Ipousteguy appears to be laughing at man while having a great time expressing this in stone. In the final analysis, this is what sculpture is all about . . . the ability to convey to the viewer the artist's feeling and how he views his world.

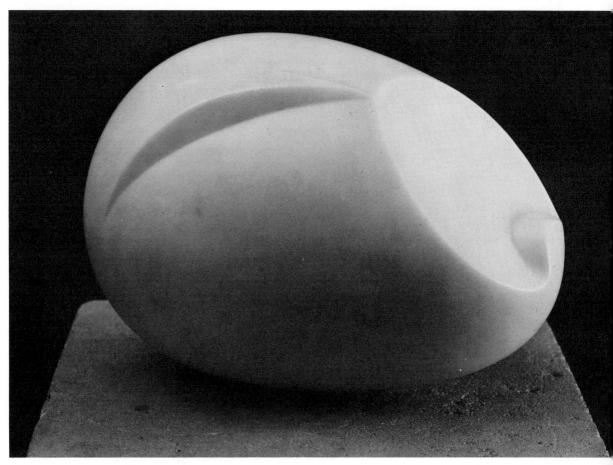

THE NEW BORN. Constantin Brancusi. 1915. Marble. 6″ high, 8⅛″ wide, 5¾″ deep. A series of egg-shaped forms was referred to by Brancusi as "Sculpture for the Blind," a title which expresses the artist's desire to give as much pleasure to the touch as to the eye. Here the egg shape suggests features. Later they were eliminated completely.

Courtesy, Philadelphia Museum of Art

STUDY FOR "THE NEW BORN." Constantin Brancusi. 1914.
Courtesy, Philadelphia Museum of Art

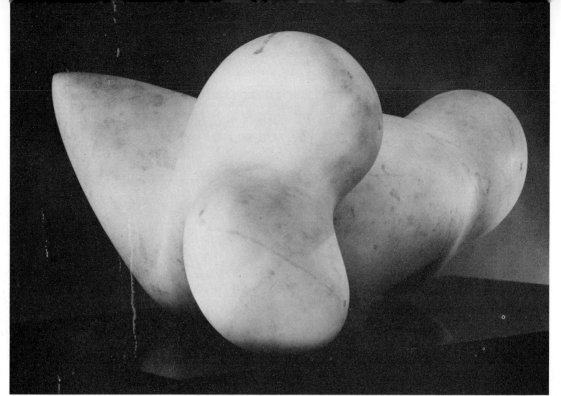

THE LION OF THE CYCLADES. Jean (Hans)
Arp. White marble. 20″ high, 24″ wide,
12″ deep.
*Collection, Montreal Museum of
Fine Arts, Canada*

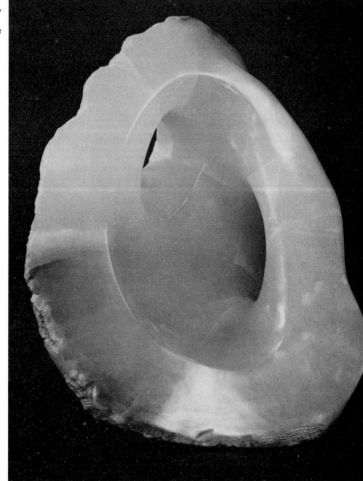

ALABASTER. Joseph De Noto. 1967. 30″
high.
*Collection, Mr. L. Oladell, New York.
Courtesy, artist*

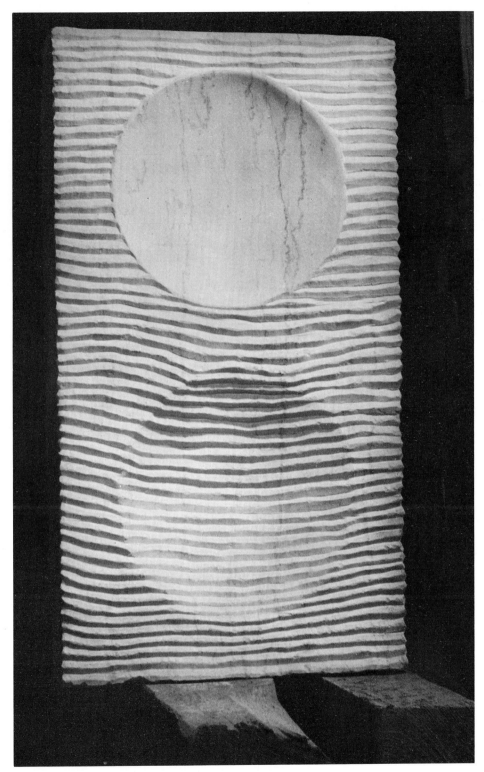

UNTITLED. Minoru Niizuma. 1968. Vermont marble.
Collection, Albright Knox Gallery, Buffalo, New York.
Courtesy, artist

GEBÄRDE. Herbert Baumann. 1964. Stone. 25″ wide.
Collection, National Gallery, Stuttgart, Germany.
Courtesy, artist

STONE FOR MEDITATION. Karl Prantl. 1965. Travertine.

Courtesy, artist.
Photo, Helmut Baar

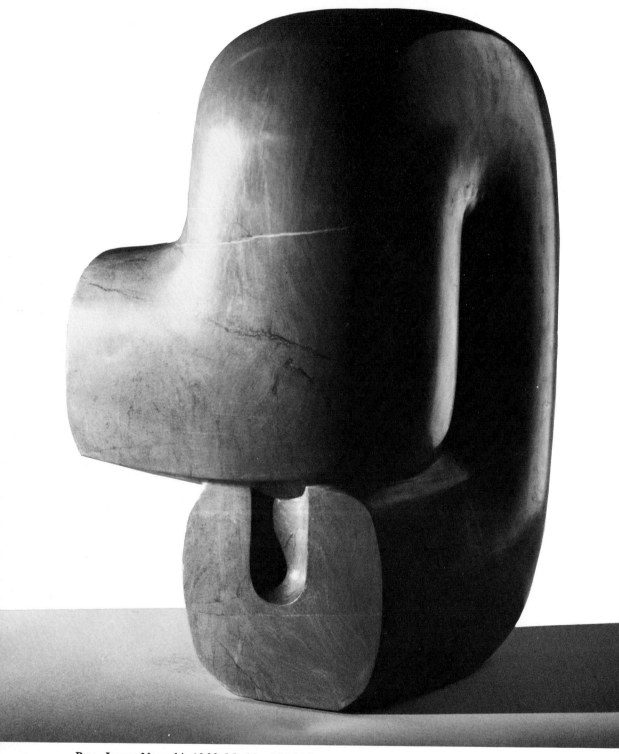

PISA. Isamu Noguchi. 1966. Marble. 15″ high.

Courtesy, Donald Morris Gallery, Detroit.
Photo, Benyas-Kaufman

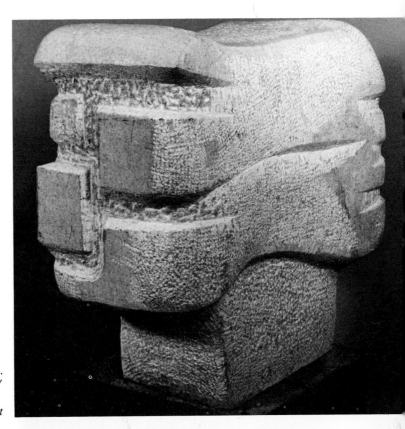

DOUBLEHEAD. Leonard Agrons. 1968. Georgia pink marble. 18″ high, 20″ wide, 10″ deep.
Courtesy, artist

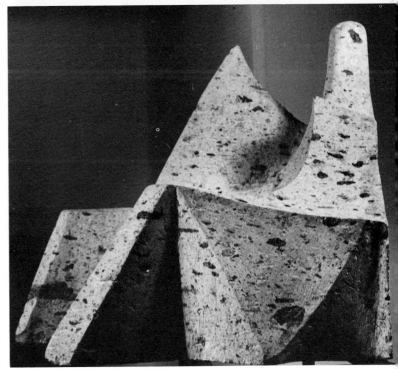

TEPOZTECO III. Angela Gurria. 1968. Cantera de Guadalajara stone.
Courtesy, artist

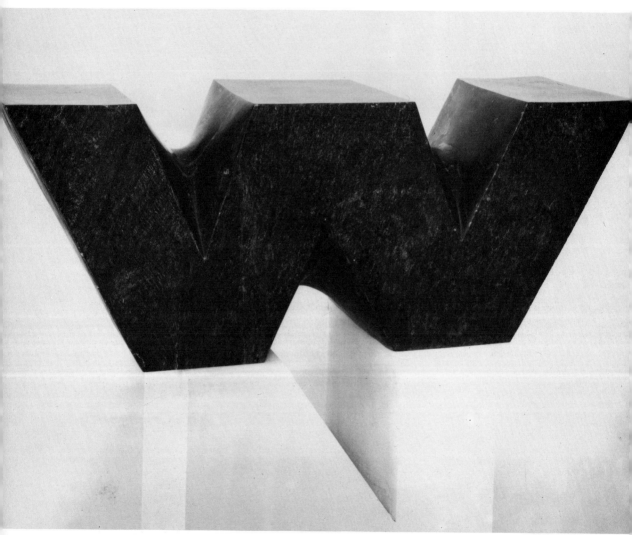

TWENTY-THIRD SIGN. Masami Kodama. 1968. Green marble. 18″ high. The artist has interpreted a series of English letters in stone. Note how the base repeats the shapes of the sculpture.

Courtesy, Stephen Radich Gallery, New York.
Photo, Peter Moore

CONSTELLATION. Thea Tewi. 1967. Mexican onyx on black Belgian marble. 58″ high. An unusual presentation of a sculpture as though floating in space. Also represents an incredible use of black Belgian marble, a very hard, dense stone.

Courtesy, La Boetie, Inc., New York.
Photo, O. E. Nelson

WHITE WIND. Minoru Niizuma. 1965. White marble on black wood base. 18¾″ high, 7½″ wide, 4″ deep. A pedestal-style base given a new twist by having the sculpture larger than the base. The base repeats the shape of the sculpture.

Collection, The Chase Manhattan Bank,
New York.
Photo, Jan Jachniewicz

UNTITLED. James Byars. 1960. Granite. 9″ high, 6½″ wide, 6″ deep.
Courtesy, Whitney Museum of American Art, New York

147

CONSTRUCTION OUT OF CIRCULAR RING.
Max Bill. 1964. Black granite. 15″ high,
15¾″ wide, 8″ deep.
Courtesy, The Art Institute of Chicago

METAMORPHOSIS. Frances Mallory Mor-
gan. Belgian marble. 17½″ high, 13″
wide, 6″ deep.
Courtesy, artist.
Photo, Soichi Sunami

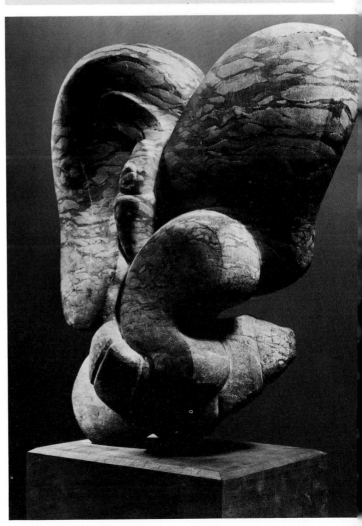

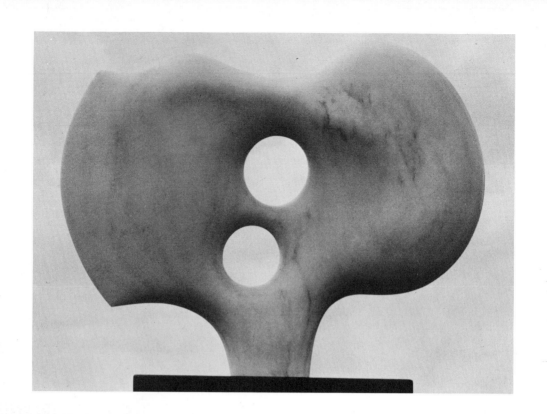

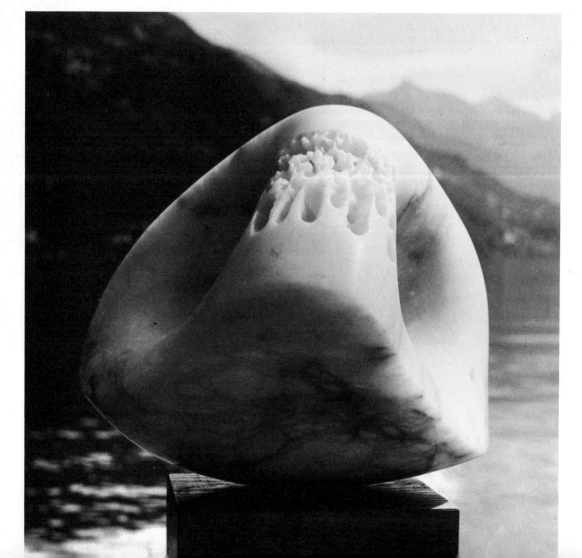

TORSO. Ralph Hartmann. 1969. Versa-stone (feather rock). 21″ high, 14″ wide, 12″ deep.
Photo, author

SYMPOSIUM ST. MARGARETHEN, AUSTRIA. Victor Rogy. 1964. Marble.
Courtesy, artist

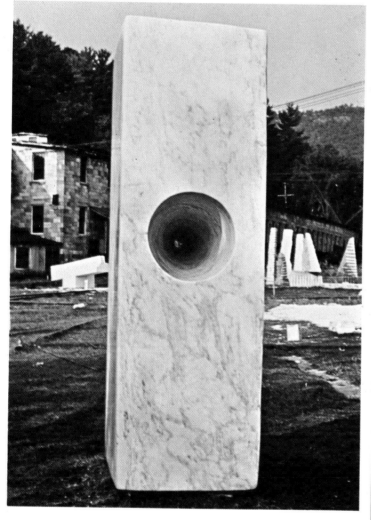

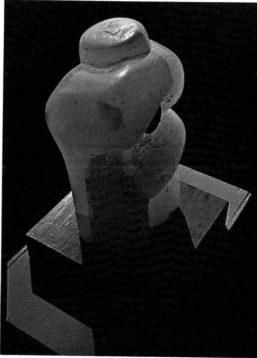

APARTHEID IRONY. Ruth Ingeborg Andris. 1968. Italian crystal white alabaster. 18″ high.
Collection, Mr. and Mrs. Bradley Steinberg, Chicago

HANDICRAFT DEPARTMENT,
KING ALFRED'S COLLEGE,
WINCHESTER.

STONE GROUP. Mary Bauermeister. 1964.
Courtesy, Galeria Bonino Ltd., New York

SONNENSCHEIBE, BERLIN. Herbert Baumann. 1961–62. Sandstone. 7' high. *Courtesy, artist*

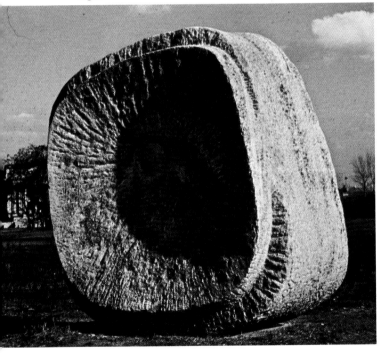

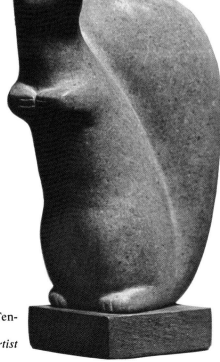

SQUIRREL. Cleo Hartwig. 1968. Tennessee marble. 13" high.
Courtesy, artist

◄
STONE WAVE. Dennis J. Kowal, Jr.
1968. Marble. 12″ high.
Courtesy, artist

◄
UNTITLED. Raffael Benazzi. 1964.
Alabaster. 12″ high, 14″ wide.
Courtesy, Gimpel & Hanover Galerie,
Zurich, Switzerland

FALLING WATER VI. Jack Zajac. 1967.
Gobbio marble. 87″ high.
Courtesy, Landau-Alan Gallery,
New York

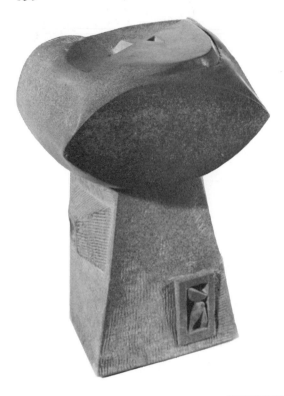

SUN DIAL. Marcelo Bonevardi. 1969. Limestone.
13½″ high, 10″ wide, 7″ deep.
Courtesy, Galeria Bonino, Ltd., New York.
Photo, Eric Pollitzer

SAMAYAKA. Tadeusz Koper. 1968. Bardillio of
Carrara.
Courtesy, Grabowski Gallery, London

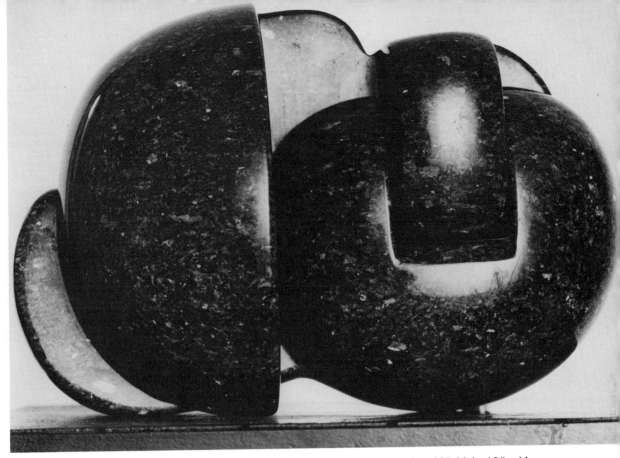

DOUBLE MORTISE. Andrea Cascella. 1968. Labrador black granite. 20″ high, 12″ wide, 12″ deep. Cascella's sculptures exhibit both a carved and constructed quality.

Courtesy, The Betty Parsons Gallery, New York

WARRIOR. Andrea Cascella. 1965. Atlantic black marble. 33″ high, 66″ wide, 30″ deep. Sculpture of interlocking forms.

Collection, Adele Sharpe Maremont, Arizona

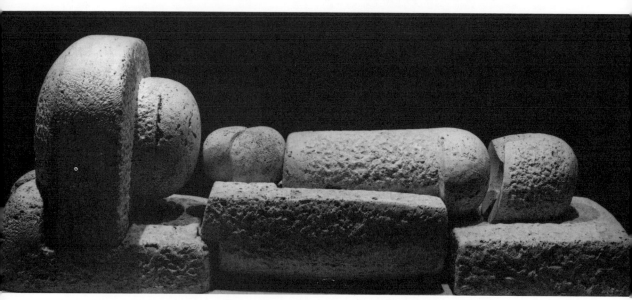

BIRTH. Pietro Cascella. 1964. Roman travertine.
Courtesy, Galeria Bonino, Ltd., New York

SUNRISE. Philip Pavia. 1966. Varied marbles. 6' high, 16' wide.
Courtesy, Martha Jackson Gallery, New York.
Photo, John D. Schiff

DUOMETRIC II. Harold Gebhardt. 1968. Blue alabaster. 31″ high, 36″ long, 14″ deep.
Courtesy, artist

THEME I. Harry Kivijärvi. 1968. Black granite. 3′2″ high, 3′8″ wide.
Courtesy, The Art Museum of Ateneum, Helsinki

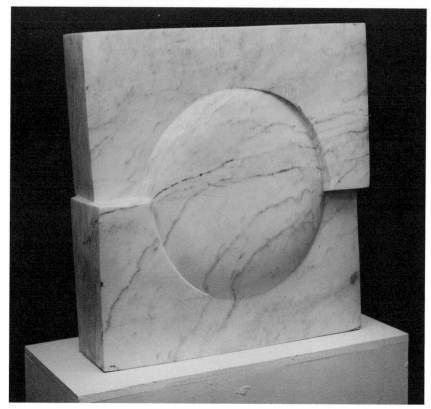

DISC INSCRIBED. Masami Kodama. 1968. Pink marble. 29″ high.
Courtesy, Stephen Radich Gallery, New York.
Photo, Peter Moore

PETITE PLACE AU SOLEIL. Émile Gilioli. 1961. White Carrara marble. 16″ high.
Courtesy, artist

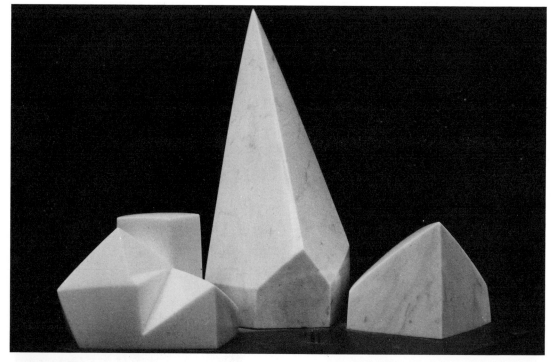

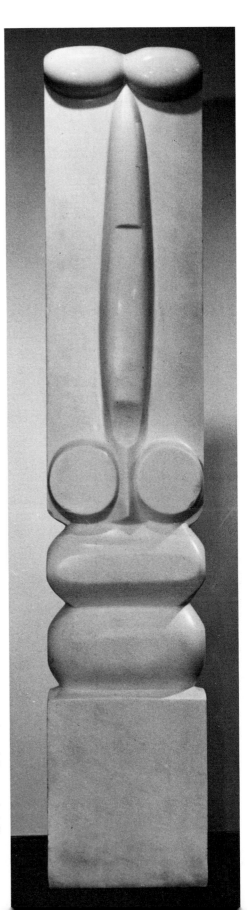

ORACLE. Marie Taylor. 1969. Green verde marble. 27" high.

Courtesy, artist.
Photo, Piaget

DEODATE. Jack White. 1966. Marble. 57½" high.
Courtesy, Lee Nordness Galleries, New York.
Photo, Nathan Rabin

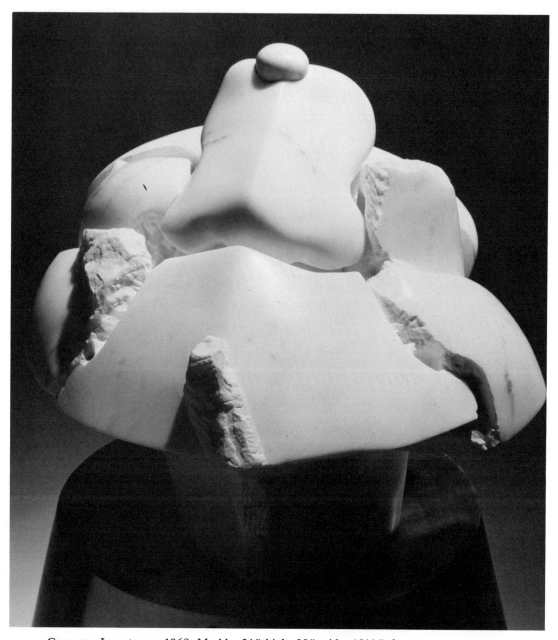

GOLIATH. Ipousteguy. 1968. Marble. 21″ high, 22″ wide, 19½″ deep.
Courtesy, Galerie Claude Bernard, Paris.
Photo, Vandor

GRAND COUDE. Ipousteguy. 1968. Marble. 26″
high, 16″ wide, 9½″ deep.
Courtesy, Galerie Claude Bernard, Paris.
Photo, Vandor

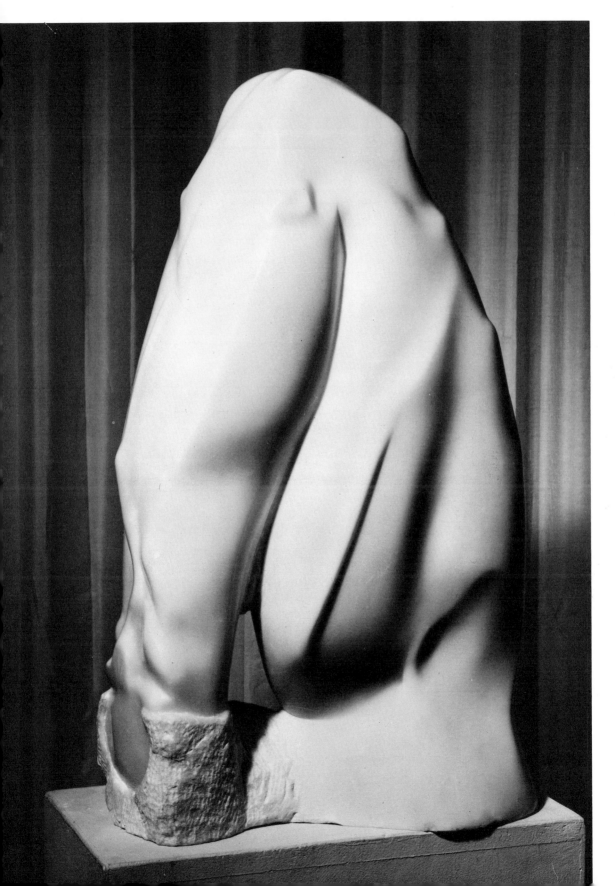

THE EVOLUTION OF A MARBLE SCULPTURE
Thea Tewi.
Courtesy, La Boetie, Inc., New York.
Photos, Cav. I. Bessi

Marble block being transported to the studio.

Marble block being carried into the studio.

The block is now outlined and partly cut.

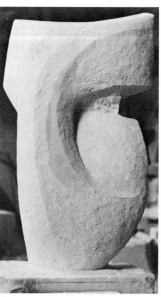

Front view of partly cut stone.

Back view of still unworked side.

Front view of the block in an advanced working stage.

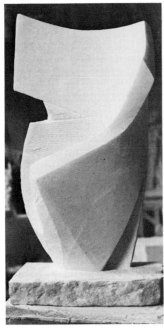 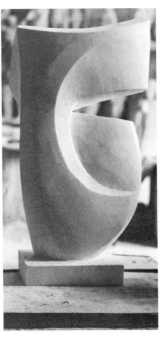 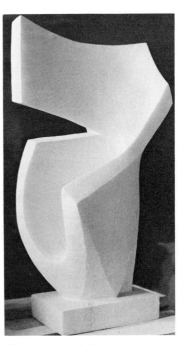

Back view of the block in an advanced working stage.

A further advanced stage showing the base cut.

Back view of the further advanced stage.

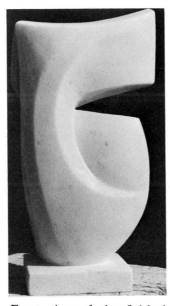 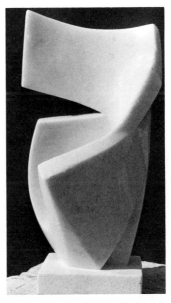

Front view of the finished sculpture, polished, and with the crystal markings in the marble in evidence. NIKE. White Naxos marble, approximately 30″ high, 15″ wide, 8″ deep.

Back view of the finished sculpture.

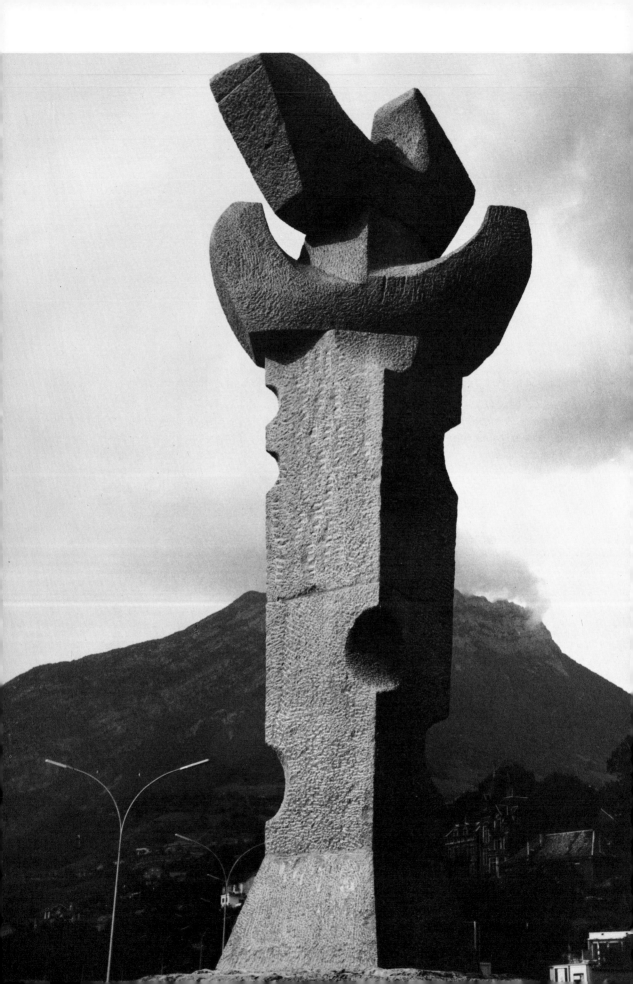

Monumental-Architectural Sculptures

Not so long ago, a monumental sculpture was one that perpetuated the memory of a person or event. Such sculptures, still in evidence in every city, are those that commemorate historic, literary, or scientific events such as military victories, signing of treaties, discoveries of new land. There are memorials to statesmen, soldiers, pets, martyrs; sculptural monuments meant to decorate a city; and all funerary sculptures, whether built within the walls of a cathedral or in the open. These monuments exhibit idealistic, realistic, pictorial representations, often fashioned after classical, romantic, and baroque styles.

Today's monumental sculpture is assuming a new identity. More often monumentality refers to size or sense of scale. The monumental sculpture is not necessarily created for a specific commemorative commission but as an expressive creative endeavor by the sculptor. It gives him an opportunity to work large. If the piece is purchased for use with a building, it becomes, by virtue of placement, an architectural sculpture.

Until 1960, the stone sculptor who wished to work on a large scale could only hope for a commission because large stones are costly to buy and transport. Even then the sculptor was often strapped by the demands of a committee or a preconceived subject. Only a few abstract stone sculptures were created for architectural use. Architects felt their buildings were in themselves the ultimate in sculpture and required no other freestanding work to enhance them.

Slowly, the attitude toward the monumental sculpture is changing, much of it directly traceable to a unique phenomenon called "the sculpture symposiums."

THE SCULPTURE SYMPOSIUM

In 1958, Karl Prantl, an Austrian stone sculptor dedicated to direct carving, conceived the idea of inviting sculptors from different countries to come and execute monumental works with complete freedom as to theme and form. Working in an abandoned quarry in St. Margarethen (Burgenland) and soliciting private funds, he invited sculptors from Yugoslavia, Israel, Japan, Canada, and elsewhere. They were given room, board, and materials for a fixed period with the understanding that the symposium would attempt to sell the sculptures (many were sold), the proceeds to go to the artists after costs were deducted.

So enthusiastic was this first young group of sculptors that many went home and organized similar symposia sponsored by government, industry, private funds, or a combination of all three. Since then, symposia have been held in Yugoslavia, Czechoslovakia, Japan, Germany, Austria, Israel, and the United States.

Yasuo Mizui, who has attended several symposia, believes they have helped the stone sculptor produce and display his work more widely in recent years. "Perhaps," he says, "it was only a natural outcome of the nature of the art, but it was also a product of the en-

OVERTURE DANS L'ESPACE. Morice Lipsi. 1967. Bretaigne granite. 11 m. high. Located at the edge of Grenoble at the expressway to Lyon, France.

Courtesy, artist.

Photo, Pierre Joly-Vera Cardot

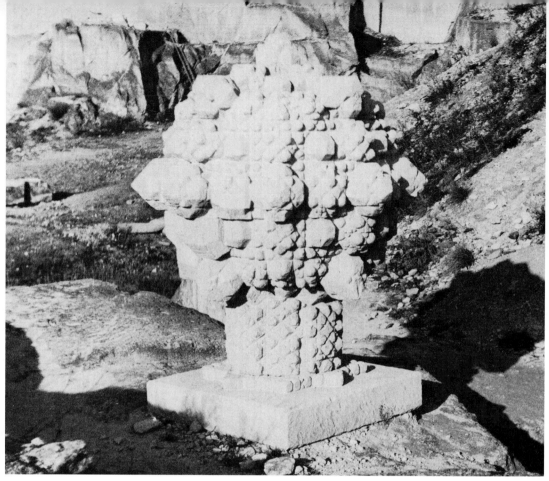

SYMPOSIUM ST. MARGARETHEN. 1962. Fritz Harlauer. Austria.
Courtesy, Symposium St. Margarethen, Austria

thusiasm of the younger generation of sculptors and of the deep understanding of sculpture shown by the public at large."

The symposium offers a new scope to both the young sculptor and the established one. Morice Lipsi, who has spent over half his long life working in stone and has executed many open-air works for parks in Switzerland and France since 1912, attended the symposium in Manazuru, Japan, for three months in 1963. It was the first time he had worked so close to the sea. The twin works he produced entitled "Oceanique" exhibited a new phase for him. It also enabled younger men to observe how another sculptor works. For example, Lipsi first places the piece of stone on which he is going to work in a very unstable position, then tilts it and rocks it so as to achieve, by a peculiar magic of his own, the final balance of the finished work.

Among the advantages of the symposium is that the sculptor works outdoors in the environment of the stone. Usually he is close to a quarry and has available to him the facilities and help of people who work in the quarry. For a young sculptor, the symposium offers a rare opportunity for creating a large-scale piece without having to consider a possible buyer's taste. The artist is his own master; he is willing to tolerate sun, sand, and wind for that freedom of expression.

The symposium environment allows for an exchange of ideas and working methods. As the years have passed since the first symposium in 1959, it is interesting to observe how sculptors have evolved into groups or categories of work. For instance, one group bases its work on a religious symbolism. Karl Prantl's stones with their indentations and protrusions suggest a pious symbolism. Herbert Baumann's

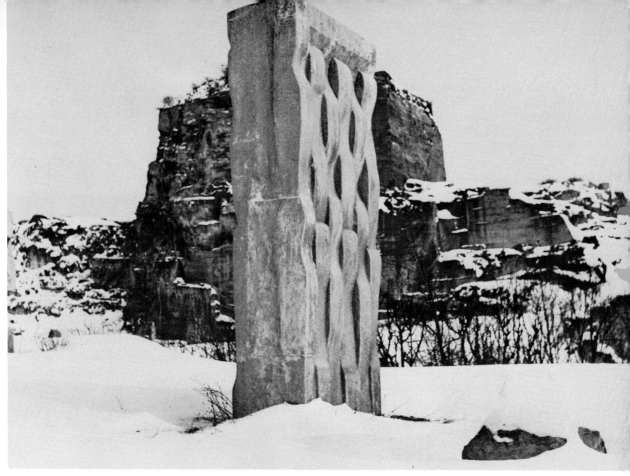

SYMPOSIUM ST. MARGARETHEN. 1960. Joachim Fritz Schultze. Berlin.
Courtesy, Symposium St. Margarethen, Austria

round shapes have an intense emotionalism about them. Erich Reischke's pillars could be totem poles of some super religion. And Pat Diska's huge stones seem to achieve a life nurtured by their setting.

The second group seems more intellectually inspired; its sculptures are symbols that represent man's environment more than his beliefs. Barna von Sartory creates works one can walk into, through, and around. Philip Pavia's assemblages are strong, powerful, and symbolic of today's complexities.

Symposia are open to sculptors who wish to participate and would benefit by the association. Paul Aschenbach, who helped organize the Vermont Marble Company's Symposium at Proctor, Vermont, in 1968, believes that the sculptor who participates in a symposium must be "one who is flexible and able to work and solve problems under strange and often adverse conditions. Symposium sculptors are resourceful and able to adapt conceptions to the material and technology available. They are able to retain identity while working in a group without being ego prone and temperamental. They are willing to help each other and respect each other's often difficult points of view. They work long and swiftly and should be able to judge their time and energy so that a projected concept can be completed within the symposium. Nothing is more sad than a work which runs overtime and is left incomplete. The artist should be able to work with people watching and be patient with many sincere but often uninformed questions from the public.

"Symposium sculptors tend not to feel competitive; each with confidence does his own thing. These artists seem not to be preoccupied with negative and literary statements but rather

163

they stress the positive. There is a great feeling of affirmation about a symposium. Because pieces tend to be large, heavy, and not 'take-homeable,' symposium sculptors are used to walking away and leaving their sculpture, often with little immediate financial return."

At present there is no general clearing house for sculptors who wish to participate in a symposium. Those who do participate usually hear about it by word of mouth or by recommendations from other sculptors. One should write to the St. Margarethen Symposium, Burgenland, Austria, for information about current symposia. The procedure is to contact those in charge and send slides of your work and a résumé.

Some symposia are created to answer specific needs and are sponsored by industries or universities. For instance, one held at the California State College, Long Beach, California,

included work in several media. The participants acted as artists in residence for the students, and the sculptures remained on the grounds of the university. Mexico City held a symposium in concrete and Tokyo held one in steel. They were planned to complement an Olympic meeting in Mexico and the World's Fair in Tokyo.

In the following pages, one can observe the sculptural expression motivated and stimulated by the sculptural symposium. One will also find examples of the second half of the twentieth-century new monumental sculpture. It is rapidly moving to long-overdue placement with architecture, at entrances to parks, and as eye-respite sources along our virginal, unbroken ribbons of concrete highways. As sculptural taste advances, uses and appreciation of such sculptures are bound to grow with it. It's an exciting development to anticipate.

SYMPOSIUM ST. MARGARETHEN EUROPE BILDHAUER. 1962. Peter Sze'kely, France.
Courtesy, Symposium St. Margarethen, Austria

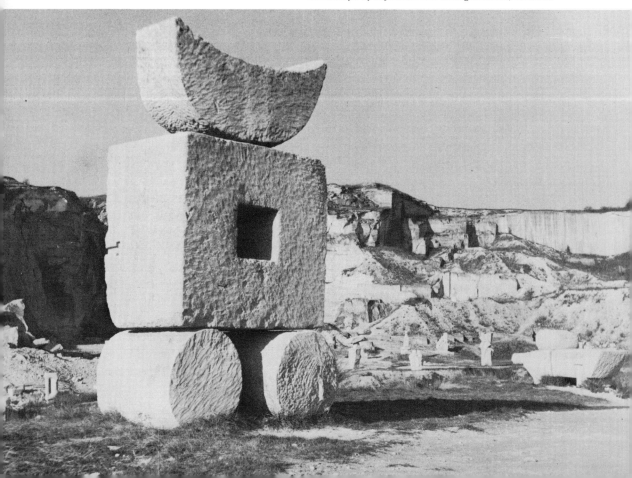

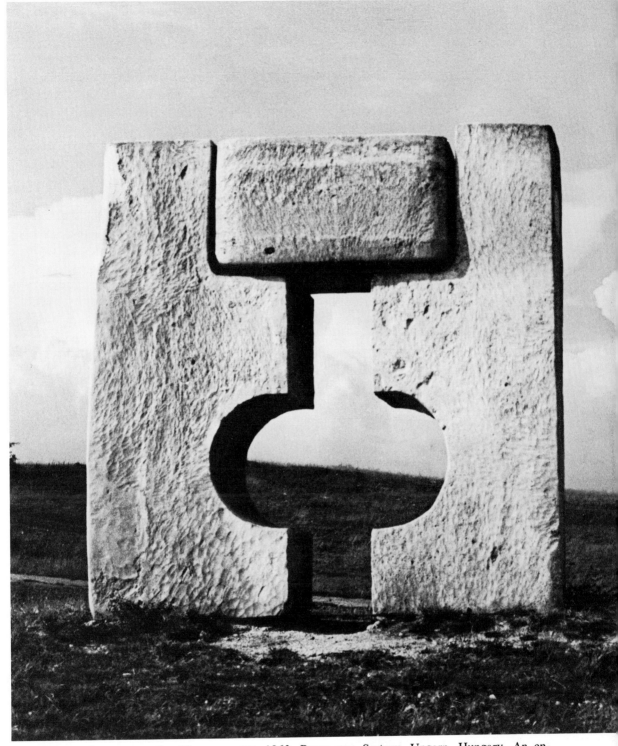

SYMPOSIUM ST. MARGARETHEN. 1963. Barna von Sartory. Ungarn, Hungary. An environmental sculpture made so one can walk through it.

Courtesy, Symposium St. Margarethen, Austria.
Photo, Helmut Baar

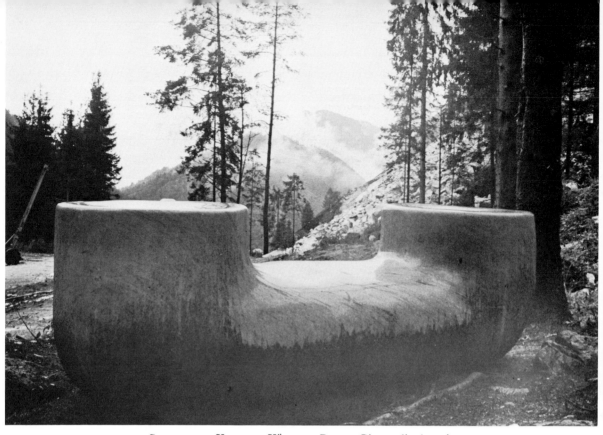

SYMPOSIUM KRASTAL KÄRTEN. Bruno Gironcoli. Austria.
Courtesy, Symposium St. Margarethen, Austria

ST. MARGARETHEN II. 1966. Hashime Togashi. Japan.
Courtesy, Symposium St. Margarethen, Austria.
Photo, Helmut Baar

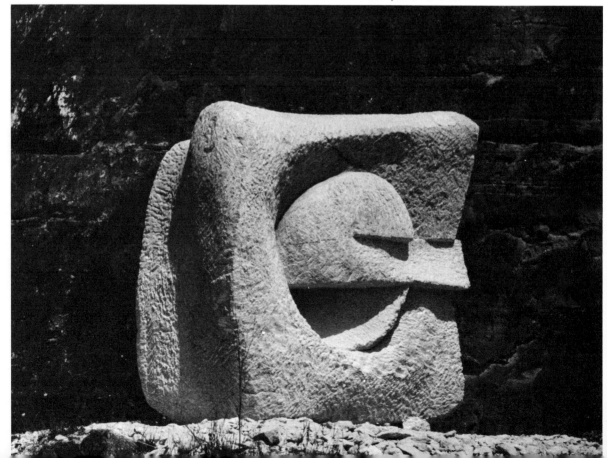

SCULPTURE OF TWO PIECES. Barna von Sartory. 1966. Travertine. Symposium Vysne Ruzbachy, Czechoslovakia. Says Sartory, "We have fallen into sleep, but we wake up by movement. I am doing sculptures which call for movement. One can walk through them and play in them and comprehend them from inside. Their measures are taken by our step." (Two views.)

Courtesy, artist

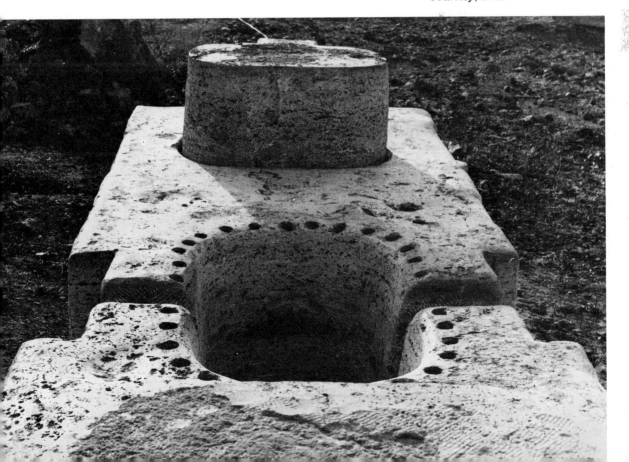

UNTITLED. Karl Prantl. Austria. 1962. Symposium in Mitspe Ramon, Negev, Israel.
Prantl's aim is a "wordless intelligibility," with his forms creating a universal vocabulary.
Prantl bases his work on the power of the spiritual sign, while other sculptors work with
organic forms or human figures. He creates icon-like pure abstractions. His stones have
a sense of repose or arrested movement.

Courtesy, Symposium St. Margarethen, Austria

UNTITLED. Karl Prantl. Austria. Symposium St. Margarethen. 1964–1965. Sandstone. Approximately 6′ square.

Courtesy, Symposium St. Margarethen.
Photo, Helmut Baar

SYMPOSIUM SCULPTURE. Karl Prantl. Austria. Vermont International Sculpture Symposium, 1968. Vermont West Rutland white marble. A meditation stone divided into five subtle convex surfaces with indentations, modulations, and forms that flow with the green and white veining.

Courtesy, "Mill 21," Vermont Marble Company, Proctor, Vermont

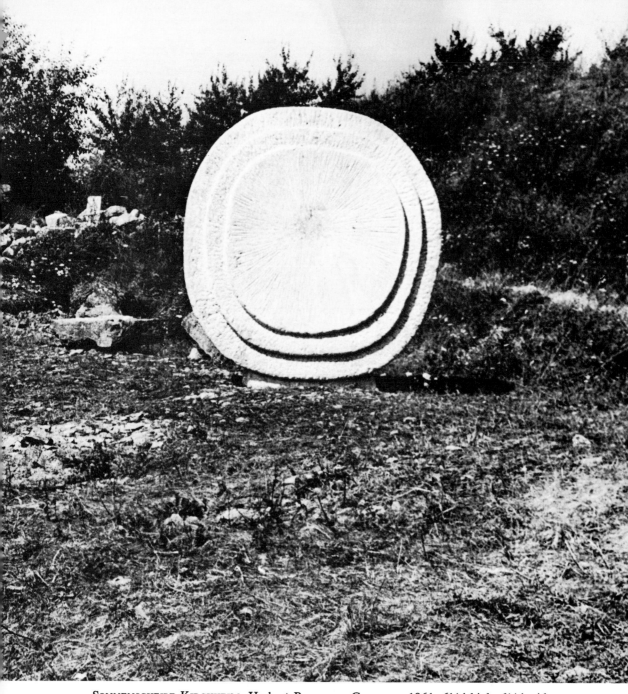

SONNENSCHEIBE KIRCHHEIM. Herbert Baumann. Germany. 1961. 6½' high, 6½' wide.
Created at International Symposium for sculptors in Kirchheim über Würzburg, Germany. Now standing in front of the Phillips-Museum "Evoluon" in Eindhoven, Holland.
Baumann works almost exclusively with the point. He is concerned with moving toward
the center of the stone to achieve an explosiveness. (Three views.)

Courtesy, artist.
Photos, Abisag Tüllmann

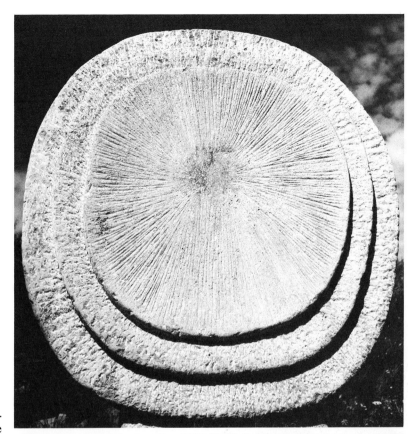

One feels drawn to the dynamic core of the sculpture as it simultaneously draws in and explodes.

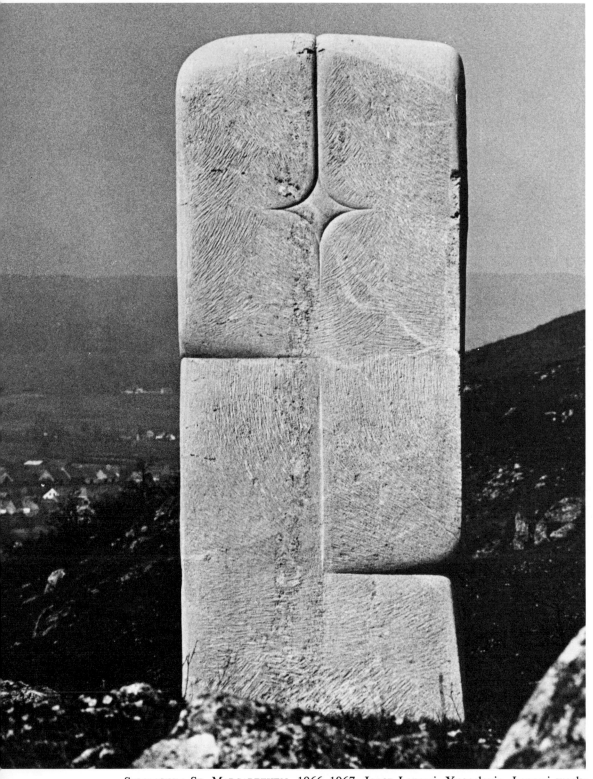

SYMPOSIUM ST. MARGARETHEN. 1966–1967. Janez Lenassi. Yugoslavia. Lenassi works with large flat planes into which are carved splits and curves that suggest penetrations into the material.

Courtesy, Symposium St. Margarethen, Austria.
Photo, Helmut Baar

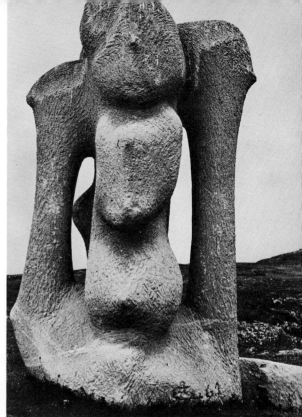

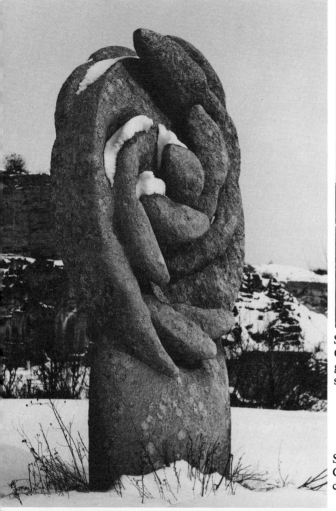

SYMPOSIUM ST. MARGARETHEN. 1961. Auguste Cardenas. Cuba. The form is open; and it disguises the mass and ponderability associated with stone.

Courtesy, Symposium St. Margarethen, Austria.
Photo, Hannes Pflaum and Michael Pilf

SYMPOSIUM ST. MARGARETHEN. 1961. Ursula Sax. Germany. Nestling, curving, unfolding shapes that catch light and shadow and snow.

Courtesy, Symposium St. Margarethen, Austria

HANDICRAFT DEPARTMENT,
KING ALFRED'S COLLEGE,
WINCHESTER.

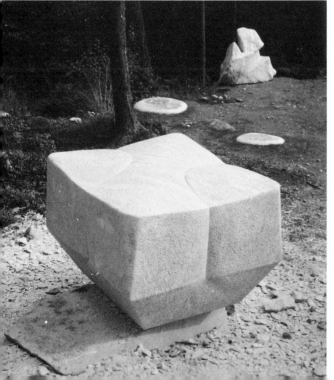

SYMPOSIUM KRASTAL. Austria. 1967. Janez Lenassi. Yugoslavia.

Courtesy, artist

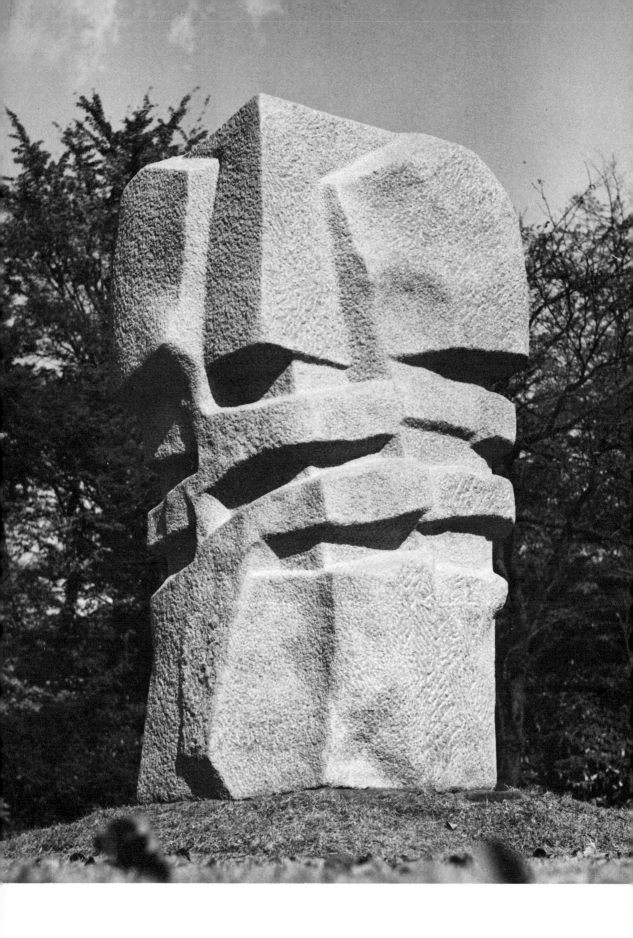

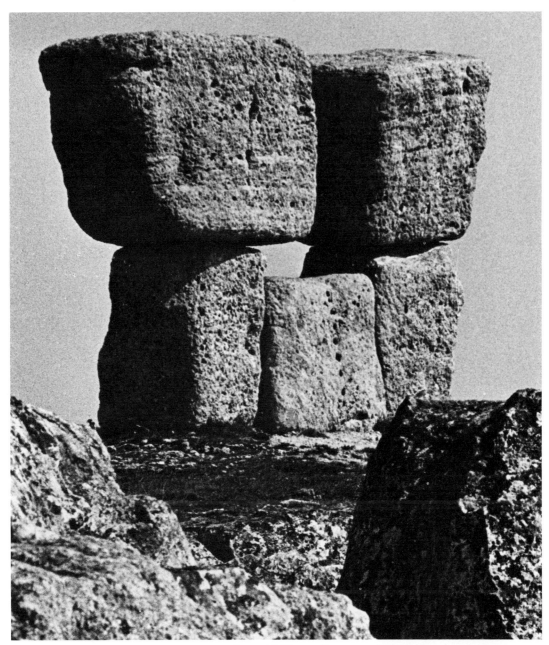

SYMPOSIUM ST. MARGARETHEN. 1964. Rolf Jörres. Germany. 8' high.
Courtesy, Symposium St. Margarethen, Austria.
Photo, Helmut Baar

◀
MICHINASHI. Yasuo Mizui. Japan and
France. 1963. Basalt lava. 8½' high.
Courtesy, artist

HOMAGE TO OSKAR SCHLEMMER.
Hans Steinbrenner. Germany.
1966. Basalt. 4' high.
Courtesy, artist

SCULPTURE GROUP. Leo Korn-
brust. Germany. 1965. Three pieces
in limestone.
Courtesy, artist

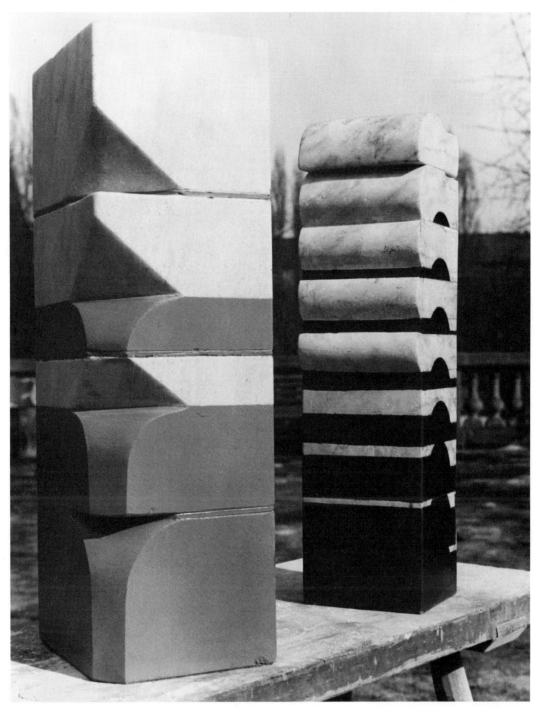

104 SEGMENTE (right); 101 STELE (left). Erich Reischke. Germany. 1969. Marble with blue paint. Reischke is concerned with creating order between organic and geometric forms and creating an environment which invites the viewer's involvement. He often assembles carved blocks of marble, then paints them for greater interplay of color, surface, and form.

Courtesy, artist.
Photo, Jacques Sehy

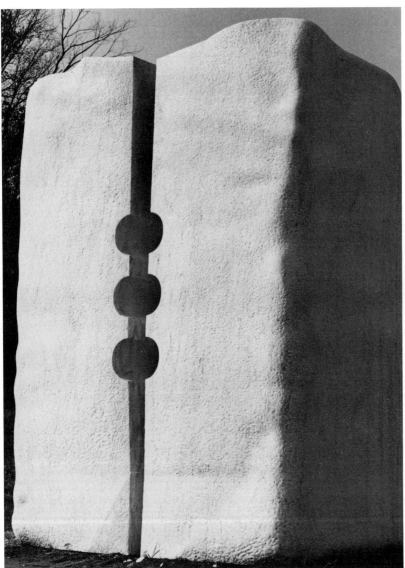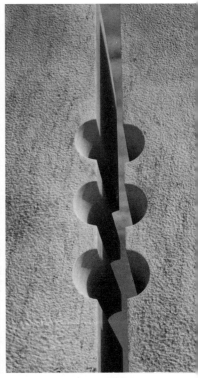

VERMONT MARBLE SYMPOSIUM. 1968. Janez Lenassi. Yugoslavia. Vermont Danby white marble. 7′ high, 9½′ wide, 5′ deep. The surface edges are rounded and gently undulate, while the central split contains hard-edged semicircles for contrast. Because the entire block has been split, the sculpture achieves a great integration of mass and space. The detail illustrates the shadow patterns created.

Courtesy "Mill 21," Vermont Marble Company, Proctor, Vermont

GROBER STEIN. Joachim-Fritz Schultze. Germany. 1962. Marble. Symposium Europäischer Bildhauer, Berlin. 9′8″ high. (At rear, Herbert Baumann's "Sonnenscheibe Kirchheim.")

Courtesy, artist

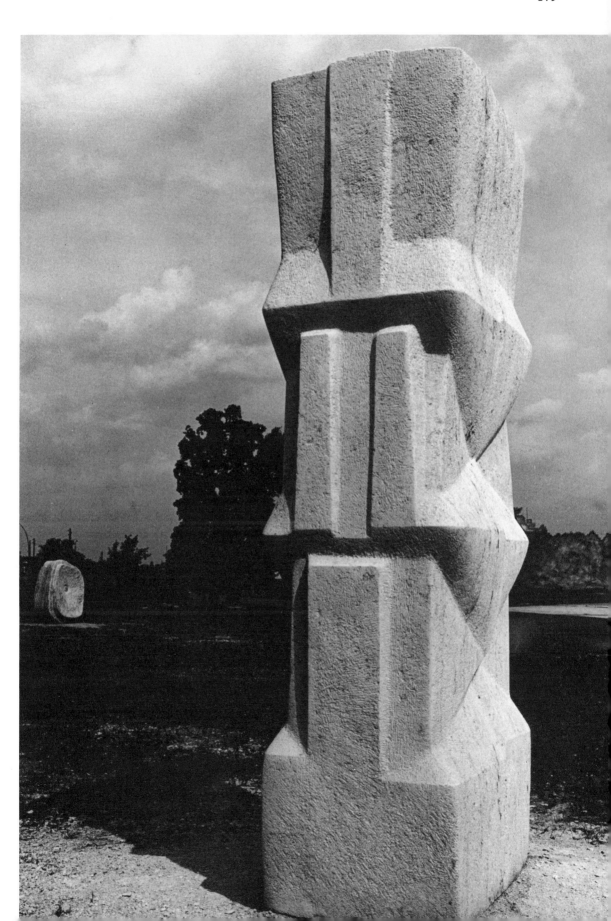

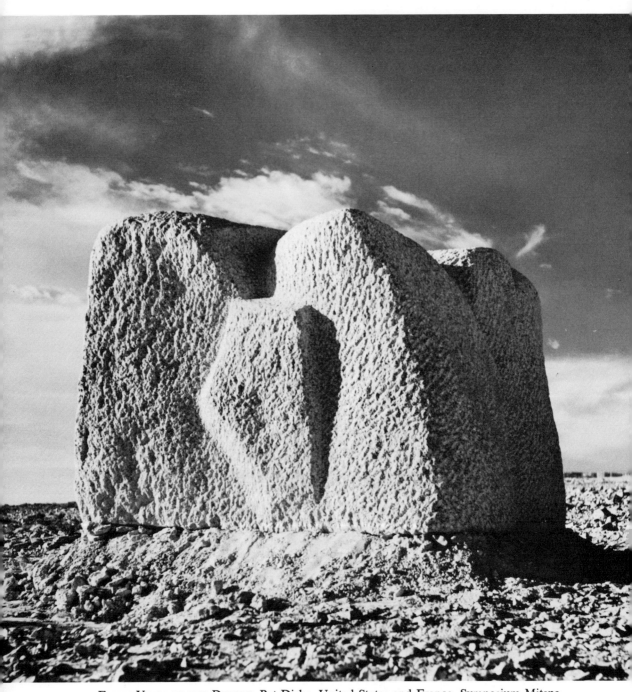

FORTY YEARS IN THE DESERT. Pat Diska. United States and France. Symposium Mitspe Ramon, Israel. 1962. Pink Eilat granite.

Courtesy, Ruth White Gallery, New York

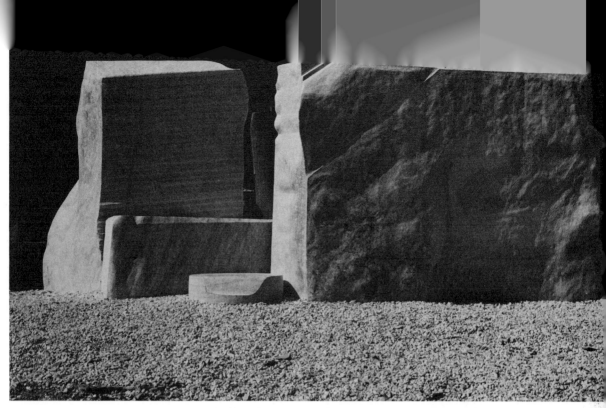

YIN AND YANG. Erich Reischke. Germany. 1968. Marble. 7' high. Three pieces.

Courtesy, artist

SYMPOSIUM ST. MARGARETHEN. 1966. Werner Mach. Germany. Organic forms and the subtle curvatures and bulges that might suggest the figure also.

Courtesy, Symposium St. Margarethen

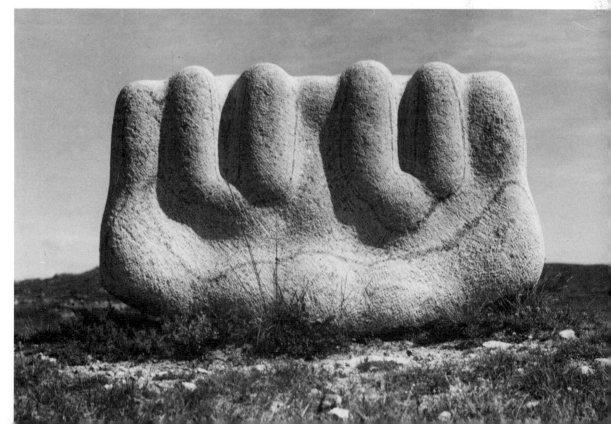

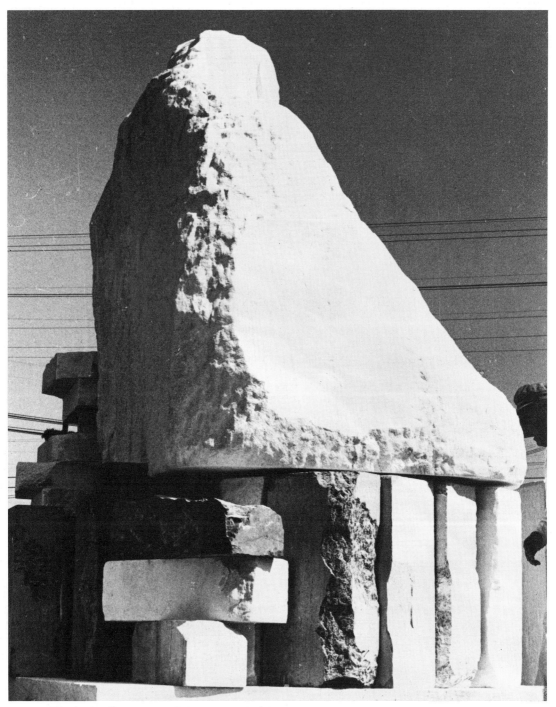

VERMONT SCULPTURE SYMPOSIUM. Philip Pavia. United States. 1968. Main piece—
Vermont Danby white marble; other pieces—Lancaster pink and Vermont radio black
marble. 9½′ high, 10½′ wide, 7½′ deep. A composite of about thirty pieces of stone
ranging in size from 180 pounds to 17 tons. Color plays an important role in this huge
assemblage; stones include reds, whites, and grays. The constantly changing play of
light and shadow causes new dramas every few minutes.

Courtesy, "Mill 21," Vermont Marble Company, Proctor, Vermont

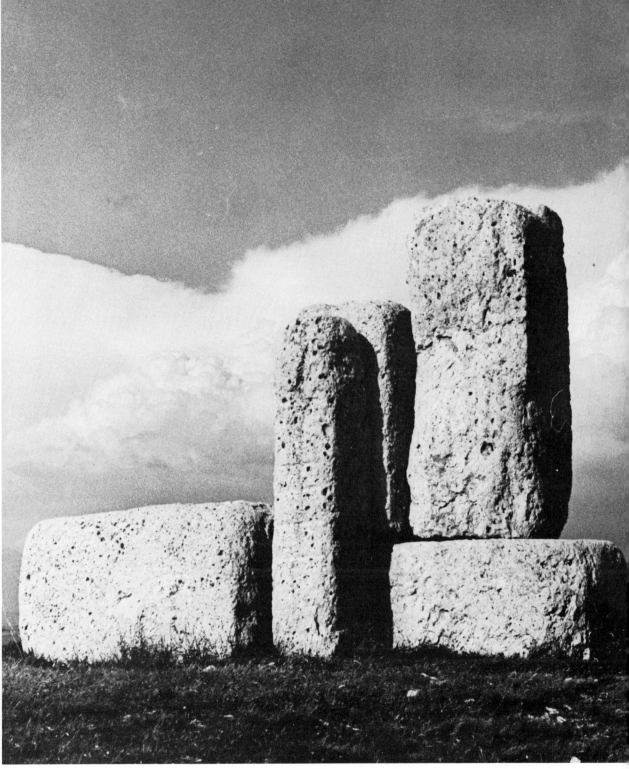

SYMPOSIUM ST. MARGARETHEN. 1963. Moshe Schwartz-Buky. Israel. The roughhewn quality of this huge rock assemblage suggests the feeling of ancient megalithic cromlechs, but with the control and relationship of the blocks to the pace of the contemporary sculptor.

Courtesy, Symposium St. Margarethen, Austria

SYMPOSIUM ST. MARGARETHEN.
1967. Leo Kornbrust. Germany.
Limestone. 5'9" high.
Courtesy, artist

SYMPOSIUM ST. MARGARETHEN.
1966. Elmar Daucher. Germany.
*Courtesy, Symposium
St. Margarethen, Austria.
Photo, Janos Frecot*

SYMPOSIUM ST. MARGARETHEN.
1966. Hermann Painitz. Austria.
Courtesy, Symposium
St. Margarethen, Austria.
Photo, Helmut Baar

SYMPOSIUM ST. MARGARETHEN.
1961. Joshikuni Iida. Japan.
Courtesy, Symposium
St. Margarethen, Austria

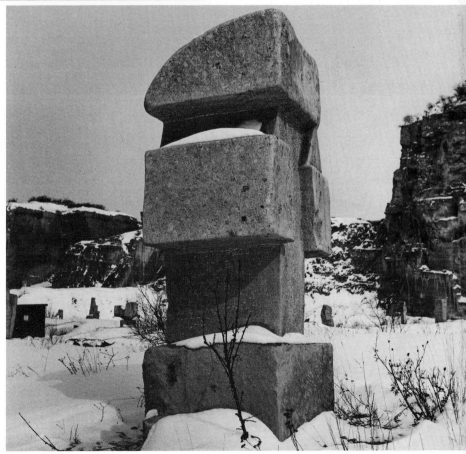

ARCHITECTURAL

It is almost impossible today to draw a line between monumental and architectural freestanding sculpture. There are commemorative works that are also created to be part of an architectural complex. Many of the monumental sculptures illustrated have been purchased to be placed in conjunction with a building.

As more people become interested in artistic understanding, one can expect a greater flourishing of sculptures in parks, in city squares, in front of buildings, sculptures purchased for their artistic value and the beautification of an area. Industry and cities, especially, are becoming patrons of contemporary monumental sculpture for their own grounds and as donations to museums.

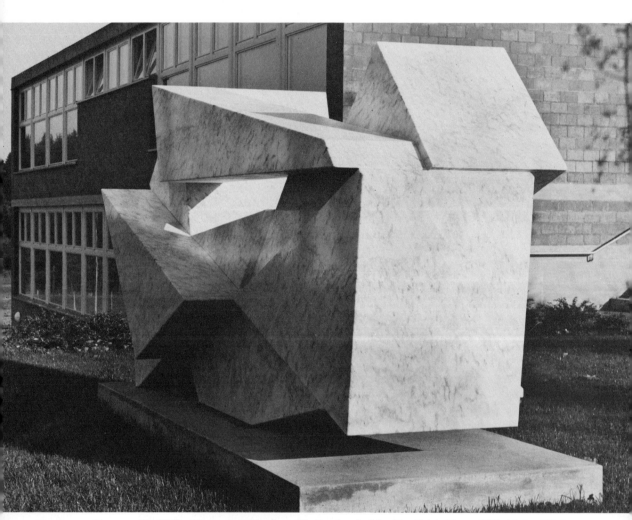

FIGURE V. 1960. Hans Aeschbacher. Switzerland. Marble Cristallina. 5′9″ high, 10′ wide. Architects: Hans Escher, Robert Weilenmann, and Roland Gross.

FIGURE III. 1964. Explorer 2. Hans Aeschbacher.
Switzerland. Carrara marble. 12′8″ high.
Courtesy and photos, artist

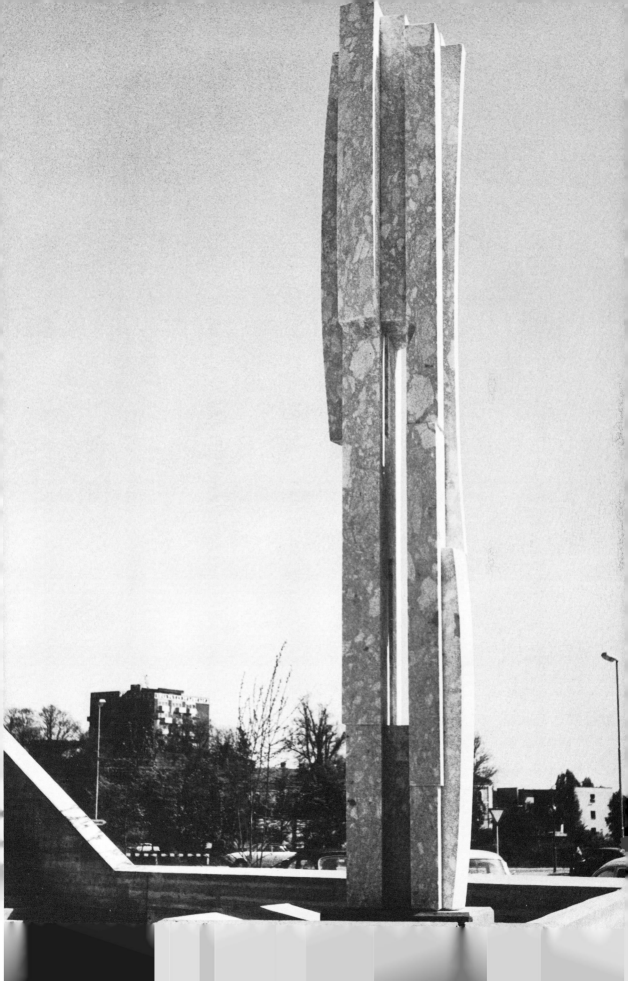

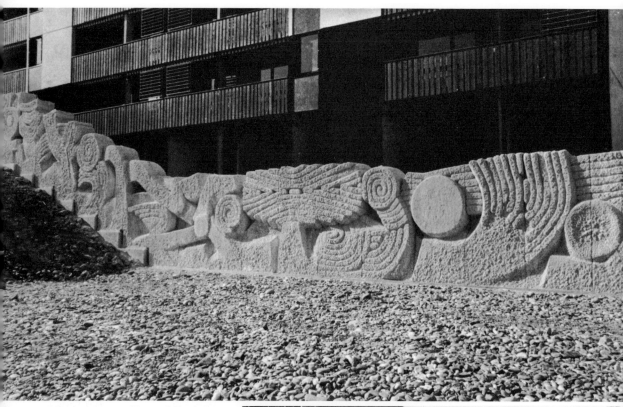

MISCROCOSME. Yasuo Mizui. Japan and France. 1967. First French symposium at Grenoble, France.
Courtesy, artist

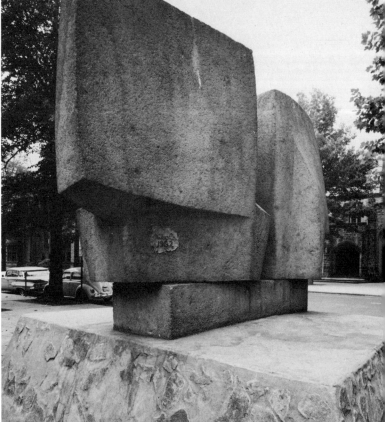

SCULPTURE FOR YALE UNIVERSITY. Constantine Nivola. 1962.
Courtesy, Yale University

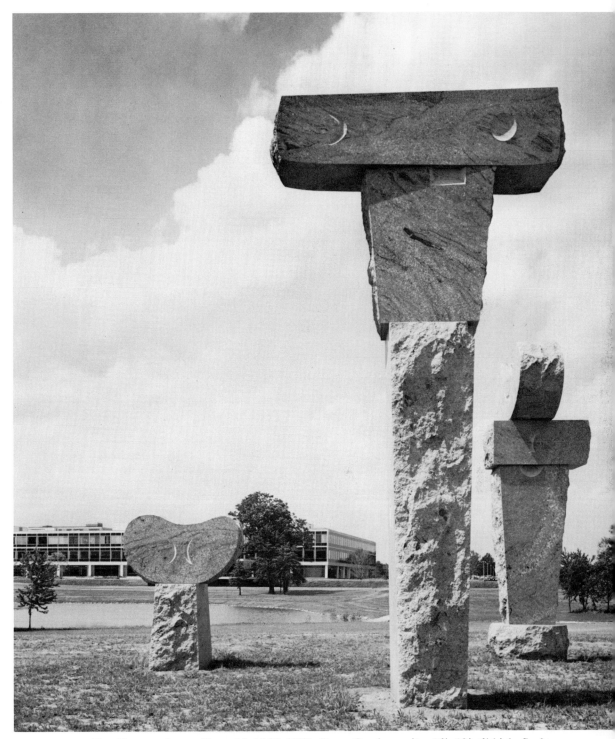

THE FAMILY. Isamu Noguchi. 1956–1957. Stony Creek granite. 16'; 12'; 6' high. Sculpture garden for the Connecticut General Life Insurance Company, Hartford, Connecticut.

Courtesy, Connecticut General Life Insurance Company.
Photo, Ezra Stoller

WALTERS MEMORIAL FOUNTAIN. William Talbot. 1959. Granite. 12′ high, 20′ wide. Missouri Botanical Gardens, St. Louis, Missouri. Composed of twenty-five carved Salisbury pink granite monoliths, it is assembled with tie rods and spacing blocks. Model detail (left) shows the pattern of water against shapes and spaces of blocks.

Courtesy, artist.
Photo, Martin Schweig

HANDICRAFT DEPARTMENT,
KING ALFRED'S COLLEGE,
WINCHESTER.

FIGURE IV. 1967. Hans Aeschbacher. Switzerland. Granite. 12′10″ high.
Courtesy and photo, artist

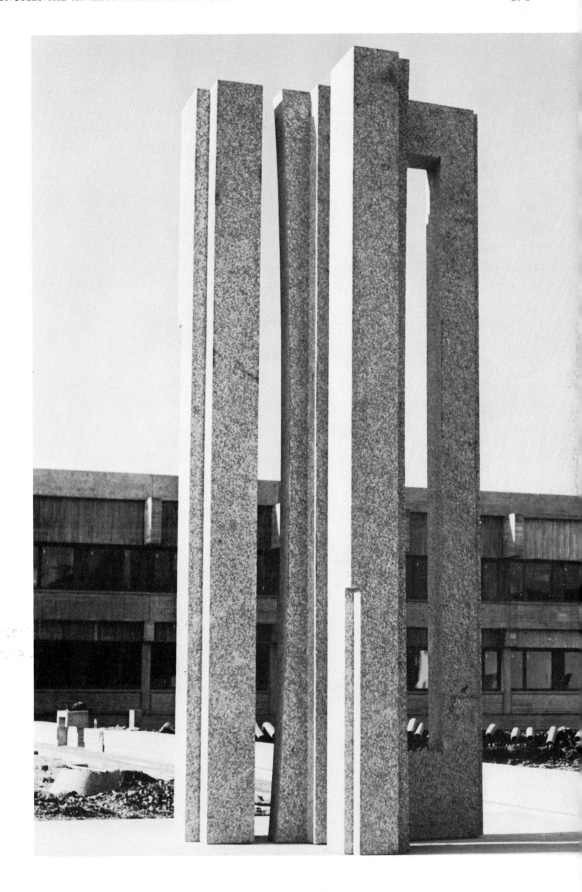

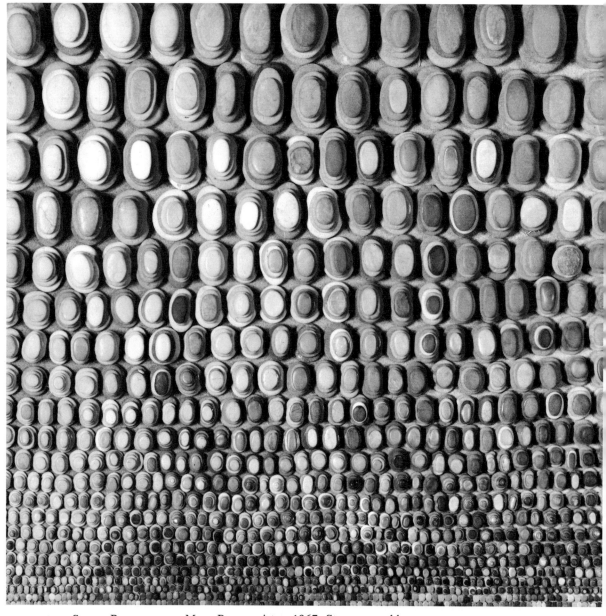

STONE PROGRESSION. Mary Bauermeister. 1967. Stone assemblage.
Courtesy, The Chase Manhattan Bank, New York.
Photo, Jan Jachniewicz

Other Ways with Stone

Throughout the book, emphasis has been on direct stone carving. Other ways to use stone directly have evolved. They utilize some of the carver's methods and require the same sense of sculptural form and dedication to the use of the natural materials.

Mary Bauermeister has pushed the idea of stone assemblage to new creative heights. By careful selection of stone and a trained artistic eye for composition, her assemblages are an important contribution to the increased interest in stone sculpture. Anita Weschler's sculptures are stones assembled with epoxy glues. Larger boulders may be rodded in the same way one places a carved stone on a base. Frankly precarious, gravity defying, sensitive sculptures can be created.

Richard Randall uses stones as an integral part of his mixed media sculptures. Their irregular shapes lend themselves to the tortured forms of the iron that surrounds them, and this selection of materials attests to the ingenuity of the creative mind.

Joan Miró has applied ceramic glazes to a rough stone which he has lightly carved to achieve an expressive form.

Lawrence Fane's use of stone aggregate over an armature welded to forged steel is an important statement in the use of combined media for expressive form. Applying a cement marble mixture directly in this manner is not modeling, not carving, yet it draws upon both methods and becomes another inspirational contribution of the successful sculptor.

The potential of stone is limited only by the imagination. When one can reject clichés, academic ideas of past generations, ignore limitations established by art critics, and have the drive to work in a dedicated fashion, it is then that the combination of perspiration and inspiration can result in innovation, achievement, and recognition.

STRANGLER No. 5. Richard
K. Randall. Rocks and welded
steel. 15″ high, 10″ wide, 8″
deep.
Courtesy, Royal S. Marks
Gallery, New York.
Photo, Jay M. Hines

BALLAST BED. Richard K.
Randall. 1964. Rock and
welded steel. 20″ high, 34″
wide, 28″ deep.
Courtesy, Walker Art Center,
Minneapolis.
Photo, Eric Sutherland

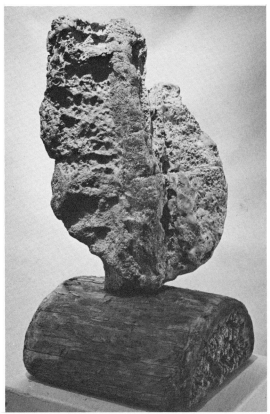

HARPY LISTENING. John R. Baxter. Stone on
wood base. 25″ high.
Courtesy, San Francisco Museum of Art

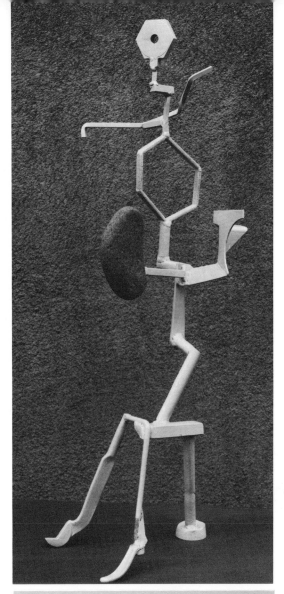

BROKEN LEG. Wilfred Zogbaum. 1963. Iron
painted white with stone. 35″ high.
Courtesy, Grace Borgenicht Gallery

STONE. Joan Miró. 1955. Stone with ceramic.
33½″ high.
Courtesy, The Art Institute of Chicago

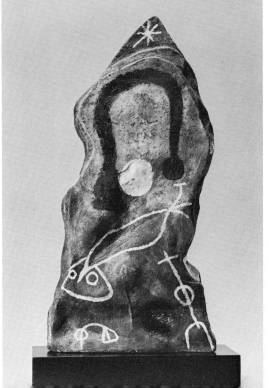

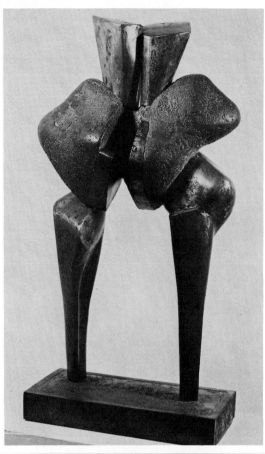

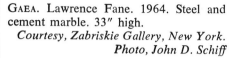

GAEA. Lawrence Fane. 1964. Steel and cement marble. 33″ high.
Courtesy, Zabriskie Gallery, New York.
Photo, John D. Schiff

STUDIES FOR SCULPTURE. Lawrence Fane. Red ink and pencil. Fane works out his sculptures carefully in drawings that have three-dimensional characteristics.
Courtesy, Zabriskie Gallery, New York

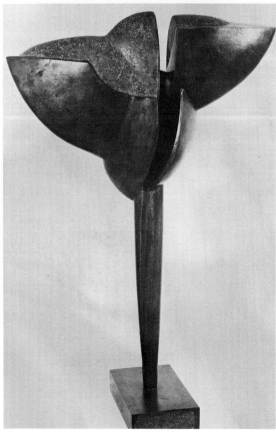

PRIMAVERA. Lawrence Fane. 1967. Metal and cement marble. 35″ high.
Courtesy, Zabriskie Gallery, New York

Lawrence Fane. A cement-marble mix-
ture is applied directly over a carefully
developed shape of galvanized hardware
cloth.

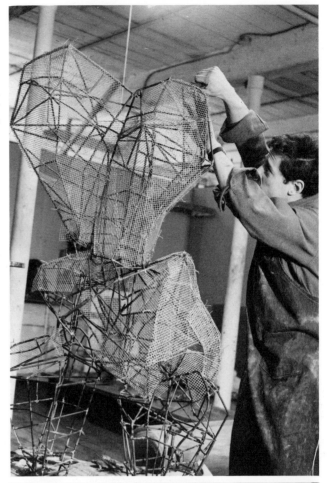

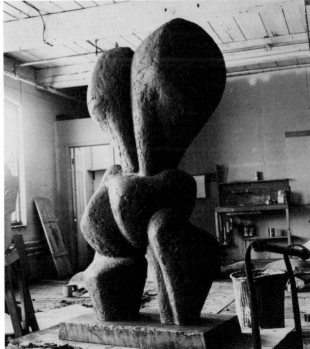

Torso. Lawrence Fane. 1964. After the
cement has been completely applied and
formed, it may be carved directly and
worked with rasps, files, polishing tools,
and a wire brush.
Collection, Champlain College,
Trent University,
Peterborough, Ontario, Canada

The armature for EVE (facing page) has been made from galvanized hardware cloth wired to rods welded to the forged steel forms.

HANDICRAFT DEPARTMENT
KING ALFRED'S COLLEGE,
WINCHESTER.

The sculptor applies the black cement marble to the mesh with a trowel. The steel parts are wrapped with plastic to keep them clean while working the cement mixture.

Photos, courtesy, artist

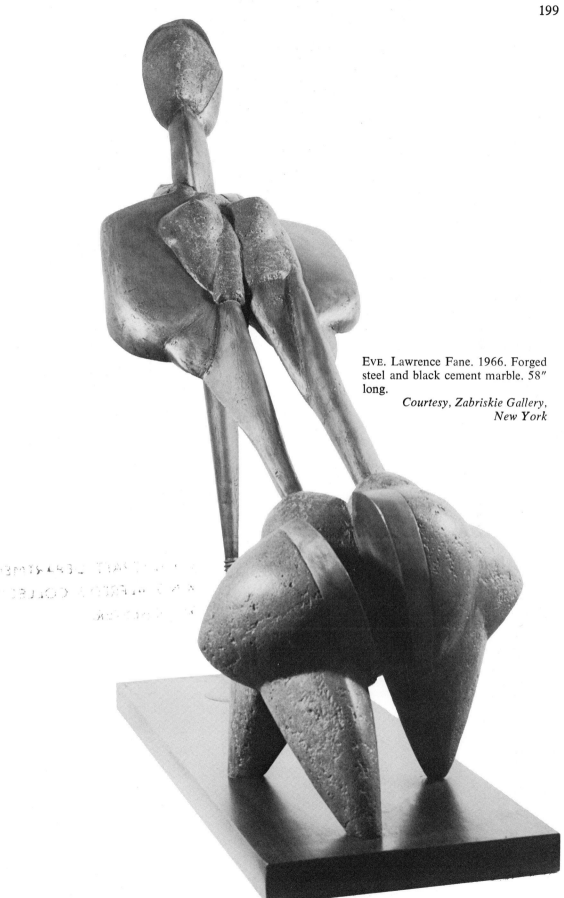

EVE. Lawrence Fane. 1966. Forged
steel and black cement marble. 58″
long.

Courtesy, Zabriskie Gallery,
New York

200

INTERCEPTOR. James Wines. 1962. Iron and cement. 30″ high, 14½″ wide, 7½″ deep.
Courtesy, Whitney Museum of American Art, New York.
Photo, Geoffrey Clements

RENASCENCE. Shirley Lichtman. 1969. Sheet brass with green recolite stone carved and polished.
Courtesy, artist

DON QUIXOTE. Katherine Nash. Welded steel and iron with stone aggregate applied.
Courtesy, artist.
Photo, Eric Sutherland

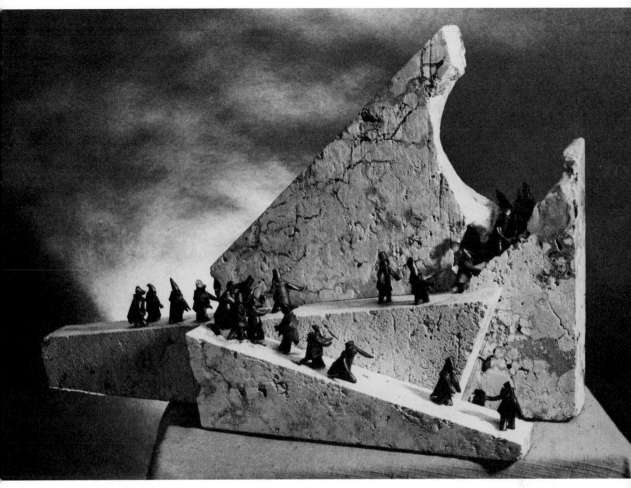

LAST EXCURSION. Albert Vrana. 1969. Travertine and bronze. 12″ high, 20″ wide.

Courtesy, artist

UNTITLED. H. C. Westermann. 1968. Stone, wood, metal chain. 9¾″ high, 23¾″ wide, 7¾″ deep.

Courtesy, Whitney Museum of American Art, New York.
Photo, Geoffrey Clements

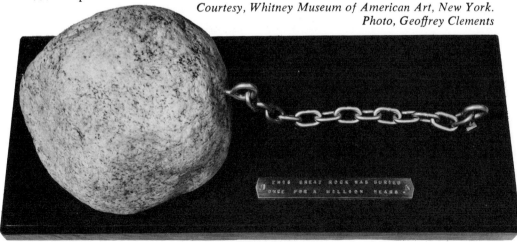

Glossary

ACADEMIC SCULPTORS

Those who continued to create forms in a traditional classical manner.

AFRICAN WONDERSTONE

A soft, easy to carve metamorphic stone.

ALABASTER

A metamorphic stone, often with some translucence, color, and marbleized effect.

ASSEMBLAGE

The technique of combining related or unrelated objects or scraps into an artistic arrangement.

BUSH HAMMER

A hammer-like tool used for wearing down stone surfaces. Two square ends have nine toothlike protuberances.

CARBORUNDUM STONES

A rough surface stone used for an abrasive.

CARRARA

A city in Italy known for its marble quarries; a specific type of marble indigenous to these quarries, usually a white statuary quality.

CARVING

The process of subtracting or taking away parts of the stone or other material and leaving a shape or design.

CASTING

The process of using a shaped mold into which a liquid material is poured and allowed to harden.

CHIPPING

Breaking away small pieces of stone a little at a time to reduce the mass.

CHISEL

A tool with a cutting edge at the end of the blade. Available in varying widths, with straight edges and teeth.

CLAY SKETCH

A carved or modeled form used as a preliminary model for a finished sculpture.

COMMEMORATIVE SCULPTURE

A sculpture created to mark a person or event.

CROSSHATCH

Placing a series of lines at parallels to each other and crossing over at about right angles with another series of lines.

DECORATIVE

An art form meant to be ornamental.

DIRECT CARVING

The sculptor works directly with his materials and is directly involved in the creation of his sculpture from beginning to end as opposed to indirect carving.

EXPRESSIVE

An art form concerned with expressing the artist's inner, or subjective, emotions and sensations.

FILE

A cutting tool with parallel ridges used for smoothing stone.

FLAKING

To break thin layers of stone away from the mass.

FLAW

A crack, gap, soft spot, bruise, or other defect in a piece of stone usually caused by natural processes.

FORGE

To shape metal by preheating and then hammering, twisting, and bending.

FORM

In sculpture, the result of uniting many diverse elements, such as shape, line, texture, subject, mass, color, and so on, until clear relationships exist and each element functions as a consistent whole.

FRACTURE

A break in a stone or rock usually resulting in a soft, crumbly layer.

GEMSTONE

Any mineral or petrified material which is hard enough to take a high degree of polish and durable enough to retain it; most often used in jewelry. For example, jade, zircon, topaz, diamonds, etc.

GOUGES

Tools with sharp blade edges in a variety of shapes from shallow U's to deep V's—usually made for wood but applicable to soft stone.

GRANITE

A natural igneous rock formation with a visibly crystalline texture. Very hard and durable, and takes a fine polish.

HARD EDGE

In art, the appearance, or actual being, of a definite line or linear shape at the edge of a form or shape.

IGNEOUS ROCKS

Rocks formed by the solidification of a molten mass: granite, basalt, diorites, rhyolite, obsidian, and similar stones.

INDIRECT CARVING

The process of creating a form in a sketch material such as wax, plaster, or clay, and reproducing it on a larger scale by the pointing method.

LAPIDARIST

One who works with gems and precious stones and understands the art of cutting them.

LIMESTONE

A rock consisting chiefly of calcium carbonate and yielding lime when burned. Crystalline limestone is called marble.

MALLET

A metal hammer-like tool for driving points and chisels into the material to be carved.

MARBLE

A crystallized form of limestone.

MASS

The total bulk of the stone or other material.

METAMORPHIC ROCK

Igneous and sedimentary stones that have changed physically by the natural forces of pressure, heat, and chemistry: marble, slate, soapstone, alabaster, onyx, and many gemstones.

MONOCHROME

A work with a single color or hue.

MONUMENTAL

May apply to the size or the idea of a sculpture; also a commemorative sculpture.

NEGATIVE SPACE

A term used in sculpture to define the open spaces or areas that allow "air" to penetrate the sculpture.

ORGANIC FORMS

Those inspired by shapes of natural, organic objects such as stone, algae, flower growths, root formations, shells, and so on.

PNEUMATIC TOOLS

Those using air pressure for the driving power of the tool.

POINTING

The procedure of reproducing a large stone sculpture from a small model by a system of measurements.

POLYCHROME

Painted or hued many colors.

PORPHYRY

An igneous rock consisting of feldspar crystals embedded in the ground mass.

PRIMITIVE SCULPTURE

Usually refers to works created by those unschooled in formal art elements. African, pre-Columbian, and Eskimo sculpture are considered primitive.

PULVERIZING

Hitting the stone repeatedly until a powdery, granular material results and disintegrates excess stone.

QUARRY

An excavated area in the mountains or underground for exposing and securing stones for building and for sculpture.

QUENCH

To dip in water and cool quickly.

RASP

A type of file with raised points that forms the cutting surface, in contrast to a true file which has parallel cutting ridges.

RESPIRATOR

A device that covers the mouth and nose to prevent inhalation of noxious substances such as stone dust.

ROUGHING OUT

Blocking out a predetermined form from a mass to a rough shape before refining.

SCRAPE

To rub over a stone with a sharp instrument to smooth the surface.

SCULPTURE IN THE ROUND

Freestanding figures, carved or modeled in three dimensions.

SCULPTURE SYMPOSIUM

A gathering of sculptors who work, discuss, and promote the creation and use of sculpture.

SEDIMENTARY ROCK

The result of deposits of sediment such as fragments of other rocks, transmitted from their sources and deposited in water and subject to erosion.

SKIN

The outer surface of a stone sculpture before it is worked to the final surface.

STONEMASONS

Artisans who work stone from designs developed by artists and architects.

STRATIFICATIONS

Layers of rock as encountered in shale, slate, and other sedimentary rocks.

STREAK (RUST AND SOFT)

In stone, a different color and density of the material caused by rust or a natural process.

STUN

To cause a change in the arrangement of molecules in a rock that may result in a bruise.

TEXTURE

The surface quality of a material that one can feel or see.

TRUTH TO MATERIALS

The concept that the inherent qualities of a material be explored and used to their full potential and not camouflaged or made to look like another material.

VOLUME

The space occupied by a sculpture.

Index

Index